CW00405431

CONWAY LLOYD MORGAN

**D'ART DESIGN GRUPPE **
UNDESIGNING

avedition **rockets**

SECTIONS \
KAPITEL

UNDESIGNING \
PROLOG
8

HAUS AM PEGEL \
BAUSTELLEN
12

PLAY \
SPIELWIESEN
42

PROCESS \
LEBENDIGE RÄUME
62

MEMORY \
ERINNERUNG
92

NARRATIVE \
HÖRENSAGEN
118

REFLECTIVITY \
SICHTWEISEN
142

COMMUNICATION \
EPILOG
158

CONTENT \
INHALT

PROJECTS \
PROJEKTE

INTERVIEWS \
INTERVIEWS

18 NEW WALLS PLEASE
HEART AM PEGEL

28 BIG X
MEHR LEBEN MIT LICHT

40 DIETER WOLFF

46 HORST IS IN THE AIR
ZUTIEFST OBERFLÄCHLICH

54 BEETRONIC, JUST (F)LYING
IN EINEM UNBEKANNTEN LAND

60 FREDDY JUSTEN

66 SAMPLE AND HOLD
DIE SUMME DER TEILE

78 LIGHT HEADED
LIGHT-GEDANKEN

90 GUIDO MAMCZUR

96 INSPIRED BY LIFE
SPURENSUCHE

104 WOODBLOCK RELOADED
DER MÄRZ WIRD HEISS

116 JOCHEN HÖFFLER

122 IMPOSSIBLE IS NOTHING
ADI DASSLER BRAND CENTER

132 HIGH TOUCH
EIN PLUS VERBINDET

140 NINA WIEMER

146 PBSA
FACHHOCHSCHULE DÜSSELDORF

152 RUDOLPH IS BACK
EINE WEIHNACHTSGESCHICHTE

162 THANKS
DANKSAGUNG

164 PICTURE CREDITS
BILDNACHWEIS

166 IMPRINT
IMPRESSUM

UN-
DESIGN-
ING

UNDESIGNING

UNDESIGNING \
PROLOG

→ "Un" is commonly a prefix about closure, about loss, about failure: unfaithful, unhappy, uncaring. It is more often final rather than ongoing: unfinished, undone, unloved. Un is negative. So what is undesigning? And why might it be something designers do? Doctors don't unheal, thieves do anything but unsteal.

But undesigning is how D'art describe what they do. It is about design, it is positive, it is ongoing – never-ending, in fact. It is open, it brings results, it is successful. What does it mean? Alan Fletcher, one of the founders of Pentagram, once classified design companies as helicopters or vending machines. It is an odd comparison – and memorable for that reason. Helicopters, he explains, can move all around a problem, up, down, left and right, even backwards, whereas with a vending machine the money goes in one slot and whatever is on the shelf falls into the bin at the bottom. Undesigning, then, is about not being a vending machine. It is about not applying ready-made solutions to design challenges.

That is the negative sense of the term: what about the positive aspect? I think it means in one sense putting design second. That is, faced with a new commission or a new opportunity, D'art's reaction is not "what is the design answer?" but "what is the question about?" It is about engaging in dialogue before reaching for the mouse or the pad and pencil, it is about becoming involved in the whole issue rather than finding a quick fix. It is about reflectivity.

A lot of design agencies will tell one that this is indeed what they do, and many even practice what they preach. D'art go a step further: by using the term undesigning to describe their activity, they bring this process of reflection and consideration to the forefront. It gives the routine activity of "thinking about the brief" a positive force in the

> CONWAY LLOYD MORGAN, EDITOR OF THE AV-EDITION ROCKETS SERIES, IS A WRITER AND CONSULTANT ON CONTEMPORARY ARCHITECTURE AND DESIGN BASED IN LONDON. HE IS ALSO PROGRAMME LEADER IN NEW MEDIA PUBLISHING AT THE UNIVERSITY OF WALES, NEWPORT.

> CONWAY LLOYD MORGAN, HERAUSGEBER DER ROCKETS-REIHE, IST AUTOR UND BERATER FÜR ZEITGENÖSSISCHE ARCHITEKTUR UND LEBT IN LONDON. ER IST LEITER DES STUDIENGANGS MEDIA PUBLISHING AN DER UNIVERSITÄT NEWPORT IN WALES.

→ Die Vorsilbe »Un« bedeutet im Deutschen »nicht«, sie ist eine Verneinung, etwas Negatives: untreu, unglücklich, ungerührt. Im Englischen bedeutet sie außerdem eine Beendigung, einen Verlust, ein Scheitern. Meist bezeichnet sie etwas Endgültiges, nichts Fortdauerndes: unfertig, unerledigt, ungeliebt. »Un« ist Negation. Was also ist »Undesigning«? Und warum sollten Designer es tun? Ärzte machen ihre Patienten nicht ungesund, Mörder ihre Opfer nicht untot.

Aber D'art beschreibt seine Arbeit als Undesigning. Es geht um Gestaltung, es ist positiv, es währt fort – es ist sogar endlos. Es ist offen, es zeitigt Ergebnisse, es ist erfolgreich. Was bedeutet es? Alan Fletcher, einer der Gründer von Pentagram, sagte einmal, Gestaltungsateliers seien entweder Hubschrauber oder Verkaufsautomaten. Ein seltsamer Vergleich – und dadurch einprägsam. Hubschrauber, erklärt er, können ein Problem umkreisen, von oben, unten, rechts, links, sogar rückwärts, wohingegen man in Verkaufsautomaten oben Geld in einen Schlitz steckt, und unten kommt das heraus, was drin war. Beim Undesigning geht es demnach darum, kein Verkaufsautomat zu sein. Es geht darum, gestalterischen Herausforderungen nicht mit vorgefertigten Lösungen zu begegnen.

Das ist die negative Seite dieses Begriffs, und wie sieht die positive aus? Ich glaube, in gewissem Sinne bedeutet Undesigning, das Design an zweite Stelle zu setzen. Das heißt, D'art reagiert auf einen neuen Auftrag oder eine neue Chance nicht mit einem »Wie sieht die gestalterische Lösung aus?«, sondern mit »Worum geht es eigentlich?«. Es geht darum, sich auf ein Gespräch einzulassen, bevor man nach Maus oder Pad oder Bleistift greift, es geht darum, sich mit der Materie zu beschäftigen, und nicht um schnelle Lösungen. Es geht um Reflexion.

Viele Gestaltungsateliers werden von sich behaupten, so zu arbeiten, und tatsächlich tun sie es auch. D'art geht aber noch einen Schritt weiter: Indem sie den Ausdruck Undesigning für ihre Arbeit verwenden, stellen sie den Prozess des Reflektierens und Abwägens in den Vordergrund. Es verleiht den routinemäßigen »Überlegungen zum Briefing« im Arbeitsprozess einen positiven Nachdruck. Es macht sie zum

working process. It makes it the key-stone of their design philosophy. This has a number of consequences. In the first place, the client is no longer just the end-user of the design solution, but part of the whole activity of creating that solution. This of course requires more involvement on the clients' part, bringing them across the table to share with the designers the creative process. Secondly, the design process becomes an open and shared one, not something that the designers reveal stage by stage but a combined series of discoveries and inventions. Thirdly, the investment of time and energy by the client ensures the durability of the design and maintains its viability after the solution is delivered. Fourthly, the client acquires ownership of the design solution through the process, and this is perhaps the most important aspect of the D'art approach.

Take for example the work D'art did for Aces at Euroshop 2005. Aces is a specialised company for high-end projects in trade fair stands, shops and showrooms. Apart from the core areas stores, stands and expotools, they offer displays and products, mainly furniture. The conventional design solution is evident: let the visitor get close to the product. One might imagine large-scale images, 3D mock-ups or a direct presentation of the furniture. But D'art saw the agenda differently. Firstly they stressed the common ground of the five core areas: the identical fields of use and their inter-communication. Secondly they wanted to highlight the workmanship of the products, and thirdly they wanted the visitor's experience to be a personal one.

So, to get up close and personal, D'art proposed a series of five leather cubes – one for each core area – into the illuminated tops of which picture slides of the products were placed for display. To get a closer look, the visitor would be

Grundpfeiler der Gestaltungsphilosophie, und das hat eine Reihe von Auswirkungen: Erstens ist der Kunde nicht mehr nur der Endbenutzer einer gestalterischen Lösung, sondern wird in den gesamten Schaffensprozess einbezogen. Das bedeutet natürlich eine stärkere Einbindung des Kunden, der mit den Gestaltern am Tisch sitzt und am kreativen Prozess teilnimmt. Zweitens ist der Gestaltungsprozess transparent, es wird nicht Schritt für Schritt etwas von den Designern enthüllt, sondern in einer zusammenhängenden Abfolge von Entdeckungen und Erfindungen gemeinsam entwickelt. Drittens wird dadurch, dass der Kunde so viel Engagement mit einbringt, die Haltbarkeit des Designs und seine Lebensfähigkeit auch nach Ablieferung gesichert. Und viertens ergreift der Kunde während des Findungsprozesses Besitz von der gestalterischen Lösung, und vielleicht ist dies der wichtigste Aspekt des Ansatzes von D'art.

Nehmen wir beispielsweise D'arts Arbeit für Aces auf der Euroshop 2005. Aces realisiert anspruchsvolle Projekte im Bereich Messen, Shops und Showrooms. Neben den Kernbereichen Stores, Stands und Expotools gehören Displays und Products (Möbel) zum Portfolio. Die konventionelle gestalterische Lösung liegt auf der Hand: man muss den Besucher nah an das Produkt heranbringen. Stark vergrößerte Bilder, 3D-Modelle oder die direkte Präsentation der seriellen Möbel wären denkbar gewesen. Aber D'art machte einen ganz anderen Vorschlag. Zum einen wurde die prinzipielle Gemeinsamkeit der fünf Kernbereiche betont: das identische Einsatzgebiet und die Kommunikation. Zum anderen sollte die handwerkliche Perfektion der Produkte herausgestellt werden, und schließlich sollte der Besucher eine persönliche Erfahrung machen.

Um den Besucher nah heranzubringen und ihn persönlich einzubeziehen, schlug D'art eine Reihe von fünf Lederkuben vor – einen für jeden der fünf Bereiche – auf deren Leuchttischoberfläche Dias von Projektbeispielen und Referenzen auslagen. Zum Erkunden der Dias erhielt der Besucher einen Diabetrachter, der anschließend als Erinnerung mitgenommen werden durfte. Das genaue Betrachten stand für den hohen Anspruch an die handwerkliche Qualität der Produkte und

given a slide viewer, which could be taken away as a souvenir. Having to look closely represented the high quality of the products and offered an opportunity for a conversation in passing. Apart from the cubes the only other element of the stand was a curtain of slats, which moved continuously like a floating veil. It would act as a kind of back wall at one time, and then form transparent spaces around the cubes. So the visitor would find himself or herself bent over the cube to examine an object closely, and on finishing would straighten up to find the curtain that was in front now soundlessly at the side, or whatever.

Getting close to the objects made the visit a personal experience, and this simple kinetic intervention made it memorable.

bot nebenbei einen Gesprächsanlass. Das einzige weitere Element des Stands war ein Fadenvorhang, der sich wie ein mobiler Schleier kontinuierlich bewegte. Einmal stellte er eine Art Rückwand dar, dann wieder formte er transparente Räume um die Kuben. Ein Besucher beugte sich vielleicht über einen der Würfel, um ein Dia aus der Nähe zu betrachten, und wenn er sich wieder aufrichtete, war der Vorhang, der hinter ihm gehangen hatte, plötzlich geräuschlos zur Seite oder anderswohin geglitten.

Den Objekten nahezukommen, machte den Besuch zu einem persönlichen Erlebnis, und dieser einfache kinetische Eingriff machte ihn einprägsam.

> A GOSSAMER VEIL MOVES OVER THE WHOLE OF THE STAND LIKE A LIGHT BREEZE AND DEPICTS THE FLOWING MOVEMENT OF SPACE AND AREA.

> WIE EINE SANFTE BRISE BEWEGT SICH EIN LUFTIG LEICHTER SCHLEIER ÜBER DEN GESAMTEN STAND UND BESCHREIBT RAUM UND FLÄCHE IN FLIESSENDER BEWEGUNG.

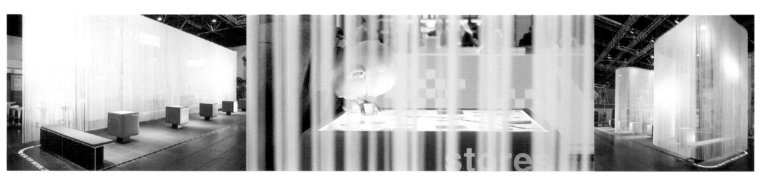

HAUS AM PEGEL \
BAUSTELLEN

→ Writing some fifteen years ago in "Sex, Drink and Fast Cars", Stephen Bayley assured his readers that a client would often show a visiting designer out to the car park "to check out his wheels". (Bayley was a consultant to a range of car manufacturers, and his first book was on the car designer Harley Earl.) This was a percipient comment, as many of his were and are. Today, however, the focus has changed. Architecture and interior space are now used as markers of attitudes and values. This is a process of maturation perhaps: deciding what car to buy is a lot less complex a decision than creating a workspace.

In what ways, then, does a work-space establish the values of an enter-prise? There are a number of levels of context. Location is perhaps the first of these: in dense and complex cities, such as London or New York, where real estate is at a premium, there is not just a spatial map but an economic overlay, in terms of value, and a further social one in terms of prestige. The degree of visibility of these distinctions depends on the viewer's access to the social and cultural system of values that underpins them.

A second context is spatial organi-sation within the workplace. What do the patterns of organisation, the arrangement of different spaces, suggest about the hierarchies that the occupiers respect? It was an adage in New York business for the post-war generation, for example, that the higher the floor the higher the rank, and the greater the number of windows in an office the greater the occupier's prestige. Modern office spaces are subject to more complex analyses, in that individual working areas are more subtly defined. In the case of design companies, the concept of the studio – a space for the physical making of objects – overlays the notion of the

→ Vor gut fünfzehn Jahren versicherte Stephen Bayley in »Sex, Drink and Fast Cars« seinen Lesern, Gestalter würden von ihren Kunden oft zum Parkplatz begleitet, weil die Kunden »ihre Wagen sehen« wollten. (Bayley war Berater einer Reihe von Automobilherstellern, sein erstes Buch schrieb er über den Autodesigner Harley Earl.) Eine scharfsinnige Beobachtung, wie viele seiner Beobachtungen. Heute hat sich die Aufmerksamkeit jedoch verlagert. Als Indikatoren für Ansichten und Wertvorstellungen gelten eher Architektur und Innenarchitektur. Vielleicht liegt dahinter ein Reifeprozess: Welches Auto man kauft, ist eine deutlich weniger komplexe Entscheidung als die Gestaltung einer Arbeits-umgebung.

Und inwiefern lässt die Arbeitsumgebung Schlüsse auf die Wertvorstellungen eines Unter-nehmens zu? Da gibt es mehrere kontextuelle Ebenen. Die erste ist vielleicht die Lage: In dichten und komplexen Städten wie London oder New York, in denen Immobilien hoch im Kurs stehen, gibt es nicht nur eine geographische Landkarte, sondern dahinter liegt noch ein wirtschaftlicher Aspekt, der den Wert betrifft, und ein sozialer, der das Prestige betrifft. Der Grad der Sichtbarkeit dieser Zeichen hängt davon ab, inwieweit der Betrachter Zugang zu dem sozialen und kulturellen System hat, auf dem sie gründen.

Ein zweiter Kontext ist die räumliche Organisation innerhalb der Arbeitsumgebung. Was sagen die Organisationsmuster, die räumliche Anordnung über die Hierarchien, denen die Benutzer unterliegen? Im New Yorker Geschäftsleben der Nachkriegsgeneration galt beispielsweise: je höher das Stockwerk, desto höher die Stellung, und je mehr Fenster, desto mehr Prestige. In modernen Bürogebäuden sind die Strukturen komplexer, denn die individuellen Arbeitsbereiche werden subtiler abgegrenzt. Bei Gestaltungsunternehmen überdeckt das Konzept des Ateliers – eines Raums für die physische Herstellung von Objekten – die Vorstellung von einem Büro und schließt Fragen der Zusammenarbeit und der Gruppendynamik ebenso ein wie die der Rolle des Einzelnen.

Ein dritter Kontext ist die Arbeitsumgebung als Lebensraum. Was sagen Möbel, Beleuchtung

office, and involves questions of team-work and team structures as well as individual roles.

A third context is the workplace as habitat. What does the furnishing, lighting and decoration of a space have to say about the values and beliefs of those who work there? This question looks at aspects of formality vs. informality, traditional vs. contemporary, organised vs. free-form and so on. While in most office spaces the visual marker today is the computer screen and keyboard, design spaces involve a wider range of tools and so use a subset of more complex signs.

The fourth element is that of degree: to what extent does it seem that a working structure or series of values has been imposed on a space, and to what extent does it appear to have evolved through use? This reflects the balance between formal order and collaboration that refers in turn to the working practice of the organisation concerned.

Take D'art Design's former offices in a disued railway station in Neuss, near Düsseldorf. The choice of location suggests functionality, rather than status, but I say "suggests" because to a British sensibility the choice of a railway station carries a set of cultural values linked to transport history: these are not necessarily paralleled in Germany. But even if the personality of the site is different, it was evidently not an anonymous modern building, nor a specific new build.

Working areas in the listed railway station intercommunicated with each other, rather than occupying isolated areas, in so far as the existing physical structure permitted. Specific openly-shared spaces, such as the kitchen area, were clearly informal and non-hierarchical.

Furnishing and decoration also embraced practicality rather than show.

und Dekoration eines Raums über die Werte und Vorstellungen derer aus, die darin arbeiten? Hier geht es um Aspekte wie: förmlich oder informell, klassisch oder zeitgenössisch, geordnet oder frei und so weiter. In den meisten Büros sind die vorherrschenden Elemente heute Computerbildschirm und Tastatur; Gestaltungsbüros verwenden aber noch deutlich mehr Geräte und dadurch auch ein komplexeres Zeichensystem. Das vierte Kontext-Element ist ein graduelles: In welchem Maße wurde dem Raum eine Struktur oder ein Wertesystem verliehen, und inwieweit hat es sich durch Benutzung entwickelt? Hieran erkennt man das Verhältnis zwischen formaler Ordnung und Zusammenarbeit, das wiederum auf die Arbeitspraxis der betreffenden Organisation verweist.

Nehmen wir beispielsweise die ehemaligen Büros von D'art Design in einem stillgelegten Bahnhof in Neuss bei Düsseldorf. Diese Ortswahl scheint eher Funktionalität als Status zu signalisieren, aber ich sage »scheint«, weil die Wahl eines Bahnhofs für britisches Empfinden eine Reihe von kulturellen Werten im Zusammenhang mit Transport impliziert: in Deutschland ist das aber nicht zwangsläufig ebenso. Aber selbst wenn der Ort eine andere Ausstrahlung hat, ist er offensichtlich weder ein anonymes modernes Gebäude noch ein eigens neu gebautes.

Die einzelnen Arbeitsplätze im denkmalgeschützten Bahnhof befanden sich in vielen Einzelräumen und waren miteinander verbunden, soweit die bestehende räumliche Struktur es erlaubte. Bestimmte Gemeinschaftsräume wie die Küche waren eindeutig informell und nicht hierarchisch.

Auch Möblierung und Dekoration waren eher nach praktischen Aspekten ausgewählt als nach Repräsentativität. Die Möbel waren eindeutig modern, aber keine Designer-Marken. Es bestand keine offensichtliche Hierarchie: keine besonderen Sessel für Vorgesetzte oder Ähnliches.

Die Nutzung des Raums hatte sich mit dem Wachstum des Unternehmens entwickelt, als es sich von einer Etage auf zwei ausbreitete. Platz war offenkundig sehr gefragt, überall standen Regale mit Büchern und Akten bis unter die Decke. Insgesamt war die Atmosphäre freundlich, aber zweckmäßig: Teamwork wurde und wird als

The furniture was clearly modern, but not designer-labelled. There was no evident hierarchy: no armchairs for senior members or suchlike.

The use of the space clearly developed with the growth of the company, as it spread from one floor onto two. Space was also evidently at a premium, with shelving everywhere extended to the ceiling to accommodate records and files. Overall the atmosphere was friendly but purposeful: teamwork was and is sensed to be a central value, and the crowded conditions were accepted as part of the enjoyment of working there.

Within the office space, it is clear that communication is a key value. Wanting the ideal space for the conceptual phase of their design work led to the decision to leave the railway station. Which is why in March 2006 they moved to new offices in the centre of town.

The new office is in the Haus am Pegel: the term refers to the tide gauge in the harbour, an indicator that tells captains, stevedores and shipowners the level of the water, and so whether they can bring their ships to the quay to load or unload. Linking the agency to this symbol of the city's commercial tradition has a certain appropriateness. Design, after all, requires much the same sensitivity to change and circumstance as the merchant venturers needed to bring their cargoes safely to port.

Docklands have become a favoured media milieu in recent years. In London, for example, television companies and newspaper offices (the latter for rather special reasons) moved from the city centre to Wapping and Canary Wharf. In Düsseldorf, just under 10 kilometres from Neuss, part of the old harbour has been named the Media Haven, in a move to encourage design and advertising agencies to take up space there, while a further part has been transformed into

> THE NEUSS INDUSTRIAL HARBOUR IS CHARACTERISED BY GRAIN AND OIL MILLS. THE FIRST RHINE OCEAN-GOING VESSELS WERE FREQUENTING THE CURRENT NEUSS HARBOUR BASIN 1 AS EARLY AS 1897.

> GETREIDE UND ÖLMÜHLEN PRÄGEN DAS BILD DES NEUSSER INDUSTRIEHAFENS. BEREITS SEIT 1897 VERKEHREN DIE ERSTEN RHEIN-SEE-SCHIFFE IM HEUTIGEN NEUSSER HAFENBECKEN 1.

Kernkompetenz empfunden, und die Überfülltheit wurde als Teil der Freude daran, hier zu arbeiten, akzeptiert.

Innerhalb des Büros ist die Kommunikation offensichtlich ein Kernpunkt. Die Überlegung, ideale Räume für die konzeptionelle Phase des Entwerfens bereitzustellen, zog die Entscheidung nach sich, den Bahnhof zu verlassen. Und so zog D'art im März 2006 in neue Büros in der Stadtmitte um.

Das neue Büro liegt im Haus am Pegel; der Name bezieht sich auf den Rheinpegel im Hafen, der Kapitänen, Schauermännern und Schiffseignern den Wasserstand anzeigt und an dem sie ablesen, ob sie mit ihren Schiffen zum Be- und Entladen anlegen können. Die Agentur mit diesem Symbol für die Handelstradition der Stadt in Verbindung zu bringen, ist durchaus angemessen. Design verlangt schließlich etwa dasselbe Gespür für Wandel und äußere Gegebenheiten, das auch die Kaufleute benötigten, um ihre Fracht sicher in den Hafen zu bringen.

Hafenviertel sind in den letzten Jahren zu begehrten Medienstandorten geworden. In London zum Beispiel sind Fernsehsender und Zeitungsredaktionen (letztere aus ganz speziellen Gründen) aus der Stadtmitte nach Wapping und Canary Wharf gezogen. In Düsseldorf, keine 10 Kilometer von Neuss entfernt, wurde ein Teil des alten Hafens in »Medienhafen« umbenannt, um Gestaltungs- und Werbeagenturen anzulocken. Ein weiterer Teil wurde zum Jachthafen umgewandelt; der Rest liegt kommerziell brach. In Neuss sieht es anders aus: Der Hafen ist noch in Betrieb, mit einem Containerterminal und einem stetigen Strom von Schiffen, die ihre Fracht den Rhein hinauf- und hinunterbringen. Das Haus am Pegel ist kein Vertreter der industriellen Retro-Mode, sondern die Wiederbelebung eines Industriegebäudes in einem intakten industriellen Kontext.

Hier konnten die Vorstellungen von der Trennung von dialogischem Konzipieren und rechnergestützter Umsetzung optimal verwirklicht werden. Die Bürofläche liegt auf einer einzigen Etage im Erdgeschoss und gliedert sich in zwei jeweils 300 m² große Räume mit einem zentralen Eingang und einem Empfangstresen. Im großen, weiß gestrichenen Bereich links des

a marina: commercially the rest is idle. In Neuss the situation is rather different: the harbour is still busy, with a container handling unit, and a steady stream of barges bringing cargoes up and down the Rhine. The Haus am Pegel is not fashionable industrial retro, but the revitalising of an industrial building in a working industrial context.

Here the idea of a separation of design dialogue and computer-aided realization could be put into effect in an ideal way. The offices take up a single level on the ground floor, divided into two rooms of 300 m² each, with a central entrance and reception desk. In the large, open, white-painted space to the left of the reception, under a four-metre ceiling, five groups of four workstations each provide individual desking, the white Vitra furniture by Ronan and Erwan Bouroullec offset by coloured half-partitions and dark Meda chairs. Five glazed office boxes down the left-hand side provide spaces for marketing staff, project management, archives and support facilities, such as printers and copiers. The whole is lit by intelligent office lights by Philips as well as by natural light from floor-length wide windows on each side, from which the city and the canals – and their passing traffic – can be seen. A comfortable, contemporary work area, comparable to many design agencies.

The space opening out to the right of the dark, under-lit reception unit is more unusual. Its footprint matches the 30 x 15 metres of the described working area, and it too is divided down the centre by a row of squat square columns. Part of one side is walled off by shelving, to create a long closed meeting area on the harbour side. On the other side a library offers a retreat, and additional groups of tables and chairs provide meeting areas. But this is not their only purpose. It is a space for conversation and the group meetings that are a key

Empfangs befinden sich die Arbeitsplätze aller Mitarbeiter. Hier bilden fünf Joyn-Arbeitsplattformen Platz für gut 20 personengebundene Arbeitsplätze unter der vier Meter hohen Decke. Die weißen, von Ronan und Erwan Bouroullec entworfenen Vitra-Möbel erhalten durch farbige, niedrige Trennelemente und dunkle Meda-Chairs einen Gegenpol. Fünf verglaste Büroräume auf der linken Seite bieten Platz für die Marketing-abteilung, Projektleitung, Archive und Technik. Das Ganze wird – neben einer intelligenten Bürobeleuchtung von Philips – von beiden Seiten durch bodentiefe, breite Fenster mit Tageslicht erleuchtet, durch die man auf die Stadt und das Hafenbecken mit seinem regen Treiben blickt. Eine komfortable, moderne Arbeitsumgebung, vergleichbar mit der vieler anderer Gestaltungs-ateliers.

Der Raum rechts der dunklen, dezent beleuchteten Rezeption ist ungewöhnlicher. Der Grundriss spiegelt die 30 x 15 Meter des beschriebenen Arbeitsbereichs und wird eben-falls in der Mitte durch kompakte, quadratische Säulen geteilt. An einer Seite ist ein Teil des Raums durch Regale abgetrennt, sodass auf der Hafenseite ein langer, geschlossener Bespre-chungsraum entsteht. Auf der anderen Seite bietet eine Bibliothek mit langen Tischen eine Rückzugsmöglichkeit; an weiteren Tischgruppen bestehen Möglichkeiten für Besprechungen. Aber dies ist nicht ihr einziger Zweck. Es ist ein Raum für Gespräche und Konzeptionsmeetings, die den Kern der Arbeit von D'art bilden, es ist aber auch – entgegen der Intuition – ein Ort der Stille, der Reflektion und der Zeit für sich selbst. Und so wird er auch genutzt: hier schreibe ich einen Großteil dieses Texts, während die Mitarbeiter der Agentur sich im Besprechungs-raum das Eröffnungsspiel der Weltmeisterschaft anschauen.

Und D'art ist gut darin, gegen die Intuition zu agieren.

part of D'art's practice, but it is also –
counter-intuitively – a quiet space, for
reflection and individual time. And it
works as such: most of this text was
written there while the agency team
were watching the World Cup opening
match in the meeting area.

But then being counter-intuitive is
something D'art do well.

NEW WALLS PLEASE \
HEART AM PEGEL

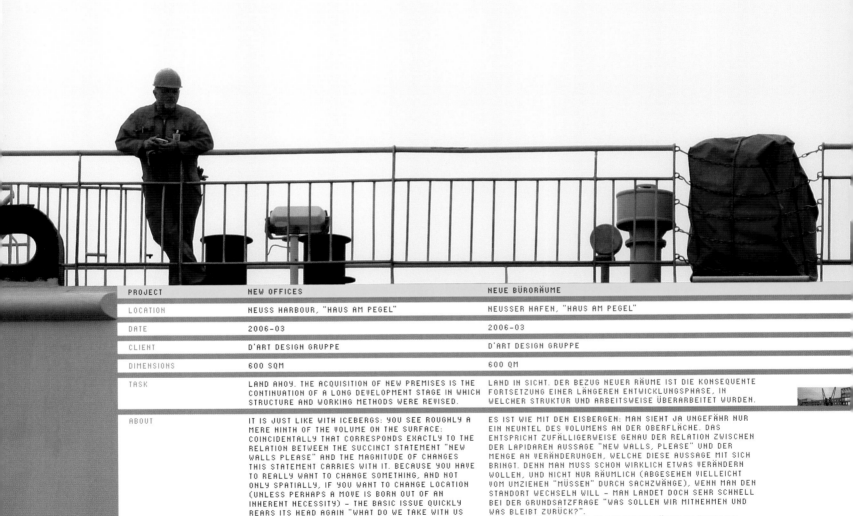

PROJECT	NEW OFFICES	NEUE BÜRORÄUME
LOCATION	NEUSS HARBOUR, "HAUS AM PEGEL"	NEUSSER HAFEN, "HAUS AM PEGEL"
DATE	2006-03	2006-03
CLIENT	D'ART DESIGN GRUPPE	D'ART DESIGN GRUPPE
DIMENSIONS	600 SQM	600 QM
TASK	LAND AHOY. THE ACQUISITION OF NEW PREMISES IS THE CONTINUATION OF A LONG DEVELOPMENT STAGE IN WHICH STRUCTURE AND WORKING METHODS WERE REVISED.	LAND IN SICHT. DER BEZUG NEUER RÄUME IST DIE KONSEQUENTE FORTSETZUNG EINER LÄNGEREN ENTWICKLUNGSPHASE, IN WELCHER STRUKTUR UND ARBEITSWEISE ÜBERARBEITET WURDEN.
ABOUT	IT IS JUST LIKE WITH ICEBERGS: YOU SEE ROUGHLY A MERE NINTH OF THE VOLUME ON THE SURFACE: COINCIDENTALLY THAT CORRESPONDS EXACTLY TO THE RELATION BETWEEN THE SUCCINCT STATEMENT "NEW WALLS PLEASE" AND THE MAGNITUDE OF CHANGES THIS STATEMENT CARRIES WITH IT. BECAUSE YOU HAVE TO REALLY WANT TO CHANGE SOMETHING, AND NOT ONLY SPATIALLY, IF YOU WANT TO CHANGE LOCATION (UNLESS PERHAPS A MOVE IS BORN OUT OF AN INHERENT NECESSITY) – THE BASIC ISSUE QUICKLY REARS ITS HEAD AGAIN "WHAT DO WE TAKE WITH US AND WHAT WILL BE LEFT BEHIND?" FOR US MOVING INTO THE NEW PREMISES IN THE "HAUS AM PEGEL" IS THE PRACTICAL IMPLEMENTATION OF THEORETICAL PLANNING IN RELATION TO THE FIELD OF WORK AND METHOD OF WORKING. OF COURSE THIS IS NOT THE FIRST REVISION AND MOST LIKELY NOT THE LAST; BUT AS GROUCHO MARX SO NICELY PUT IT: "THESE ARE MY PRINCIPLES, IF YOU DON'T LIKE THEM, I HAVE OTHERS".	ES IST WIE MIT DEN EISBERGEN: MAN SIEHT JA UNGEFÄHR NUR EIN NEUNTEL DES VOLUMENS AN DER OBERFLÄCHE. DAS ENTSPRICHT ZUFÄLLIGERWEISE GENAU DER RELATION ZWISCHEN DER LAPIDAREN AUSSAGE "NEW WALLS, PLEASE" UND DER MENGE AN VERÄNDERUNGEN, WELCHE DIESE AUSSAGE MIT SICH BRINGT. DENN MAN MUSS SCHON WIRKLICH ETWAS VERÄNDERN WOLLEN, UND NICHT NUR RÄUMLICH (ABGESEHEN VIELLEICHT VOM UMZIEHEN "MÜSSEN" DURCH SACHZWÄNGE), WENN MAN DEN STANDORT WECHSELN WILL – MAN LANDET DOCH SEHR SCHNELL BEI DER GRUNDSATZFRAGE "WAS SOLLEN WIR MITNEHMEN UND WAS BLEIBT ZURÜCK?". FÜR UNS IST DER UMZUG IN DIE NEUEN RÄUME IM "HAUS AM PEGEL" DIE PRAKTISCHE UMSETZUNG VON THEORETISCHEN PLANUNGEN IN BEZUG AUF ARBEITSFELD UND ARBEITSWEISE. NATÜRLICH IST DAS NICHT DIE ERSTE ÜBERARBEITUNG UND WOHL AUCH NICHT DIE LETZTE, ABER WIE SAGTE GROUCHO MARX SO SCHÖN: "THESE ARE MY PRINCIPLES, IF YOU DON'T LIKE THEM, I HAVE OTHERS".

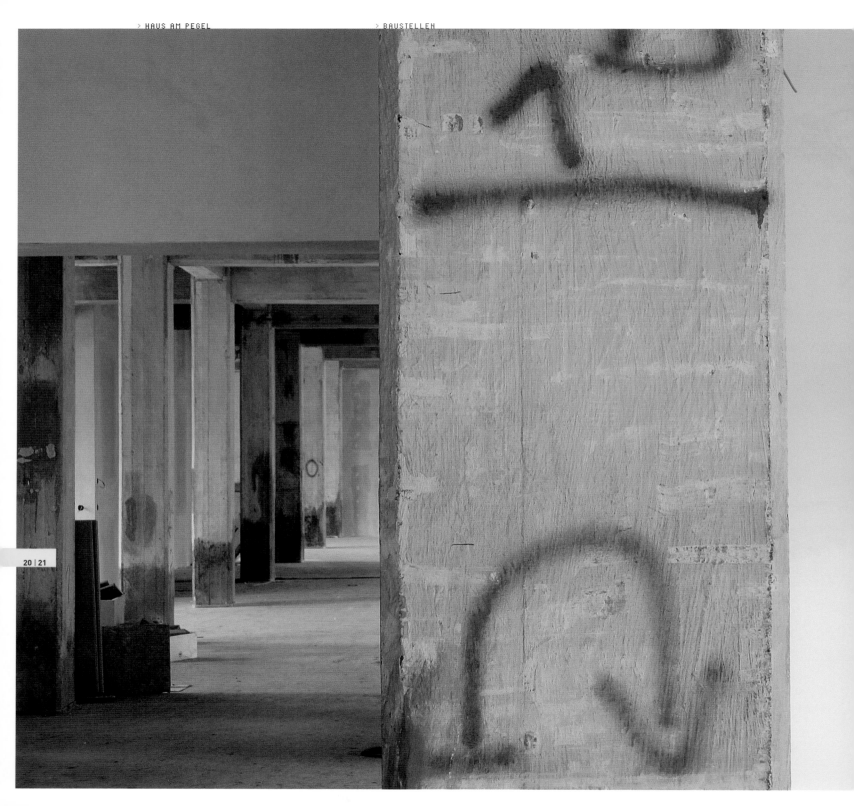

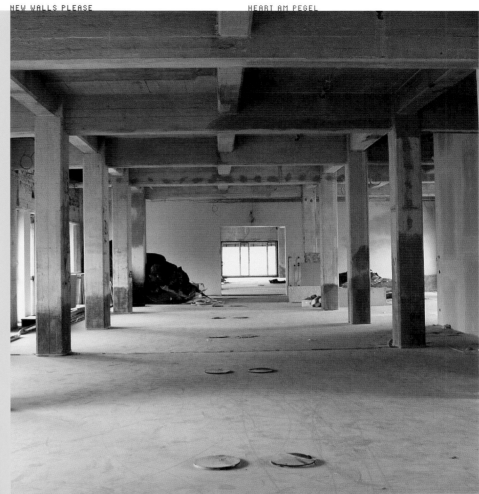

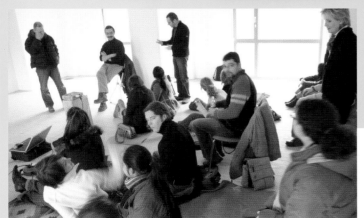

> THE FORMER NESKA WAREHOUSES IN THE FIRST HARBOUR BASIN OF THE NEUSS RHINE HARBOUR FORM THE LINK BETWEEN THE HARBOUR AND NEUSS CITY CENTRE. ALONGSIDE THE NUMEROUS RATIONAL ARGUMENTS, THE FASCINATING BORDER LOCATION BETWEEN THE ROUGH INDUSTRIAL HARBOUR, GALLOP RACECOURSE AND HISTORICAL OLD TOWN WAS PARTICULARLY CONVINCING FOR US (ARCHITECTURE: FRITSCHI, STAHL, BAUM).

> DIE EHEMALIGEN NESKA-LAGERHALLEN AM ERSTEN HAFENBECKEN DES NEUSSER RHEINHAFENS BILDEN DAS BINDEGLIED ZWISCHEN HAFEN UND NEUSSER INNENSTADT. NEBEN DER VIELZAHL DER RATIONALEN ARGUMENTE HAT UNS HIER BESONDERS DIE SPANNENDE GRENZLAGE ZWISCHEN RAUHEM INDUSTRIEHAFEN, GALOPPRENNBAHN UND HISTORISCHER ALTSTADT ÜBERZEUGT (ARCHITEKTUR: FRITSCHI, STAHL, BAUM).

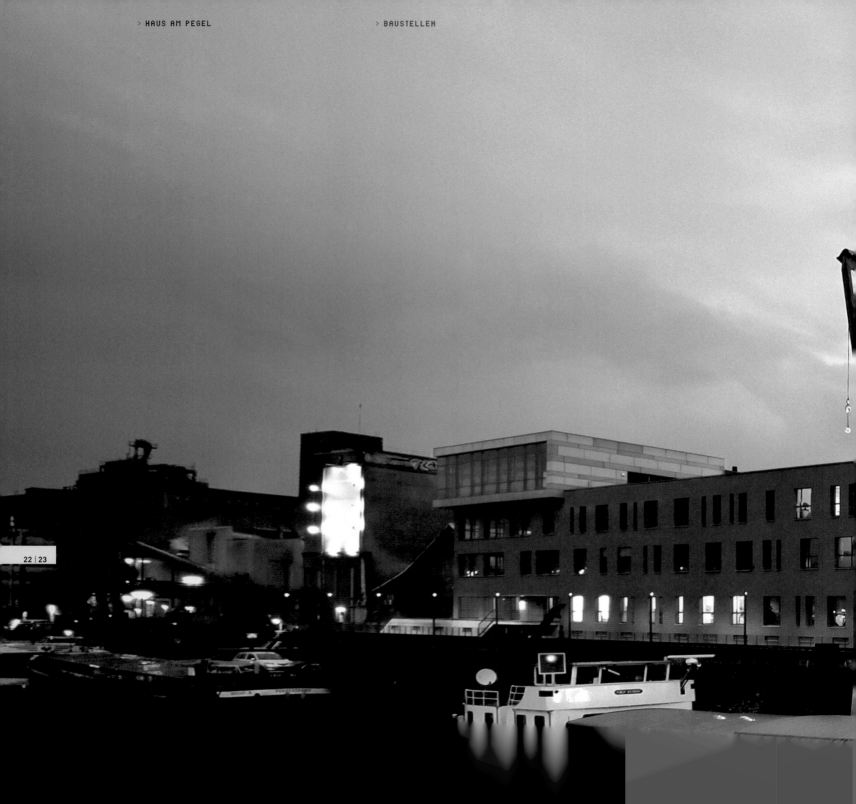

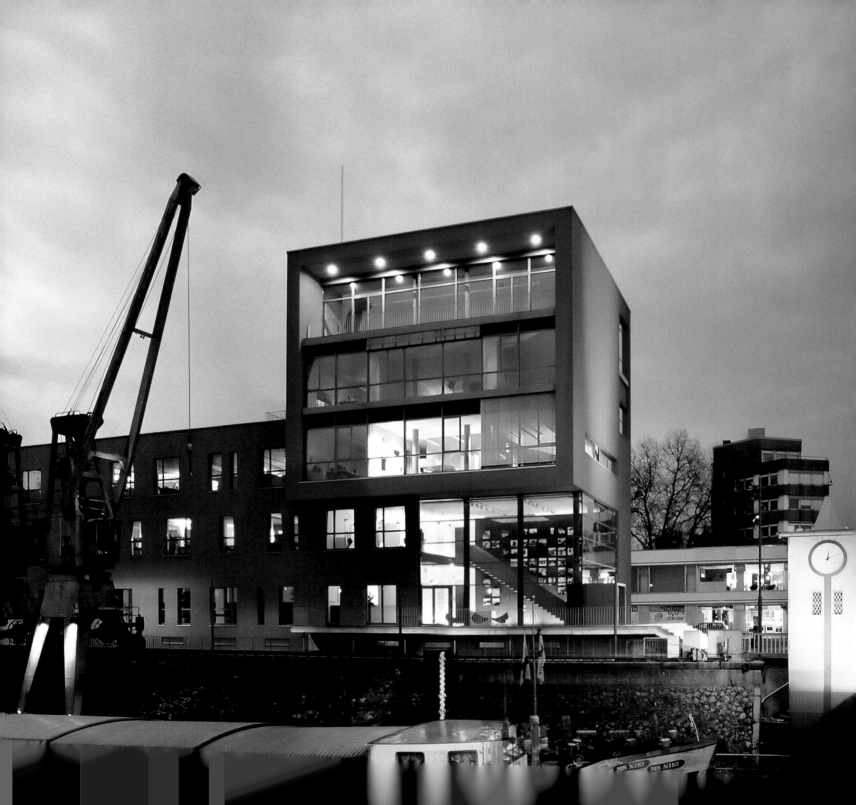

> THE ENTRANCE AREA COMMUNICATES IMAGE DETAILS FROM CURRENT PROJECTS VIA A PROJECTOR. THE HOME TEAM AND GUESTS CAN PLAY AGAINST EACH OTHER AT TABLE FOOTBALL IN A SMALL LOUNGE AREA WHENEVER THEY LIKE. ADJOINING THIS IS THE GALLEY AND BREAK AREA PROVIDING GREEN TEA, HEALTH FOOD AND A CHIP BAR.

> DER EINGANGSBEREICH KOMMUNIZIERT ÜBER PROJEKTIONEN BILDDETAILS AUS AKTUELLEN PROJEKTEN. HEIMMANNSCHAFT UND GÄSTE KÖNNEN SICH JEDERZEIT IN EINEM KLEINEN AUFENTHALTSBEREICH AM KICKER MESSEN. ANGRENZEND BEFINDET SICH DIE KOMBÜSE UND DER PAUSENBEREICH FÜR GRÜNTEE, TRENNKOST UND POMMES-SCHRANKE.

> THE LIBRARY AND FREE AREAS CAN BE USED BY WORK GROUPS. THE OFF-SHORE TERRACE AND THE PROMENADE CAN ALSO BE USED IN THE SUMMER.

> BIBLIOTHEK UND FREIE ZONEN KÖNNEN VON ARBEITSGRUPPEN GENUTZT WERDEN. DIE VORGE-LAGERTE TERRASSE UND DIE PROMENADE KÖNNEN IM SOMMER EBENFALLS MITGENUTZT WERDEN.

KÜCHE

ABSTELLRAUM

BUCHHALTUNG / MEETING 02

WAIT'N SEE

EINKAUF

EMPFANG

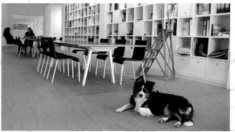

THINK'N WORK

BIBLIOTHEK think'n read

24 | 25

WAIT'N SEE

MEETING 01

> THE SOUNDPROOF "LARGE" MEETING ROOM WITH ITS OPULENT VIEW OF THE HARBOUR BASIN MAY ALSO BE OPTICALLY DETACHED IF REQUIRED.

> DER ABHÖRSICHERE "GROSSE" BESPRECHUNGSRAUM MIT OPULENTEM BLICK AUF DAS HAFENBECKEN LÄSST SICH BEI BEDARF ABER AUCH OPTISCH ENTKOPPELN.

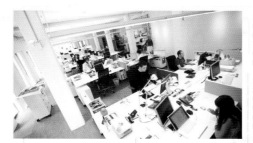

> THE WORK AREAS ARE ARRANGED IN SMALL GROUPS
OF 2-4 PEOPLE. EXTENSIVE SCIENTIFIC ANALYSES
HAVE DETERMINED THAT THE AMOUNT OF BELONGINGS
TO BE TAKEN FROM THE OLD WORK PLACE SHOULD
OPTIMALLY FIT EXACTLY INTO A STANDARD WASHING
BASKET.

> DIE ARBEITSBEREICHE SIND IN KLEINGRUPPEN VON
2-4 PERSONEN GEGLIEDERT. DURCH UMFANGREICHE
WISSENSCHAFTLICHE ANALYSEN HAT SICH DIE MENGE
VON EXAKT EINEM STANDARD-WÄSCHEKORB ALS
OPTIMUM DER VOM ALTEN ARBEITSPLATZ MITZUNEH-
MENDEN DINGE HERAUSGESTELLT.

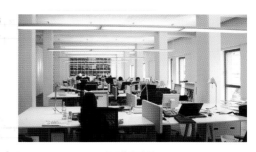

GF / MEETING 03

MODELLBAU
AUSSENDUNG

KOPIERER &
BÜROMATERIAL

> THE ENTIRE AREA IS DIVIDED INTO TWO PARTS: THE RIGHT PART OFFERS SPACE FOR CONCENTRATED WORK AT
INDIVIDUALLY ALLOCATED, FIXED WORKPLACES. EMPLOYEES WHO SPEND A LOT OF TIME ON THE TELEPHONE OR
ARE PERMANENTLY IN MEETINGS ARE DETACHED BY THE GLASS ANNEXES. VIEWED IN A NAUTICAL SENSE,
EVERYONE IS SITTING IN A "BOAT" (CAPTAIN INCLUDED). THE LEFT HALF IS MULTIFUNCTIONAL AND IS FREELY
AVAILABLE TO 3-4 (VOCIFEROUS) WORK GROUPS. AND IF IT GETS REALLY LOUD, THERE'S ALWAYS THE TERRACE
TO ESCAPE TO.

> DIE GESAMTE FLÄCHE IST ZWEIGETEILT: DER RECHTE TEIL BIETET RAUM FÜR KONZENTRIERTES ARBEITEN AN
FESTEN, PERSONENGEBUNDENEN PLÄTZEN. VIELTELEFONIERER UND DAUERBESPRECHER WERDEN DURCH DIE
GLASANLAGEN ENTKOPPELT. NAUTISCH GESEHEN SITZEN ABER ALLE IN EINEM "BOOT" (KAPITÄNE EINGESCHLOS-
SEN). DIE LINKE HÄLFTE IST MULTIFUNKTIONAL UND STEHT 3-4 (LAUTSTARKEN) ARBEITSGRUPPEN ZUR FREIEN
VERFÜGUNG. WENN ES MAL GANZ LAUT WIRD, KANN MAN AUCH AUF DIE TERRASSE FLÜCHTEN.

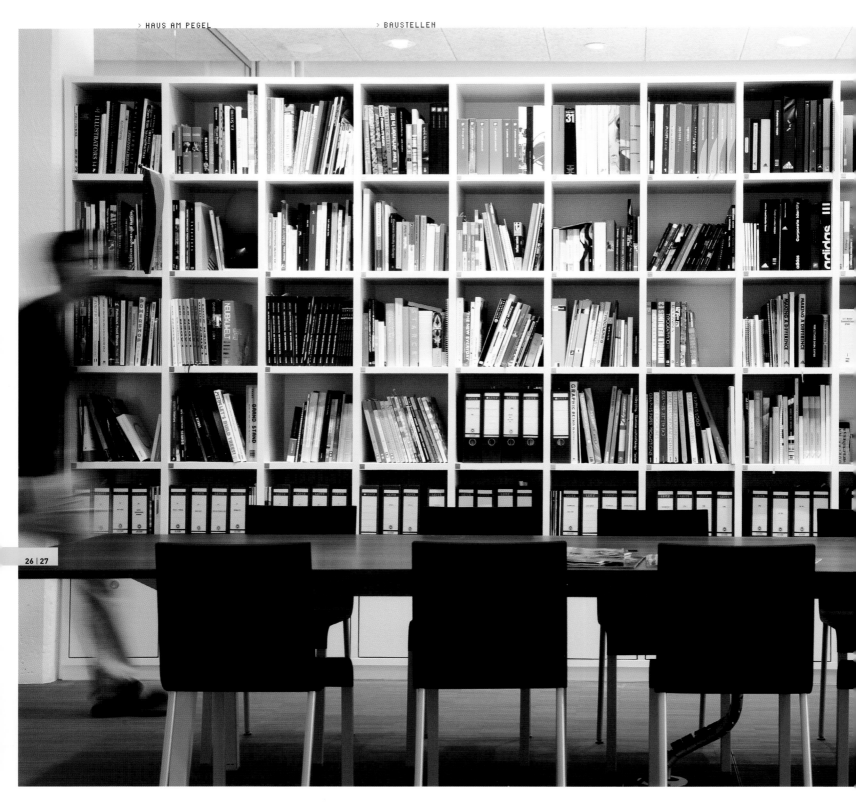

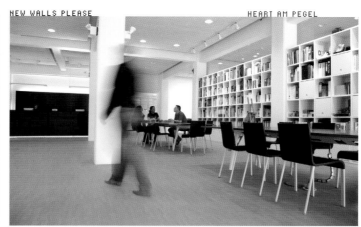

> INSPIRATION REQUIRES FREE SPACE TO DEVELOP. TO CREATE SOMETHING NEW
REQUIRES SPACE AND TIME ALONGSIDE AN IDEA FOR IT TO DEVELOP. OUR PLANNING
FOR THE NEW PREMISES IN THE "HAUS AM PEGEL" IS THUS ALSO "REDUCED"
ACCORDINGLY AS FAR AS THE OBLIGATORY SPECIFICATIONS ARE CONCERNED. WE
CONSIDER OURSELVES IN THIS SENSE A PERMANENT BUILDING SITE THAT NEEDS TO
BE CONSTANTLY TENDED.

> INSPIRATION BRAUCHT FREIRAUM: DAMIT ETWAS NEUES ENTSTEHEN KANN,
BRAUCHT ES NEBEN EINER IDEE AUCH RAUM UND ZEIT, SICH ZU ENTWICKELN.
UNSERE PLANUNG FÜR DIE NEUEN RÄUMLICHKEITEN IM "HAUS AM PEGEL" IST DANN
AUCH ENTSPRECHEND "REDUZIERT", WAS DIE ZWINGENDEN FESTLEGUNGEN ANGEHT.
WIR BETRACHTEN UNS HIER GERNE ALS "DAUERBAUSTELLE" MIT KONSTANTEM
PFLEGEBEDARF.

**BIG X **
MEHR LEBEN MIT LICHT

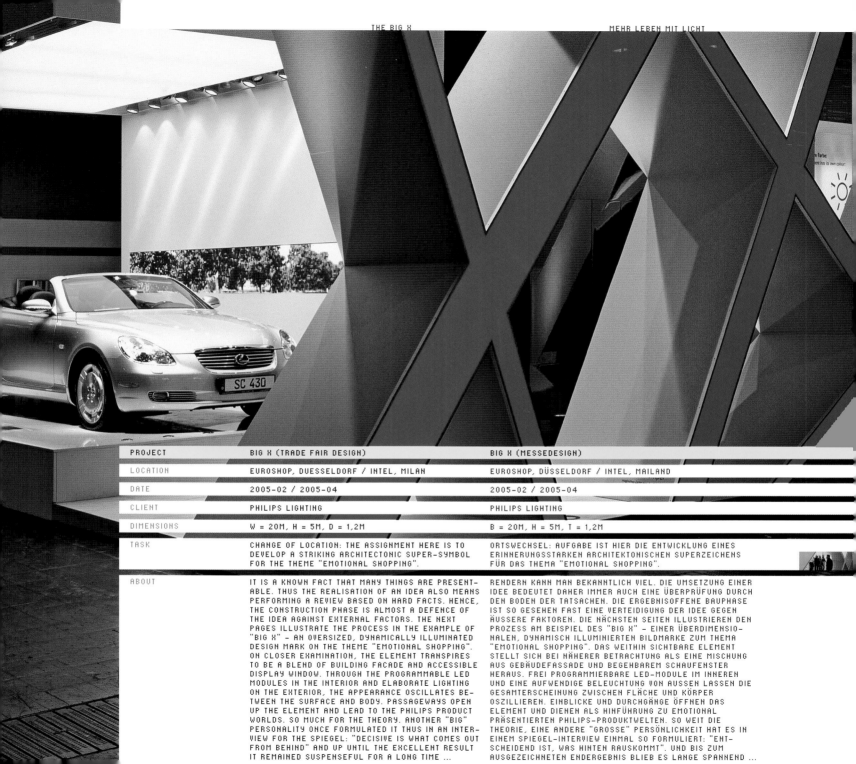

PROJECT	BIG X (TRADE FAIR DESIGN)	BIG X (MESSEDESIGN)
LOCATION	EUROSHOP, DUESSELDORF / INTEL, MILAN	EUROSHOP, DÜSSELDORF / INTEL, MAILAND
DATE	2005-02 / 2005-04	2005-02 / 2005-04
CLIENT	PHILIPS LIGHTING	PHILIPS LIGHTING
DIMENSIONS	W = 20M, H = 5M, D = 1,2M	B = 20M, H = 5M, T = 1,2M
TASK	CHANGE OF LOCATION: THE ASSIGNMENT HERE IS TO DEVELOP A STRIKING ARCHITECTONIC SUPER-SYMBOL FOR THE THEME "EMOTIONAL SHOPPING".	ORTSWECHSEL: AUFGABE IST HIER DIE ENTWICKLUNG EINES ERINNERUNGSSTARKEN ARCHITEKTONISCHEN SUPERZEICHENS FÜR DAS THEMA "EMOTIONAL SHOPPING".
ABOUT	IT IS A KNOWN FACT THAT MANY THINGS ARE PRESENTABLE. THUS THE REALISATION OF AN IDEA ALSO MEANS PERFORMING A REVIEW BASED ON HARD FACTS. HENCE, THE CONSTRUCTION PHASE IS ALMOST A DEFENCE OF THE IDEA AGAINST EXTERNAL FACTORS. THE NEXT PAGES ILLUSTRATE THE PROCESS IN THE EXAMPLE OF "BIG X" – AN OVERSIZED, DYNAMICALLY ILLUMINATED DESIGN MARK ON THE THEME "EMOTIONAL SHOPPING". ON CLOSER EXAMINATION, THE ELEMENT TRANSPIRES TO BE A BLEND OF BUILDING FACADE AND ACCESSIBLE DISPLAY WINDOW. THROUGH THE PROGRAMMABLE LED MODULES IN THE INTERIOR AND ELABORATE LIGHTING ON THE EXTERIOR, THE APPEARANCE OSCILLATES BETWEEN THE SURFACE AND BODY. PASSAGEWAYS OPEN UP THE ELEMENT AND LEAD TO THE PHILIPS PRODUCT WORLDS. SO MUCH FOR THE THEORY. ANOTHER "BIG" PERSONALITY ONCE FORMULATED IT THUS IN AN INTERVIEW FOR THE SPIEGEL: "DECISIVE IS WHAT COMES OUT FROM BEHIND" AND UP UNTIL THE EXCELLENT RESULT IT REMAINED SUSPENSEFUL FOR A LONG TIME ...	RENDERN KANN MAN BEKANNTLICH VIEL. DIE UMSETZUNG EINER IDEE BEDEUTET DAHER IMMER AUCH EINE ÜBERPRÜFUNG DURCH DEN BODEN DER TATSACHEN. DIE ERGEBNISOFFENE BAUPHASE IST SO GESEHEN FAST EINE VERTEIDIGUNG DER IDEE GEGEN ÄUSSERE FAKTOREN. DIE NÄCHSTEN SEITEN ILLUSTRIEREN DEN PROZESS AM BEISPIEL DES "BIG X" – EINER ÜBERDIMENSIONALEN, DYNAMISCH ILLUMINIERTEN BILDMARKE ZUM THEMA "EMOTIONAL SHOPPING". DAS WEITHIN SICHTBARE ELEMENT STELLT SICH BEI NÄHERER BETRACHTUNG ALS EINE MISCHUNG AUS GEBÄUDEFASSADE UND BEGEHBAREM SCHAUFENSTER HERAUS. FREI PROGRAMMIERBARE LED-MODULE IM INNEREN UND EINE AUFWENDIGE BELEUCHTUNG VON AUSSEN LASSEN DIE GESAMTERSCHEINUNG ZWISCHEN FLÄCHE UND KÖRPER OSZILLIEREN. EINBLICKE UND DURCHGÄNGE ÖFFNEN DAS ELEMENT UND DIENEN ALS HINFÜHRUNG ZU EMOTIONAL PRÄSENTIERTEN PHILIPS-PRODUKTWELTEN. SO WEIT DIE THEORIE, EINE ANDERE "GROSSE" PERSÖNLICHKEIT HAT ES IN EINEM SPIEGEL-INTERVIEW EINMAL SO FORMULIERT: "ENTSCHEIDEND IST, WAS HINTEN RAUSKOMMT". UND BIS ZUM AUSGEZEICHNETEN ENDERGEBNIS BLIEB ES LANGE SPANNEND ...

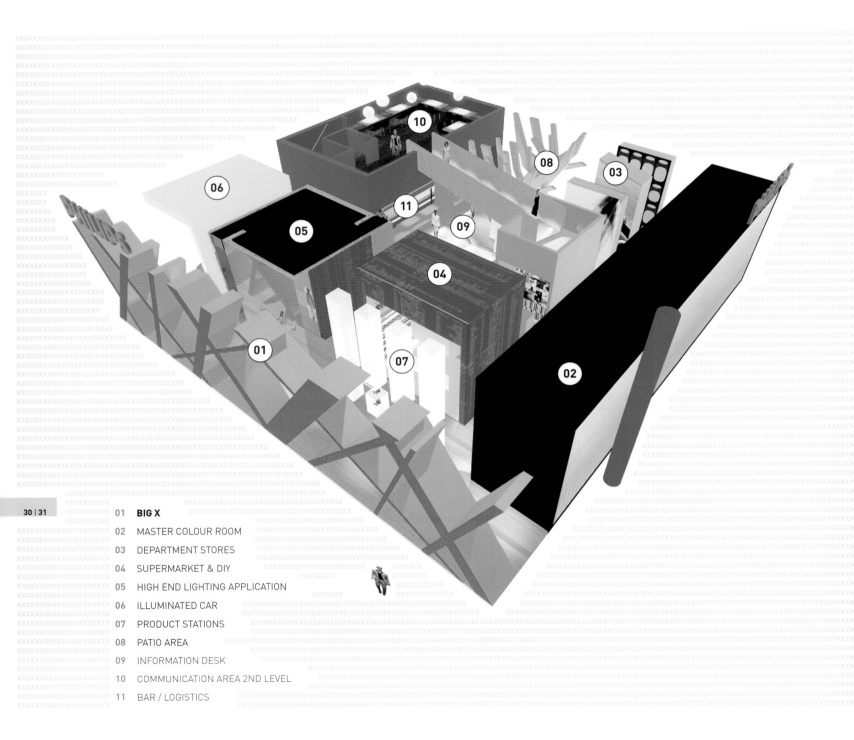

01 **BIG X**

02 MASTER COLOUR ROOM

03 DEPARTMENT STORES

04 SUPERMARKET & DIY

05 HIGH END LIGHTING APPLICATION

06 ILLUMINATED CAR

07 PRODUCT STATIONS

08 PATIO AREA

09 INFORMATION DESK

10 COMMUNICATION AREA 2ND LEVEL

11 BAR / LOGISTICS

Enhance People's Lives with Lighting

> ONCE THE CONCEPT IS FOUND IN A SMALL GROUP, THE WORK REALLY BEGINS. NOT ONLY DO THE WORK GROUPS SUDDENLY BECOME LARGER, THE GENERAL CONDITIONS ARE NUMEROUS AND CAN CHANGE FROM ONE MINUTE TO THE NEXT: DREADED "NEW HALL PILLARS" APPEAR FROM OUT OF NOWHERE AND NECESSITATE, TOGETHER WITH CHANGES IN CONTENT, MIRRORING THE ENTIRE AREA (CF. PHOTO OF MODEL / RENDERING).

> WENN DAS KONZEPT IM "KLEINEN KREIS" GEFUNDEN IST, GEHT DIE ARBEIT ERST RICHTIG LOS: NICHT NUR DIE ARBEITSGRUPPEN WERDEN SCHLAGARTIG GRÖSSER, AUCH DIE RAHMENBEDINGUNGEN SIND ZAHLREICH UND KÖNNEN SICH SCHLAGARTIG ÄNDERN: SO TRETEN GEFÜRCHTETE "NEUE HALLENSÄULEN" AUS DEM NICHTS IN ERSCHEINUNG UND ERZWINGEN ZUSAMMEN MIT INHALTLICHEN ÄNDERUNGEN EINE SPIEGELUNG DER GESAMTEN FLÄCHE (VERGL. MODELLFOTO / RENDERING).

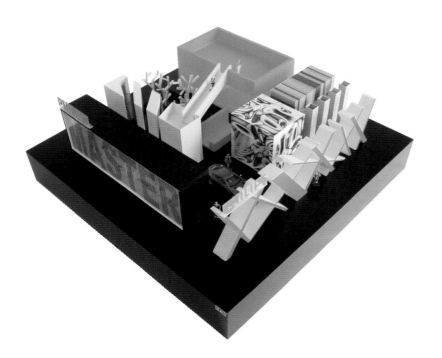

> THE ATMOSPHERIC EFFECTS OF VARIOUS LIGHT SOURCES ARE EXAMINED BY THE 3D SIMULATION.

> DIE ATMOSPHÄRISCHEN AUSWIRKUNGEN UNTERSCHIEDLICHER LICHTQUELLEN WERDEN IN DER 3D-SIMULATION GEPRÜFT.

> ALONGSIDE A MODULAR INSTALLATION (MULTIPLE USE) AND THE TEMPORARY INTEGRATION OF GARDEN GNOMES, THE PARTIAL TEST SUPERSTRUCTURE ON A SCALE OF 1:1 BECAME INCREASINGLY IMPORTANT. ONLY IN THE REAL IMAGE SIZE CAN THE EXACT LIGHT DISPERSION AND SHADOWS BE EFFECTIVELY WORKED ON. AFTER THE SECOND ATTEMPT, AN OPTIMUM BLEND OF NUMBER OF LIGHT SPOTS, INTERIOR CONSTRUCTION AND PLEXIGLAS WAS FOUND.

> NEBEN EINEM MODULAREN AUFBAU (MEHRFACH-EINSATZ) UND DER TEMPORÄREN INTEGRATION VON GARTENZWERGEN WURDEN DIE PARTIELLEN TESTAUFBAUTEN IM MASSSTAB 1:1 IMMER WICHTIGER. ERST IN DER REALEN ABBILDUNGSGRÖSSE LASSEN SICH EXAKTE LICHTSTREUUNG UND VERSCHATTUNGEN INNERHALB DES BAUKÖRPERS SINNVOLL BEARBEITEN. NACH DEM ZWEITEN ANLAUF WURDE EIN OPTIMALER MIX AUS LICHTPUNKT-ANZAHL, INNENKONSTRUKTION UND ACRYLGLAS GEFUNDEN.

PHILIPS

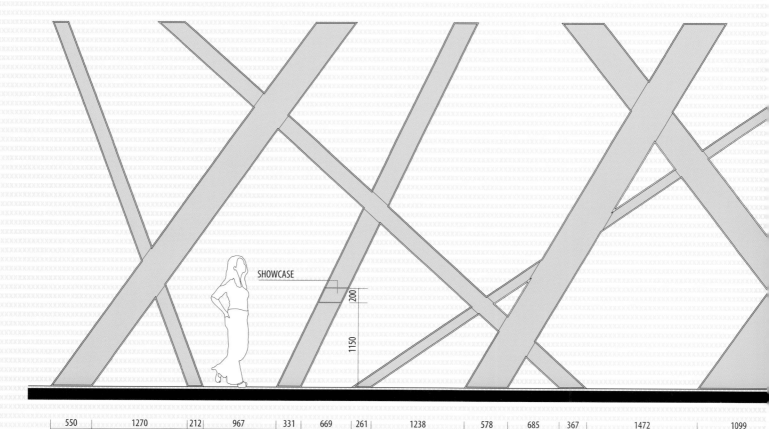

SHOWCASE

200

1150

550 1270 212 967 331 669 261 1238 578 685 367 1472 1099

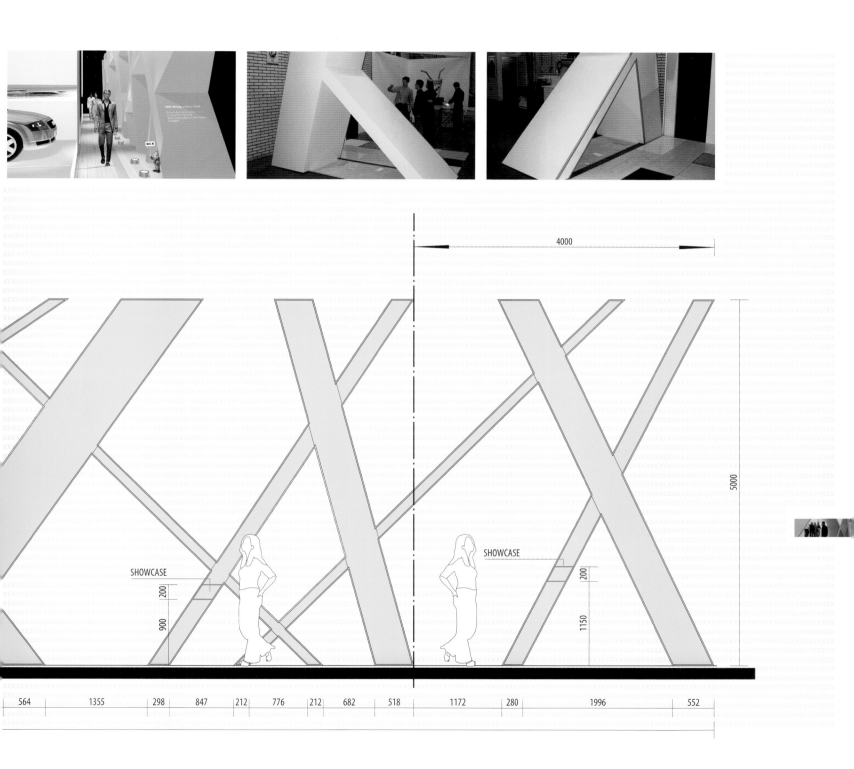

SHOWCASE

200

900

SHOWCASE

200

1150

4000

5000

| 564 | 1355 | 298 | 847 | 212 | 776 | 212 | 682 | 518 | 1172 | 280 | 1996 | 552 |

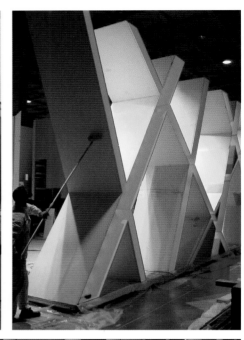

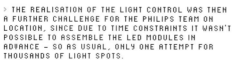

> THE REALISATION OF THE LIGHT CONTROL WAS THEN
A FURTHER CHALLENGE FOR THE PHILIPS TEAM ON
LOCATION, SINCE DUE TO TIME CONSTRAINTS IT WASN'T
POSSIBLE TO ASSEMBLE THE LED MODULES IN
ADVANCE — SO AS USUAL, ONLY ONE ATTEMPT FOR
THOUSANDS OF LIGHT SPOTS.

> DIE UMSETZUNG DER LICHTSTEUERUNG WAR DANN
NOCH EINE WEITERE HERAUSFORDERUNG FÜR DAS
PHILIPS-TEAM VOR ORT, DENN AUS ZEITGRÜNDEN WAR
ES NICHT MÖGLICH, DIE LED-MODULE IM VORFELD ZU
KONFEKTIONIEREN — ALSO WIE ÜBLICH: NUR EIN
VERSUCH FÜR TAUSENDE VON LICHTPUNKTEN.

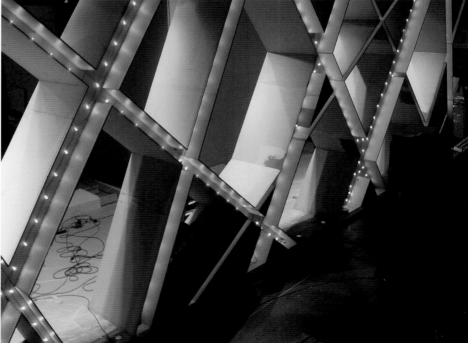

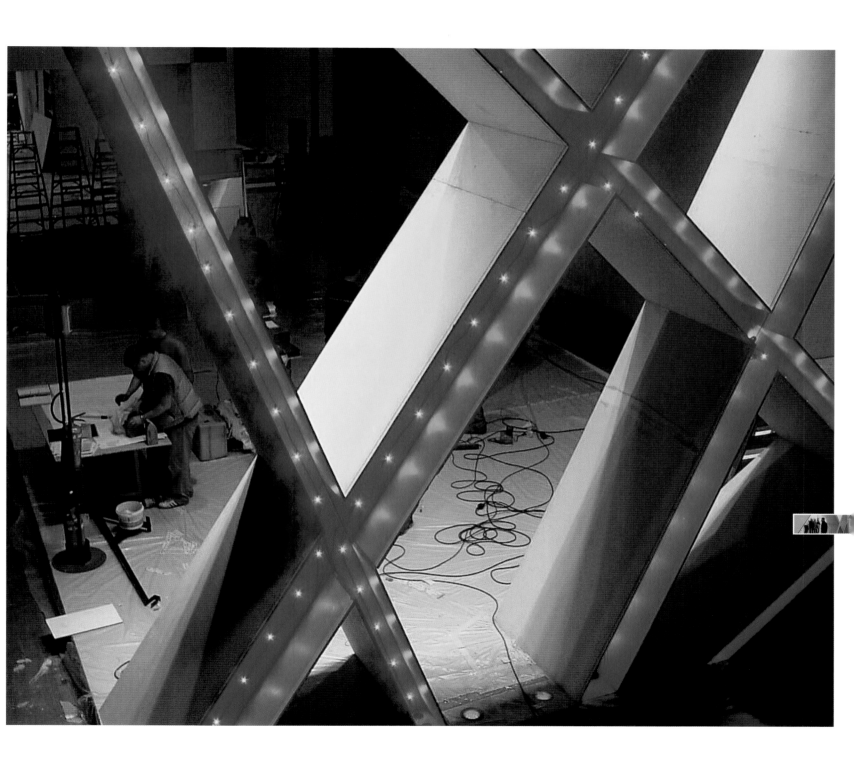

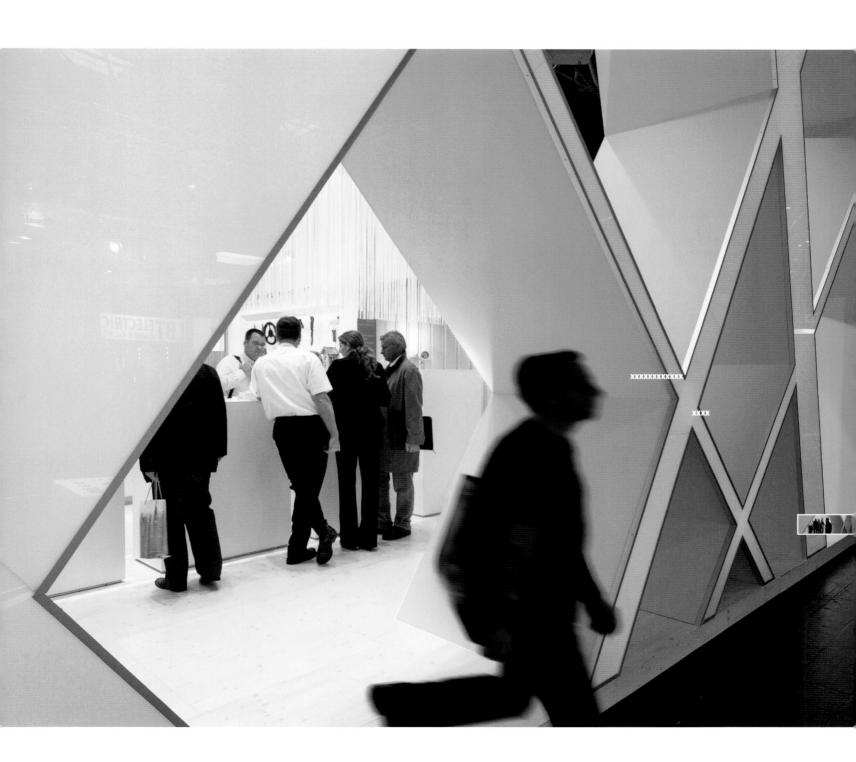

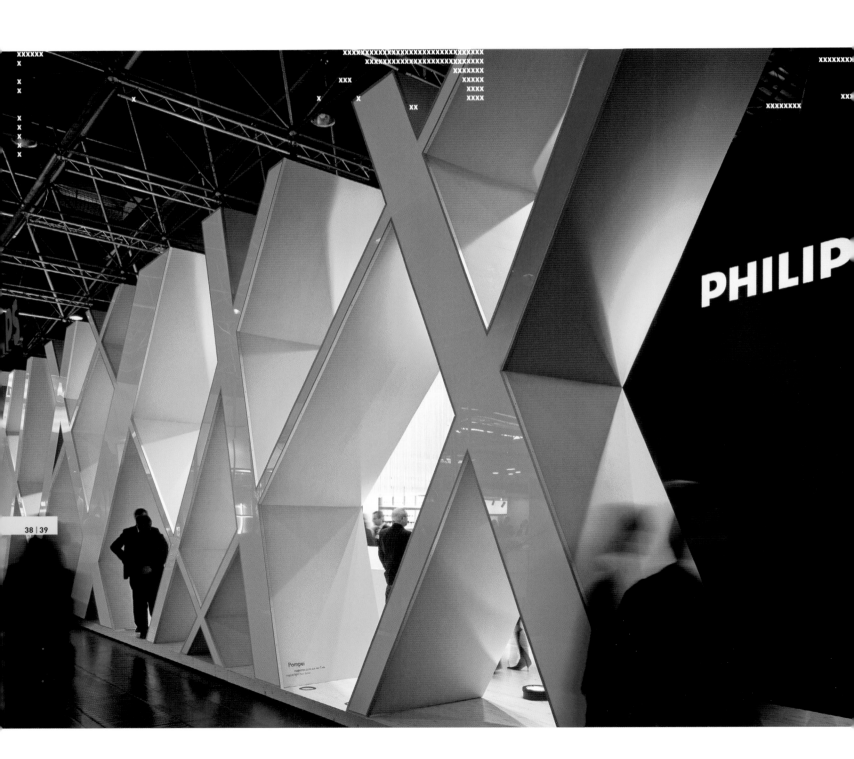

38 | 39

" ... we begin with the project and not with the people."

> **→ A new client approaches D'art: what would happen next?**

Our first task is to listen. When a new customer approaches us, we don't say, "we'll send X because he's done technology companies before, or Y because she knows about fashion or whatever." We discuss as a group whether to get involved – and often opinions differ – but if we agree to get involved then the right person to go will be identified through that. We don't have fixed sectors we work in anyway. We have people who are specialised in communication, or multimedia or graphics or interior architecture, but we begin with the project and not with the people. The team is never fixed from the start to the end: as the work evolves so the team evolves.

Why does it happen that the team "evolves"?

All our projects start with a wide-ranging discussion involving quite a large group, and from those discussions the core message or concept is identified. That is used as the basis to identify a team that, in turn, has two roles to fulfil: firstly to develop the design and communication concept the client is looking for, and secondly to develop the presentation method for the concept, so as to involve the client in the proposed solution.

This notion of "involving the client" in the solution seems to be quite important for your work.

What we try to do is not just deliver what the client wants but what the client needs, so we try to take the client further. And sometimes this will lead to a field of virgin soil that needs to be explored first before it can be cultivated. To do that you will need to have the visible commitment of everybody involved. Otherwise you may go too far in proposing concepts that are too advanced or just incomprehensible.

Is it possible to work like that even with a big international company?

You can't as a design team work with a company. In fact, you work with individuals. This has its advantages and disadvantages, and what is important here is scale. If the company is effectively controlled by a few individuals, then discourse is difficult, and if the design team is too small there can be a similar problem. There needs to be a sufficient number of contributing voices. There also needs to be a sufficient range of contacts across different companies for a design agency: if one is too dependent on a single client then the agency's philosophy begins to mirror that of the client. And even with a range of clients, knowing too much about one company can be a limiting factor. One tends to think, "we can't do that, as we couldn't last time" and so on.

How does this feed back into the D'art lectureship at the Peter Behrens School of Architecture?

Sure, the students get a horde of anecdotes from the forefront of reality … [laughing] we are already notorious … seriously, we do have a strong commitment to make it possible for the students to have direct contact to "real" clients and to implement their ideas. It's pointless to develop communication in ivory towers. Practical experience is a really crucial factor for the job and it's important to generate an area where it is possible to make mistakes and learn by experience.

> DIETER WOLFF

BORN 1958, STUDIED INTERIOR DESIGN AT THE UNIVERSITY OF APPLIED SCIENCES DÜSSELDORF, CO-FOUNDER AND PART OF THE D'ART DESIGN GRUPPE MANAGEMENT TEAM, MEMBER OF THE FDA (FORUM DESIGN UND ARCHITEKTUR), TEACHER AT THE PETER BEHRENS SCHOOL OF ARCHITECTURE (PBSA) IN DÜSSELDORF

> DIETER WOLFF

JAHRGANG 1958, STUDIUM
DER INNENARCHITEKTUR
AN DER FACHHOCHSCHULE
DÜSSELDORF,
MITBEGRÜNDER UND TEIL
DER GESCHÄFTSFÜHRUNG
DER D'ART DESIGN
GRUPPE, MITGLIED IM
FORUM DESIGN UND
ARCHITEKTUR (FDA),
LEHRTÄTIGKEIT AN DER
PETER BEHRENS SCHOOL
OF ARCHITECTURE (PBSA)
IN DÜSSELDORF

→ Ein neuer Kunde tritt an D'art heran: was passiert?

Als erstes hören wir zu. Wenn ein neuer Kunde an uns herantritt, sagen wir nicht »wir schicken X, weil er schon mal mit Technologie-Unternehmen zu tun hatte, oder Y, weil sie sich mit Mode auskennt«. Wir besprechen als Gruppe, ob wir den Auftrag übernehmen – und da sind wir oft verschiedener Meinung –, und wenn wir uns dafür entscheiden, dann ergibt sich daraus auch, wen wir hinschicken. Wir haben ohnehin keine fest definierten Arbeitsbereiche. Manche Mitarbeiter sind zwar auf Kommunikation oder Multimedia oder Innenarchitektur spezialisiert, aber wir fangen immer mit dem Projekt an, nicht mit den Leuten. Das Team ist nie von Anfang bis Ende dasselbe: mit dem Projekt entwickelt sich auch das Team.

Wie kommt es, dass das Team sich »entwickelt«?

Wir beginnen all unsere Projekte mit einer breiten Diskussion in einer relativ großen Gruppe, und aus dieser Diskussion ergibt sich die Kernaussage oder das Konzept. Daraus erwächst die Zusammenstellung des Teams, das dann zwei Rollen ausfüllen muss: zum einen das Design und die Kommunikationsstrategie entwerfen, die der Kunde möchte,

unerforschtes Gelände, das erst erkundet werden muss, bevor wir es ›beackern‹ können. Um das zu erreichen, müssen alle Beteiligten sich sichtbar engagieren. Sonst besteht die Gefahr, dass das vorgeschlagene Konzept zu weit geht oder einfach unverständlich ist.

Kann man derart auch mit einem großen, international tätigen Unternehmen zusammenarbeiten?

Als Gestaltungsteam kann man nicht mit einer »Firma« arbeiten. Man arbeitet immer mit Einzelpersonen. Das hat seine Vor- und Nachteile, wichtig ist die Balance. Wenn das Unternehmen von wenigen Personen straff geführt wird, wird eine Diskussion schwierig, und wenn das Gestaltungsteam zu klein ist, kann es ähnliche Probleme geben. Es müssen genügend Stimmen ihren Beitrag leisten. Ein Gestaltungsatelier braucht eine große Bandbreite an Kontakten zu unterschiedlichen Unternehmen: Wenn man zu sehr von einem Kunden abhängig ist, spiegelt die Philosophie der Agentur irgendwann die des Kunden wider. Und selbst wenn man unterschiedliche Kunden hat, kann es hinderlich sein, ein Unternehmen zu gut zu kennen. Man neigt zu Annahmen wie »das können wir nicht machen, konnten wir letztes Mal auch nicht«, etc.

» … wir fangen mit dem Projekt an, nicht mit den Leuten.«

und zum anderen ein Präsentationskonzept entwickeln, mit dem der Kunde in die Arbeit am Lösungsvorschlag einbezogen wird.

Der Ansatz, den Kunden einzubeziehen, scheint in Ihrer Arbeit eine wichtige Rolle zu spielen.

Wir versuchen, nicht nur das zu liefern, was der Kunde möchte, sondern das, was er braucht, wir versuchen also, ihn weiterzubringen. Und das führt uns manchmal in

Wie beeinflusst dies die D'art-Dozentur an der Peter Behrens School of Architecture?

Nun ja, die Studenten hören schon jede Menge Anekdoten aus der Realität … [lacht] … dafür sind wir schon berüchtigt … im Ernst, wir setzen uns sehr dafür ein, den Studenten Kontakte zu »realen« Kunden zu ermöglichen und ihre Ideen umzusetzen. Es hat ja keinen Zweck, Kommunikation in einem Elfenbeinturm zu entwickeln. Praktische Erfahrung ist ein wichtiger Faktor für den Job, und man muss einen Bereich schaffen, in dem man Fehler machen und aus Erfahrung lernen kann.

PLAY \
SPIELWIESEN

→ Johan Huizinga's "Homo Ludens" offered a different interpretation of the human condition to the Darwin/Huxley model of endless animal strife for 'the survival of the fittest'. He wrote that "the spirit of playful competition is, as a social impulse, older than culture itself and pervades all life like a veritable ferment. Ritual grew up in sacred play; poetry was born in play and nourished on play; music and dancing were pure play [...] . We have to conclude, therefore, that civilization is, in its earliest phases, played. It does not come from play [...] it arises in and as play, and never leaves it." The book was written in imprisonment, and displays an unquenchable optimism. The theory he sets out is open to a number of objections, but the work remains still a cry for freedom at a totalitarian moment. The role of play in the animal world is now linked to cognitive development: it is probable that it plays a similar role in human development, but were it not for Huizinga's pioneering work we would not be so far ahead.

How the theory reads today is not perhaps so important as the opportunity it offers to reconsider a received tradition. Looking at D'art's work, this concept can be seen as still potent. Sending clients a stone in a box just doesn't demonstrate a sense of humour, but more importantly a sense of play. Projects such as Horst and Sample also show this. Both were self-promotions at the Euroshop trade fair. This is both an opportunity and a serious challenge: the design company is its own client, often a pretext for self-indulgence and overstatement.

Horst (it's the German word for nest, but it could also be considered as the name of an individual) consisted of a white base stand over which several hundred white tubular balloons were suspended, each one inscribed with a different word in black sans serif type.

→ Johan Huizingas »Homo Ludens« bietet eine andere Interpretation des Zustands der Menschheit als das Darwin-/Huxley-Modell des endlosen animalischen Kampfs um das »Überleben des Stärkeren«. Er schrieb: »Spielender Wetteifer als Gesellschaftsimpuls, älter als die Kultur selbst, erfüllte von jeher das Leben und brachte die Formen der archaischen Kultur wie Hefe zum Wachsen. Der Kult entfaltete sich in heiligem Spiel. Die Dichtkunst wurde im Spiel geboren und erhielt immerfort aus Spielformen ihre beste Nahrung. Musik und Tanz waren reines Spiel. [...] Die Folgerung muss sein: Kultur in ihren ursprünglichen Phasen wird gespielt. Sie entspringt nicht aus Spiel, [...] sie entfaltet sich in Spiel und als Spiel.« Das Buch wurde in der Gefangenschaft geschrieben und zeugt von einem unauslöschlichen Optimismus. Man könnte eine Reihe von Einwänden gegen seine Theorie vorbringen, aber sie bleibt doch ein Schrei nach Freiheit in einem totalitären Augenblick. Die Rolle des Spiels im Tierreich wird inzwischen mit der kognitiven Entwicklung in Verbindung gebracht. Es ist wahrscheinlich, dass das Spiel für die Entwicklung des Menschen eine ähnliche Rolle spielt, und ohne Huizingas Pionierarbeit wären wir jetzt noch nicht so weit.

Wie seine Theorie sich heute liest, ist vielleicht weniger wichtig als die darin angelegte Einladung, über bestehende Traditionen nachzudenken. Im Hinblick auf D'arts Arbeit ist das Konzept immer noch überzeugend. Kunden einen Stein in einer Schachtel zu schicken, zeigt nicht nur einen Sinn für Humor, sondern, viel wichtiger, einen Sinn für das Spielerische. Projekte wie Horst oder Sample zeigen dies ebenfalls. Beide waren Eigendarstellungen auf der Messe Euroshop, was sowohl eine Chance als auch eine Herausforderung darstellt: das Gestaltungsunternehmen als sein eigener Kunde, oft ein Vorwand für Maßlosigkeit und Übertreibung.

Horst (entweder das Nest eines Greifvogels oder der Vorname) war ein Stand mit einem weißen Boden, über dem mehrere hundert weiße, röhrenförmige Ballons hingen. Alle waren in schwarzen, serifenlosen Typen mit unterschiedlichen Wörtern beschriftet. Die Besucher wurden eingeladen – indirekt –, sich die Worte

The visitor was invited – indirectly – to select those terms he or she most identified with, and so create an image of their own personality via the stand.

In this sense the stand neither introduced the visitor to D'art's portfolio, nor made a direct brand statement, nor presented a new product or offer. In short, it negated all the basic principles of stand design. And the public loved it. Not just the public at the fair itself, but after the end of the fair the kindergarten children who got to play with the balloons, the occupants of a home for retired people who discovered that the balloons were exactly the flotation devices they needed to use their indoor pool to best advantage, and, finally, the tomatoes which found shelter from the rain underneath them.

Sample was not as abstract a proposal as Horst but also invited the visitor to follow a personal journey: play a little table soccer on a pitch three metres long, have a go at drag racing with models cars, uncover and discover. All on a stand at a human height and conceived in human proportions.

Inviting the visitor to explore and enjoy is in itself a ludic function – they are invited to play, after all. But what places play at the heart of these two concepts is not just the visitor's experience. It is the design intention. Here, how the design came about becomes important.

D'art wanted to be present at Euroshop in order to win new clients for their design services. The formal way to do so would be to present their record to date within a visually compelling context. The way to do it would be to put together a design team, give them the data, and tell them to produce a result. Not for D'art. They brought as many people as they could into a meeting, and asked for ideas. Someone suggested balloons, and someone else remarked "People will ask if we've gone mad."

auszusuchen, mit denen sie sich am meisten identifizierten, und so über den Stand ein Bild von ihrer eigenen Persönlichkeit zu entwerfen.

Der Stand stellte dem Besucher also weder D'arts Portfolio vor, noch lieferte er ein Marken-Statement, noch präsentierte er ein neues Produkt oder Angebot. Kurz, er missachtete sämtliche Grundprinzipien des Standdesigns. Und das Publikum liebte den Stand. Nicht nur die Öffentlichkeit während der Messe, sondern auch die Kindergartenkinder, die nach der Messe mit den Ballons spielten, die Bewohner eines Seniorenheims, die die Ballons als optimale Schwimmhilfe in ihrem Hallenbad entdeckten und die Tomaten, die unter ihrer Hülle Schutz vor dem Regen fanden.

Sample war weniger abstrakt als Horst, lud die Besucher aber ebenfalls zu einer persön-lichen Reise ein: an einem drei Meter langen Tisch ein bisschen Tischfußball spielen, sich im Dragracing mit Modellautos versuchen, auf-decken und entdecken. Alles an einem Stand in Hüfthöhe und in menschlichen Proportionen. Den Besucher zum Erkunden und Spaßhaben einzuladen, hat schon an sich etwas Spieleri-sches – schließlich werden sie zum Spielen eingeladen. Aber was das Spiel in den Mittelpunkt dieser beiden Entwürfe stellt, ist nicht nur die Erfahrung des Besuchers. Es ist die gestalte-rische Absicht. Hier ist die Entstehungsgeschichte dieser Entwürfe wichtig.

D'art wollte auf der Euroshop vertreten sein, um neue Kunden auf sich aufmerksam zu machen. Das übliche Vorgehen wäre es gewesen, ihre Referenzen bis zu diesem Zeitpunkt in einer optisch ansprechenden Umgebung zu präsen-tieren. Dafür würde man ein Designteam zusam-menstellen, ihm die Daten geben und es beauftragen, ein Ergebnis zu abzuliefern. Nicht so bei D'art. Sie holten so viele Leute, wie sie konnten, zu einem Meeting und baten um Ideen. Jemand schlug Ballons vor, und jemand anderes sagte: »Da fragen die Leute uns doch, ob wir verrückt geworden sind«. Die Antwort war vernünftig – die meisten Reaktionen darauf hätten sich auf das Wort »verrückt« bezogen, aber für D'art war der erste Teil wichtiger: »die Leute fragen uns«, wir kommen ins Gespräch. Und zwar mit Leuten, die ein Gespräch wollen,

The response was a reasonable one, and most responses to it would have focused on the word 'mad'; but for D'art it was the first part that mattered: people will ask: we will start a dialogue. And with people who want dialogue, not just answers. Everyone else at Euroshop was only offering answers, after all.

Sample emerged from the same consultation process, but in answer to a different question. What do visitors take away from a trade fair? Physically bags of samples and catalogues, as anyone who has been to a fair knows, but the reality is rather different: what the visitor takes away is memories, the physical clutter of paper and bits only serving, in the end, to evoke memories. So at the Sample stand there were indeed objects to take away, but only such as would serve as vehicles for memory. And some memories had no physical form – you beat your marketing director at drag racing, for example, but only you two know among the crowd who was playing whom. Yes, but memory, and the fun of it.

These two stands – which stand as D'art's statement of who they are – are not just ludic in content, but also ludic in intention. This is a bold strategy, given that a lot of serious people go to trade fairs, but it is also a positive one; Huizinga, perhaps, would have been delighted with it.

nicht nur Antworten. Schließlich boten alle anderen auf der Euroshop nur Antworten.

Sample entstand durch den gleichen Prozess, aber als Antwort auf eine andere Frage. Was nehmen Besucher von einer Messe mit? Rein materiell tütenweise Muster und Kataloge, wie jedermann weiß, der schon einmal auf einer Messe war. Die Wirklichkeit sieht aber anders aus: Was der Besucher mitnimmt, sind Erinnerungen; all das Papier und der Krimskrams dienen am Ende nur dazu, diese Erinnerungen wachzurufen. Vom Sample-Stand konnte man tatsächlich Dinge mitnehmen, aber nur solche, die als Erinnerungsvehikel dienten. Und für manche Erinnerungen gab es gar keine materielle Form – man schlägt zum Beispiel seinen Vertriebsleiter im Dragracing, aber nur Sie beide unter all den Leuten wissen, wer gegen wen gespielt hat. Die Erinnerung daran und der Spaß, den sie hatten, bleibt für lange Zeit in den Köpfen der Besucher.

Diese beiden Stände – als Statement, wer D'art ist – sind nicht nur inhaltlich verspielt, sondern haben auch eine spielerische Absicht. Eine kühne Strategie, wenn man bedenkt, dass lauter seriöse Leute auf Messen gehen, aber es ist auch eine positive; Huizinga wäre vielleicht begeistert gewesen.

> CHRIS IS A CHARACTER FROM THE D'ART DESIGN GRUPPE "DAYMAKER" FAMILY, MORE AT: WWW.D-ART-DESIGN.DE/DAYMAKER

> CHRIS IST EINE FIGUR AUS DER REIHE DER D'ART DESIGN GRUPPE "DAYMAKER", MEHR UNTER: WWW.D-ART-DESIGN.DE/DAYMAKER

HORST IS IN THE AIR \
ZUTIEFST OBERFLÄCHLICH

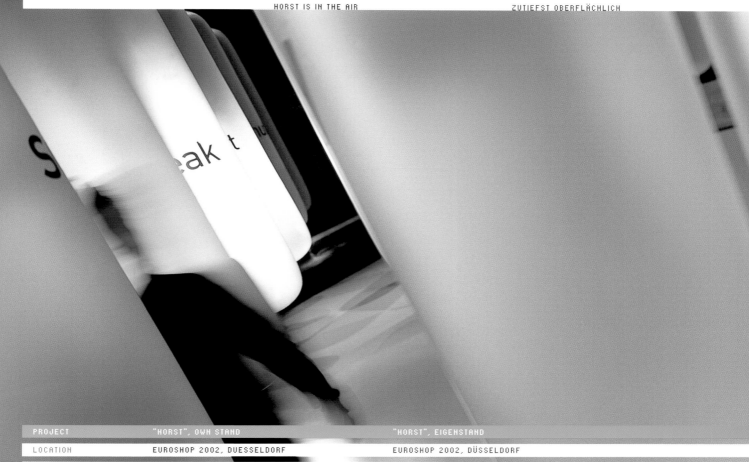

PROJECT	"HORST", OWN STAND	"HORST", EIGENSTAND
LOCATION	EUROSHOP 2002, DUESSELDORF	EUROSHOP 2002, DÜSSELDORF
DATE	2002-02	2002-02
CLIENT	D'ART DESIGN GRUPPE	D'ART DESIGN GRUPPE
DIMENSIONS	200 SQM	200 QM
TASK	HORST IS IN THE AIR: THE ASSIGNMENT IS THE SELF-REPRESENTATION OF THE D'ART DESIGN GRUPPE AT THE EUROSHOP 2002 IN DUESSELDORF.	HORST IS IN THE AIR: DIE AUFGABE IST DIE EIGENDARSTELLUNG DER D'ART DESIGN GRUPPE AUF DER EUROSHOP 2002 IN DÜSSELDORF.
ABOUT	AT THE ONSET OF ANY "ORDERLY" MADNESS IS THE DEVELOPMENT OF AN ALTER EGO. HORST REPRESENTS A CROSSMEDIAL TIGHTROPE WALK BETWEEN SURFACE AND CONTENT. HORST IS AT ONCE THE LOCATION AND PERSON. HORST IS ABOVE, BUT ALSO OFTEN ON THE MOVE. ALWAYS SOMEONE ELSE, NEVER READY AND OFTEN DIFFICULT TO REACH. HORST'S PURPOSE IS TO FIND A MATE. HORST IS NOT ANY OLD NEST, BUT ALWAYS LOTS OF THEM. 154 AIR-FILLED BALLOONS SUSPENDED FROM THE CEILING DEPICT A SEMI-TRANSPARENT VOLUME OF INTIMATIONS. THROUGH THE EXTREME REDUCTION, THE OVERALL APPEARANCE IS AT ONCE ALIEN AND CLINICAL, THOUGH ALSO INVITING AND PLAYFULLY FAMILIAR. THE FREE MOVEMENT OF THE DETACHED BALLOONS, THEIR VOLUME AND THEIR POSITIONING IN THE ROOM CREATE REFERENCES SUCH AS "PARK, GARDEN, GLADE". SLOWLY CHANGING "SOUNDSCAPES" ARE GENERATED WITH THE AID OF SUBTLE SUPERSONIC SOUNDING (CRICKETS CHIRPING, GULLS CRYING, INSECTS IN FLIGHT, ETC.).	AM ANFANG EINES JEDEN "ORDENTLICHEN" WAHNSINNS STEHT DIE ENTWICKLUNG EINES ALTER EGO: HORST STEHT FÜR EINE CROSSMEDIALE GRATWANDERUNG ZWISCHEN OBERFLÄCHE UND INHALT. HORST IST ORT UND PERSON ZUGLEICH. HORST IST OBEN, ABER AUCH HÄUFIG UNTERWEGS. IMMER JEMAND ANDERES, NIE FERTIG UND HÄUFIG SCHWER ZU ERREICHEN. HORST IST ZUM BRÜTEN DA. HORST DIENT DER PAARFINDUNG. HORST IST NICHT IRGENDEIN NEST, SONDERN IMMER VIELE: 154 LUFTGEFÜLLTE, VON DER DECKE ABGEHÄNGTE BALLONS BESCHREIBEN EIN HALBTRANSPARENTES VOLUMEN VON ANDEUTUNGEN. DAS GESAMTBILD ERSCHEINT DURCH DIE EXTREME REDUKTION ZUGLEICH FREMD UND LABORARTIG, ABER AUCH EINLADEND, SPIELERISCH VERTRAUT. DIE FREIE BEWEGLICHKEIT DER ABGEHÄNGTEN BALLONS, IHR VOLUMEN UND IHRE POSITIONIERUNG IM RAUM SCHAFFEN BEZÜGE WIE "PARK, GARTEN, LICHTUNG". UNTERSTÜTZT DURCH EINE SUBTILE BESCHALLUNG (GRILLENGEZIRPE, MÖVENGESCHREI, FLUGGERÄUSCHE VON INSEKTEN, ETC.) ENTSTEHEN LANGSAM WECHSELNDE "SOUNDSCAPES".

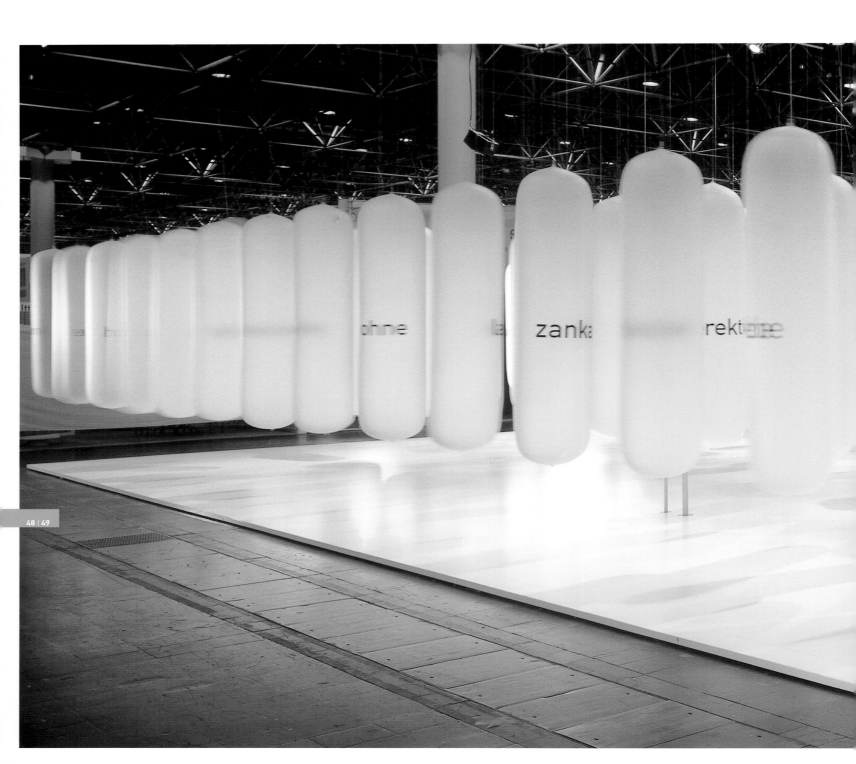

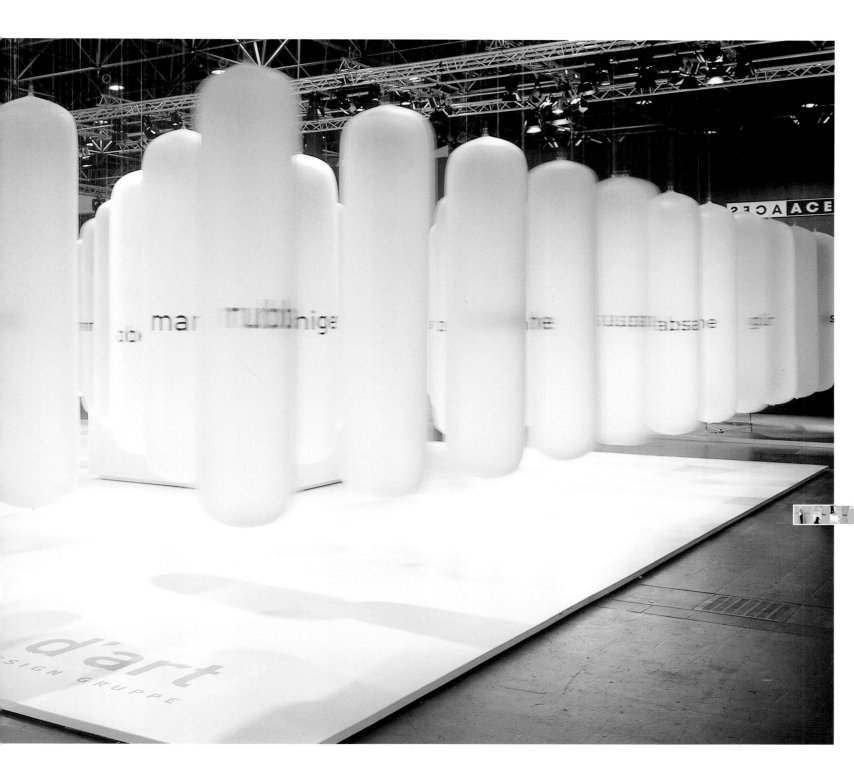

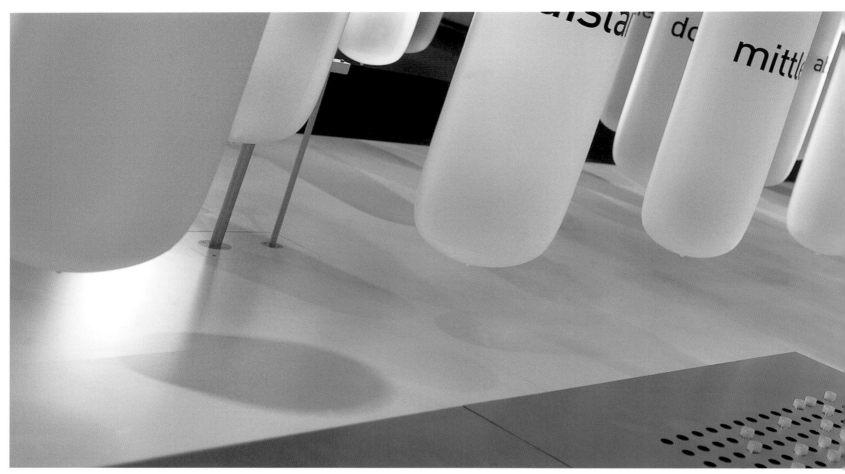

> IN THE RUN-UP, 2000 AIR-FILLED INVITATIONS WITH "DESIGN-AIR" ALONGSIDE VIRTUAL HORST PR INTERVIEWS ALREADY CREATE A LONGING FOR MORE.

> 2.000 MIT "DESIGNAIR" GEFÜLLTE EINLADUNGEN MACHEN ZUSAMMEN MIT VIRTUELLEN HORST-PR-INTERVIEWS BEREITS IM VORFELD LUST AUF MEHR.

> GIVE-AWAYS WITH VARIOUS PECULIAR INSCRIPTIONS GUARANTEE A PERFECT MEMORY OF THE MEETING WITH HORST.

> GIVE-AWAYS MIT UNTERSCHIEDLICHEN AUFSCHRIFTEN VERSPRECHEN EINE PERFEKTE ERINNERUNG AN DIE BEGEGNUNG MIT HORST.

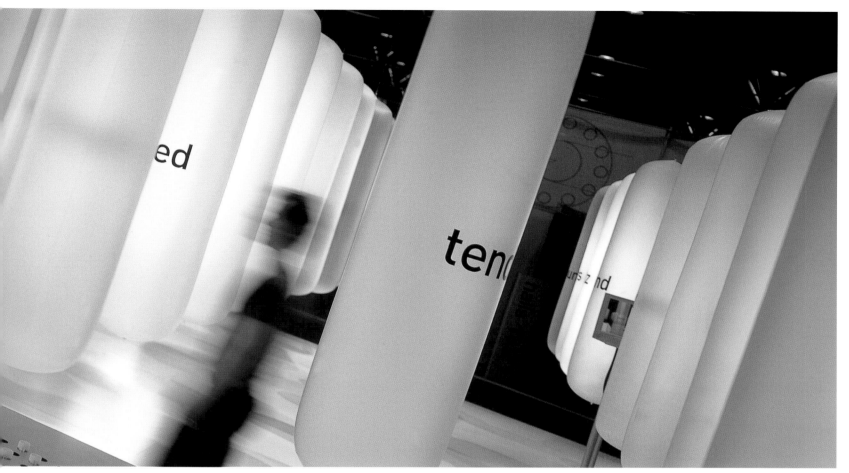

> SCATTERED AMIDST THE FOREST OF BALLOONS ARE PC PLAY STATIONS
WITH A VIRTUAL 3D RENDITION OF THE TRADE FAIR STAND. EXPLORING
THIS PARALLEL WORLD REVEALS PROJECT EXAMPLES AND VIDEO CLIPS.

> VERSTREUT IM BALLONWALD BEFINDEN SICH PC-SPIELSTATIONEN MIT
EINER VIRTUELLEN 3D-UMSETZUNG DES MESSESTANDES. DIE ERKUNDUNG
DIESER PARALLELWELT ENTHÜLLT PROJEKTBEISPIELE UND VIDEOCLIPS.

> THE CONCEPT COULD ALSO BE SUCCESSFULLY
IMPLEMENTED WITH CONSIDERABLY YOUNGER TARGET
GROUPS.

> DAS KONZEPT KONNTE AUCH BEI DEUTLICH JÜNGEREN
ZIELGRUPPEN MIT ERFOLG EINGESETZT WERDEN.

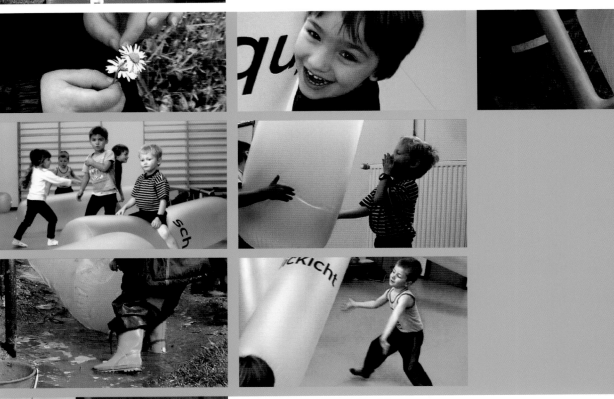

> THE TWO YOUNG WOMEN CONDUCTED THE INDOOR
TESTING, BUT THERE WAS ALSO A SPECIAL GROUP FOR
THE OUTDOOR AREA.

> DIE BEIDEN JUNGEN DAMEN LEITETEN DAS INDOOR-
TESTING, ES GAB ABER AUCH EINE SPEZIELLE GRUPPE
FÜR DEN OUTDOOR-BEREICH.

> THANKS TO THE EXTENSIVE TESTS, SUCCESSFUL
SERIAL PRODUCTION OF A PRODUCT ALSO ULTIMATELY
BECAME POSSIBLE.

> DANK DER UMFANGREICHEN TESTS WURDE LETZTLICH
AUCH EIN ERFOLGREICHES SERIENPRODUKT MÖGLICH.

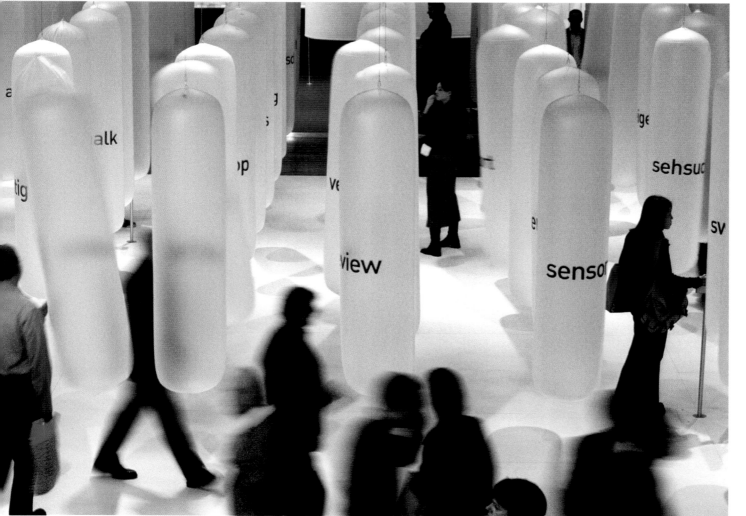

BEETRONIC, JUST (F)LYING \
IN EINEM UNBEKANNTEN LAND

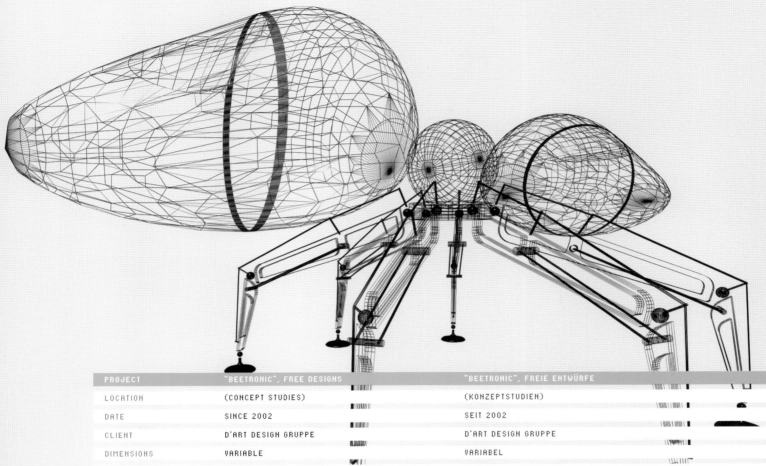

PROJECT	"BEETRONIC", FREE DESIGNS	"BEETRONIC", FREIE ENTWÜRFE
LOCATION	(CONCEPT STUDIES)	(KONZEPTSTUDIEN)
DATE	SINCE 2002	SEIT 2002
CLIENT	D'ART DESIGN GRUPPE	D'ART DESIGN GRUPPE
DIMENSIONS	VARIABLE	VARIABEL
TASK	THE DISCOVERY OF NEW TERRITORIES AND FURTHER DEVELOPMENT IS THE AIM OF THE FICTITIOUS ASSIGNMENTS WITHIN THE BEETRONIC PROJECT.	NEULAND ZU ENTDECKEN UND DIE DINGE WEITERZUENTWICKELN IST DAS ZIEL DER FIKTIVEN AUFGABENSTELLUNGEN INNERHALB DES PROJEKTES BEETRONIC.
ABOUT	YES, IT'S TRUE: AS SOON AS WE FIND OURSELVES UNOBSERVED, WE JUST THINK UP SOMETHING NEW AND DON'T WORRY ABOUT THE BRIEFING, BRANDING AND BUDGET. "FREE LOVE" SO TO SPEAK, OR "BEETRONIC" AS WE CALL IT. THE NAME STANDS FOR FICTITIOUS COMPANIES WITH ASSIGNMENTS FROM THE FIELD OF COMMUNICATION IN SPACE. WE DESIGN THE COMPANY AT THE SAME TIME. THE ROLE-PLAY GOES AS FOLLOWS: WE IMAGINE A COMPANY AND MAKE UP A HISTORY, RANGE AND TARGET GROUPS. THE POSITIONING IN SOCIETY OR ON THE MARKET IS DETERMINED AND AN ASSIGNMENT FORMULATED. THIS IS THEN CALLED BEETRONIC AND IT CONTINUES: WE THINK ABOUT STRATEGIES AND SOLUTIONS. IF WE ARE IN AGREEMENT WITH THE "CLIENT", THE NECESSARY MEDIA ARE DESIGNED. THIS WOULD INCLUDE THE SLOGAN THROUGH GUERRILLA CAMPAIGNS TO THE CONCRETE SHOP/TRADE FAIR DESIGN. THE PLANNING DOCUMENTATION IS THEN SENT, E.G. IN THE RUN UP TO A TRADE FAIR, AS A "MISDIRECTED LETTER" TO THE POTENTIAL COMPETITORS OF BEETRONIC ...	JA, ES IST WAHR: SOBALD WIR UNBEOBACHTET SIND, ERFINDEN WIR EINFACH MAL WAS NEUES UND SCHEREN UNS NICHT UM BRIEFING, BRANDING UND BUDGET. "FREIE LIEBE" SOZUSAGEN ODER "BEETRONIC", WIE WIR DAS NENNEN. DER NAME STEHT DABEI FÜR FIKTIVE UNTERNEHMEN MIT AUFGABENSTELLUNGEN AUS DEM BEREICH DER KOMMUNIKATION IM RAUM. DABEI GESTALTEN WIR DAS UNTERNEHMEN GLEICH MIT. DAS ROLLEN-SPIEL GEHT SO: MAN STELLT SICH EIN UNTERNEHMEN ODER EINE INSTITUTION VOR UND ERFINDET VORGESCHICHTE, ANGEBOT UND ZIELGRUPPEN. MAN LEGT DIE AKTUELLE POSITIONIERUNG IN GESELLSCHAFT ODER MARKT FEST UND FORMULIERT EINE AUFGABENSTELLUNG. DAS NENNT MAN DANN BEETRONIC, UND WEITER GEHTS: MAN MACHT SICH GEDANKEN ÜBER STRATEGIEN UND LÖSUNGSWEGE. IST MAN SICH MIT DEM "KUNDEN" EINIG, WERDEN DIE NÖTIGEN MEDIEN GESTALTET. DAS GEHT DANN VON CLAIM UND GUERILLA-AKTIONEN BIS HIN ZUM KONKRETEN SHOP-/MESSEDESIGN. DIE PLANUNGSUNTERLAGEN SCHICKT MAN DANN Z.B. IM VORFELD EINER MESSE ALS "POST-IRRLÄUFER" AN DIE MÖGLICHEN WETTBEWERBER VON BEETRONIC ...

NETWORKING
(GROUPWARE/FLOW)

EMBEDDED TECHNOLOGIES
(BLUETOOTH/HOMING)

> IN THIS CASE BEETRONIC IS A SUPPLIER OF MOBILE PHONES AND FIXED COMMUNICATIONS SERVICES: A NEW PDA GENERATION ALLOWS THE FORECASTED MEDIA CONVERGENCE TO BECOME REALITY. THE WHOLE THING CAN BE PLAYFULLY EXPERIENCED AT THE CEBIT, WITHIN THE SPECIAL EXHIBITION AREA "FUTURE LAB", AS AN ACCESSIBLE MEDIA LANDSCAPE.

> IN DIESEM FALL IST BEETRONIC EIN ANBIETER VON MOBILEN UND STATIONÄREN KOMMUNIKATIONSDIENSTLEISTUNGEN: EINE NEUE PDA-GENERATION LÄSST DIE PROGNOSTIZIERTE MEDIENKONVERGENZ WIRKLICHKEIT WERDEN. SPIELERISCH ERLEBBAR IST DAS GANZE AUF DER CEBIT INNERHALB DER SONDERAUSSTELLUNGS-FLÄCHE "FUTURE LAB" ALS BEGEHBARE MEDIENWIESE.

CEBIT_ HALL 11_ STAND F 38 | FUTURE LAB _ **WWW.BEETRONIC.COM**

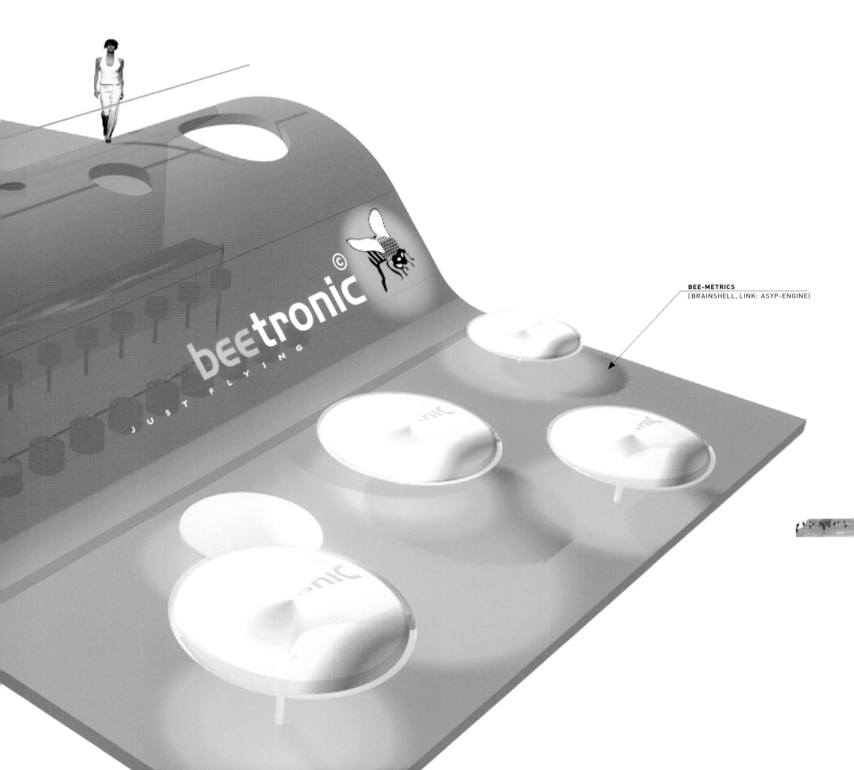

BEE-METRICS
(BRAINSHELL, LINK: ASYP-ENGINE)

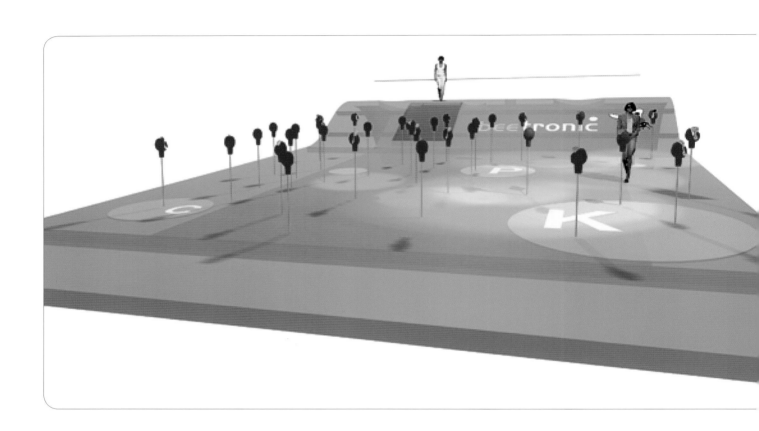

> PDA PRODUCT PRESENTATIONS
> PDA-PRODUKTPRÄSENTATION

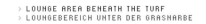

> LOUNGE AREA BENEATH THE TURF
> LOUNGEBEREICH UNTER DER GRASNARBE

I had the impression the Americans – if you are willing to accept this oversimplification – like to see us from time to time as a label of quality but do not really see us as competitors in stand design. From that point of view we appear as some kind of "out of the ordinary" German design-flavour and not as the regular agency that is taken seriously. In my eyes it seems that for some designers the way of doing something is much too important: they think that if they do it the

… so high expectations from the visitors are combined with in-house pressure to perform?

True, that's the challenge and it's very good for the agency itself, on the outside and the inside, to do such a project, difficult as it is. We loop this loop every three years, but we come out 'refined' each time. The high amount of reflectivity within every kind of self-projection makes it so difficult. It is linked to the basic problem of communication: you necessarily need to be capable of communicating by speaking, hearing, writing, etc. so as to be able to start thinking about such a project – although you already are capable of doing it.

'We loop this loop every three years, but we come out 'refined' each time."

right way the end result will be good. In fact it's not that way around at all: if the result is good then you did it the right way!

What was the reaction when you presented projects like "Horst" or "Sample" to the audience?

Horst and Sample were very successful – a lot of designers picked up on them. They were basically people exhibits. But of course Horst was somehow complete in itself, you couldn't develop it much further. Sample had the advantage of being different: it didn't look too polished or too expensive or too "designed." People loved it right away, without the necessity of having to understand it in every detail. Voluntarily they became part of it and accepted the invitation to carry on our ideas on spatial communication. And for the next Euroshop we are certainly going to continue in this way. If only because they're waiting for us round the corner, and if we do a conventional stand …

The result is that by thinking about possible transformations for Euroshop you are also transforming the group itself?

Yes, the project works like a kind of catalyst for all the little incremental changes a group of 28 people generates automatically – and we are very happy using this effect. To do so you need to be willing to give something a try, to see what happens. It is a way of creating free designs if you are able to gather the right type of people. D'art Design is basically a bunch of curious people: it's obvious – we don't have a technology base or an architecture base. It isn't the material finish or the complexity of the presentation but the people that matter – both on the inside of the agency and outside in the trade fair or the shop.

> FREDDY JUSTEN

BORN 1963, STUDIED PRODUCT DESIGN AT THE INSTITUT DES BEAUX ARTS IN LÜTTICH, CO-FOUNDER AND PART OF THE D'ART DESIGN GROUP MANAGEMENT TEAM, MEMBER OF THE FDA (FORUM DESIGN UND ARCHITEKTUR), TEACHER AT THE PETER BEHRENS SCHOOL OF ARCHITECTURE (PBSA) IN DÜSSELDORF

»Wir vollführen diesen Looping alle drei Jahre und gehen jedes Mal ›geläutert‹ daraus hervor.«

→ **Sie wurden kürzlich gebeten, auf der »Gravity Free«-Konferenz in San Francisco zu sprechen. Wenn Sie die amerikanische Art, an die Dinge heranzugehen, mit Ihrem »Europäischen Ansatz« vergleichen, gibt es da Unterschiede?**

Ich hatte den Eindruck, die Amerikaner – wenn man diese extreme Pauschalisierung mal so stehen lässt – sehen uns gelegentlich gern als Qualitätsmarke, nehmen uns aber nicht wirklich als Mitbewerber im Bereich »Standdesign« wahr. Aus diesem Blickwinkel erscheinen wir eher als ungewöhnliches deutsches Design, und nicht wie eine der »normalen«, ernstzunehmenden Agenturen. Ich habe den Eindruck, manche Gestalter nehmen die Art und Weise, wie sie etwas tun, zu wichtig: sie glauben, wenn sie es nur auf die richtige Weise tun, wird das Ergebnis automatisch gut. Tatsächlich ist es aber umgekehrt: wenn das Ergebnis gut ist, hat man es richtig angepackt!

Wie war die Reaktion des Publikums auf Projekte wie »Horst« oder »Sample«?

Horst und Sample waren sehr erfolgreich – eine ganze Reihe von Gestaltern hat darauf Bezug genommen. Sie waren vor allem aber etwas für die Besucher. Horst war aber auch in sich geschlossen, es war nicht mehr viel daran weiterzuentwickeln. Sample hatte den Vorteil, anders zu sein: es wirkte nicht zu rausgeputzt oder zu teuer oder zu »designed«. Den Leuten hat es sofort gefallen, ohne dass sie jedes Detail hätten verstehen müssen. Sie beteiligten sich freiwillig und nahmen die Einladung an, unsere Vorstellungen von räumlicher Kommunikation weiterzuentwickeln. Auf der nächsten Euroshop werden wir mit Sicherheit so weitermachen. Schon weil sie um die Ecke stehen und auf uns

warten, und wenn wir dann einen konventionellen Stand machen …

Das heißt, die hohen Erwartungen der Besucher erhöhen den hausinternen Druck?

Ja, das ist die Herausforderung, und es ist sehr gut für die Agentur selbst, nach außen wie nach innen, ein solches Projekt zu haben, so schwierig es auch ist. Wir vollführen diesen Looping alle drei Jahre und gehen jedes Mal »geläutert« daraus hervor. Der hohe Anteil an Reflexion in jeder Art von Selbst-Projektion macht es schwierig. Es hängt mit dem grundsätzlichen Problem von Kommunikation zusammen: man muss in der Lage sein, durch Sprechen, Zuhören, Schreiben etc. zu kommunizieren, um überhaupt über ein solches Projekt nachdenken zu können – obwohl man es bereits durchführen könnte, ohne aber erklären zu können, wie es funktioniert.

Und das führt dazu, dass sich, wenn Sie über mögliche Umgestaltungen bei der Euroshop nachdenken, auch die Gruppe selbst umgestaltet?

Ja, das Projekt wirkt wie ein Katalysator für all die kleinen Veränderungen, die eine Gruppe von 28 Personen automatisch durchläuft – und wir wollen diesen Effekt. Um das tun zu können, muss man bereit sein, etwas auszuprobieren, mal zu versuchen, was »geht«. Man kann sehr frei gestalten, wenn man es schafft, die richtigen Leute zusammenzubringen. D'art Design ist vor allem ein Haufen neugieriger Menschen, das ist offensichtlich – es geht nicht um eine spezielle Technologie oder Architektur. Es geht nicht um besondere Materialien oder die Komplexität der Präsentation, sondern um die Menschen – sowohl innerhalb der Agentur als auch außerhalb, auf der Messe oder im Shop.

> FREDDY JUSTEN

JAHRGANG 1963, STUDIUM PRODUKTDESIGN AM INSTITUT DES BEAUX ARTS IN LÜTTICH, MITBEGRÜNDER UND TEIL DER GESCHÄFTSFÜHRUNG DER D'ART DESIGN GRUPPE, MITGLIED IM FORUM DESIGN UND ARCHITEKTUR (FDA), LEHRTÄTIGKEIT AN DER PETER BEHRENS SCHOOL OF ARCHITECTURE (PBSA) IN DÜSSELDORF

PROCESS \
LEBENDIGE RÄUME

→ Another way of considering the concept of undesigning is to look at the difference between essential and process. An essentials-based approach implies that there are in advance a certain number of design elements, rules and solutions and it is the designer's task to select the correct combination of elements to reach the right solution. A process-based approach implies that the solution is derived from the design process, through incremental or radical changes to an initial idea through the input of the interaction between client and designer and the synergies of the design team. This contrast can be found – through allusion rather than direct comparison – earlier in other domains, such as the differing approaches of classical biology and those generated by the discoveries of Darwin, or between linguistics pre and post Saussure. In the 20th century this distinction – or rather the validity of the process-based approach – was extended and analysed by different generations of philosophers, anthropologists and linguists, such as Gilles Deleuze and Claude Levi-Strauss (though this is to select two names out of a whole gallery of candidates). The whole Structuralist and post-Structuralist argument sets a challenge to received hegemonies and at the same time militates against replacing them with a new hegemony. As Catherine Belsey has said, post-Structuralism "is more useful in prompting the uncertainty of questions than in delivering the finality of answers". It is about – again in her words – "a more sharply focused undecidability that specifies the options while leaving them open to debate".

Whether or not one accepts the post-Structural analysis of contemporary society, the interesting question is when and where design – as a practice – became involved in this debate. The answer is – surprisingly – only marginal.

→ Man kann sich dem Konzept des Undesigning auch nähern, indem man den Blick auf den Unterschied zwischen einem voraussetzungsorientierten und einem prozessorientierten Ansatz richtet. Ein voraussetzungsorientierter Ansatz bedeutet, dass eine Reihe von Gestaltungselementen, Regeln und Lösungen feststeht und die Aufgabe des Gestalters darin besteht, die beste Kombination von Elementen für eine optimale Lösung zusammenzustellen. Bei einem prozessorientierten Ansatz entwickelt die Lösung sich aus dem Gestaltungsprozess heraus, in kleinschrittigen oder radikalen Veränderungen einer Ausgangsidee, aus dem Gespräch zwischen Kunde und Gestalter und den Synergien des Designteams heraus. Dieser Kontrast findet sich schon früher – eher assoziativ als direkt vergleichbar – in anderen Bereichen, etwa bei den unterschiedlichen Ansätzen der klassischen Biologie und denen, die sich aus den Erkenntnissen Darwins entwickelten, oder zwischen der Linguistik vor und nach de Saussure. Im 20. Jahrhundert wurde diese Unterscheidung – oder eher die Gültigkeit des prozessorientierten Ansatzes – von mehreren Generationen von Philosophen, Anthropologen und Linguisten ausgeweitet und analysiert, etwa von Gilles Deleuze und Claude Levi-Strauss (wobei das nur zwei Namen aus einer ganzen Galerie von Kandidaten sind). Die gesamte Strukturalismus- und Poststrukturalismus-Debatte stellt eine Herausforderung für die anerkannten Hegemonien dar und spricht gleichzeitig dagegen, sie durch eine neue Hegemonie zu ersetzen. Wie Catherine Belsey sagte, dient der Poststrukturalismus eher dazu, die Ungewissheit der Fragen darzustellen, als dass er endgültige Antworten liefern würde. Es geht – wieder in ihren Worten – um eine dezidierte Unentscheidbarkeit, die die Möglichkeiten benennt und sie zur Diskussion stellt.

Ob man der poststrukturalistischen Analyse unserer heutigen Gesellschaft zustimmt oder nicht, die interessante Frage ist, wann und wo die Gestaltung – als Verfahren – in die Debatte kommt. Die Antwort lautet, überraschenderweise: nur am Rande. Ich glaube, dafür gibt es verschiedene Gründe. Erstens gab es da den Modernismus, der als jüngste und stärkste der

I think there are several reasons for this. Firstly there was the presence of Modernism, which can be seen as the most recent – and most vigorous – of the hegemonies, and which, with its insistence on absolute values, clear rules and ultimate forms, provided a very stable and also passionate model for several generations of designers. Secondly there is no single model for design activity. This is not surprising given the differing focuses of early design practice (for example if one compares the attitudes and values of the Bauhaus in Europe with those of Raymond Loewy, Bel Geddes and others in New York at the same time). The same is true today: there are considerable differences between the way in which a "design name" such as Marc Newson operates and the functioning of a design group such as D'art. There is, in effect, no sociology of designing. Finally, the language of designing remains endlessly fluid (itself an effect of process, as it happens) and so there is a poor framework on which to establish a theoretical analysis of design.

It is for such reasons, rather than from any attachment to outdated models, that some design agencies continue to promote an essentials-based design practice. It is not, of course, in capable hands, at all an unworkable method or one inapt for producing interesting results. But the general state of indeterminacy about the nature of contemporary design practice also makes the task of distinguishing and describing innovative approaches such as undesigning more difficult.

genannten Hegemonien betrachtet werden kann und der mit seinem Beharren auf absoluten Werten, klaren Regeln und ultimativen Formen ein sehr stabiles und auch leidenschaftliches Modell für mehrere Generationen von Designern bot. Zweitens gibt es kein eigenes Modell für Gestaltungstätigkeiten. Das überrascht nicht weiter, wenn man die unterschiedlichen Anschauungen hinter den ersten gestalterischen Tätigkeiten bedenkt (vergleicht man zum Beispiel die Einstellungen und Wertvorstellungen des europäischen Bauhaus mit denen von Raymond Loewy, Bel Geddes und anderen zur gleichen Zeit in New York). Heute gilt dasselbe: Es gibt beträchtliche Unterschiede zwischen der Arbeitsweise eines »großen Designer-Namens« wie Marc Newson und dem Funktionieren einer Gestaltergruppe wie D'art. Und das führt dazu, dass es keine gestalterische Soziologie gibt. Die Sprache des Gestaltens bleibt schließlich ewig fließend (was an sich schon eine Auswirkung eines Prozesses ist), und daher gibt es kaum einen Rahmen, innerhalb dessen sich Design theoretisch analysieren ließe.

Aus diesen Gründen, und nicht aus Anhänglichkeit an veraltete Modelle, verfolgen manche Gestaltungsateliers weiterhin einen voraussetzungsorientierten Ansatz. Und diese Methode ist, in fähigen Händen, auch keineswegs unbrauchbar oder ungeeignet für interessante Ergebnisse. Aber die allgemeine Unbestimmtheit der Arbeitsweise in der zeitgenössischen Gestaltungspraxis macht es schwierig, innovative Ansätze wie das Undesigning zu beschreiben und von anderen abzusetzen.

> DIALOGUE: OF COURSE, EVERYONE WANTS IT, BUT
ONE ONLY GETS IT IF ONE IS ALSO PREPARED TO
SUFFER THE CONSEQUENCES: AN INDEFINITE OUTCOME
OF THE CONVERSATION.

> DIALOG: HABEN WILL IHN NATÜRLICH JEDER, ABER
MAN BEKOMMT IHN NUR, WENN MAN BEREIT IST, AUCH
DIE KONSEQUENZEN ZU TRAGEN: EINEN UNBESTIMMTEN
AUSGANG DES GESPRÄCHS.

SAMPLE AND HOLD \
DIE SUMME DER TEILE

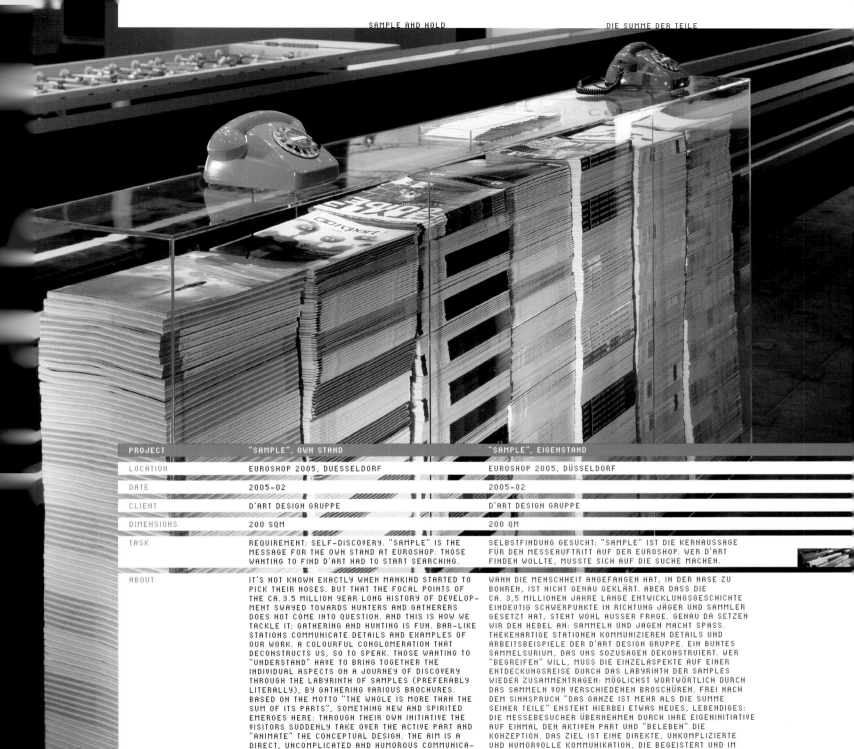

PROJECT	"SAMPLE", OWN STAND	"SAMPLE", EIGENSTAND
LOCATION	EUROSHOP 2005, DUESSELDORF	EUROSHOP 2005, DÜSSELDORF
DATE	2005-02	2005-02
CLIENT	D'ART DESIGN GRUPPE	D'ART DESIGN GRUPPE
DIMENSIONS	200 SQM	200 QM
TASK	REQUIREMENT: SELF-DISCOVERY. "SAMPLE" IS THE MESSAGE FOR THE OWN STAND AT EUROSHOP. THOSE WANTING TO FIND D'ART HAD TO START SEARCHING.	SELBSTFINDUNG GESUCHT: "SAMPLE" IST DIE KERNAUSSAGE FÜR DEN MESSEAUFTRITT AUF DER EUROSHOP. WER D'ART FINDEN WOLLTE, MUSSTE SICH AUF DIE SUCHE MACHEN.
ABOUT	IT'S NOT KNOWN EXACTLY WHEN MANKIND STARTED TO PICK THEIR NOSES. BUT THAT THE FOCAL POINTS OF THE CA. 3.5 MILLION YEAR LONG HISTORY OF DEVELOPMENT SWAYED TOWARDS HUNTERS AND GATHERERS DOES NOT COME INTO QUESTION. AND THIS IS HOW WE TACKLE IT: GATHERING AND HUNTING IS FUN. BAR-LIKE STATIONS COMMUNICATE DETAILS AND EXAMPLES OF OUR WORK. A COLOURFUL CONGLOMERATION THAT DECONSTRUCTS US, SO TO SPEAK. THOSE WANTING TO "UNDERSTAND" HAVE TO BRING TOGETHER THE INDIVIDUAL ASPECTS ON A JOURNEY OF DISCOVERY THROUGH THE LABYRINTH OF SAMPLES (PREFERABLY LITERALLY), BY GATHERING VARIOUS BROCHURES. BASED ON THE MOTTO "THE WHOLE IS MORE THAN THE SUM OF ITS PARTS", SOMETHING NEW AND SPIRITED EMERGES HERE: THROUGH THEIR OWN INITIATIVE THE VISITORS SUDDENLY TAKE OVER THE ACTIVE PART AND "ANIMATE" THE CONCEPTUAL DESIGN. THE AIM IS A DIRECT, UNCOMPLICATED AND HUMOROUS COMMUNICATION THAT IS BOTH INSPIRING AND MEMORABLE.	WANN DIE MENSCHHEIT ANGEFANGEN HAT, IN DER NASE ZU BOHREN, IST NICHT GENAU GEKLÄRT. ABER DASS DIE CA. 3,5 MILLIONEN JAHRE LANGE ENTWICKLUNGSGESCHICHTE EINDEUTIG SCHWERPUNKTE IN RICHTUNG JÄGER UND SAMMLER GESETZT HAT, STEHT WOHL AUSSER FRAGE. GENAU DA SETZEN WIR DEN HEBEL AN: SAMMELN UND JAGEN MACHT SPASS. THEKENARTIGE STATIONEN KOMMUNIZIEREN DETAILS UND ARBEITSBEISPIELE DER D'ART DESIGN GRUPPE. EIN BUNTES SAMMELSURIUM, DAS UNS SOZUSAGEN DEKONSTRUIERT. WER "BEGREIFEN" WILL, MUSS DIE EINZELASPEKTE AUF EINER ENTDECKUNGSREISE DURCH DAS LABYRINTH DER SAMPLES WIEDER ZUSAMMENTRAGEN: MÖGLICHST WORTWÖRTLICH DURCH DAS SAMMELN VON VERSCHIEDENEN BROSCHÜREN. FREI NACH DEM SINNSPRUCH "DAS GANZE IST MEHR ALS DIE SUMME SEINER TEILE" ENSTEHT HIERBEI ETWAS NEUES, LEBENDIGES: DIE MESSEBESUCHER ÜBERNEHMEN DURCH IHRE EIGENINITIATIVE AUF EINMAL DEN AKTIVEN PART UND "BELEBEN" DIE KONZEPTION. DAS ZIEL IST EINE DIREKTE, UNKOMPLIZIERTE UND HUMORVOLLE KOMMUNIKATION, DIE BEGEISTERT UND IM GEDÄCHTNIS BLEIBT.

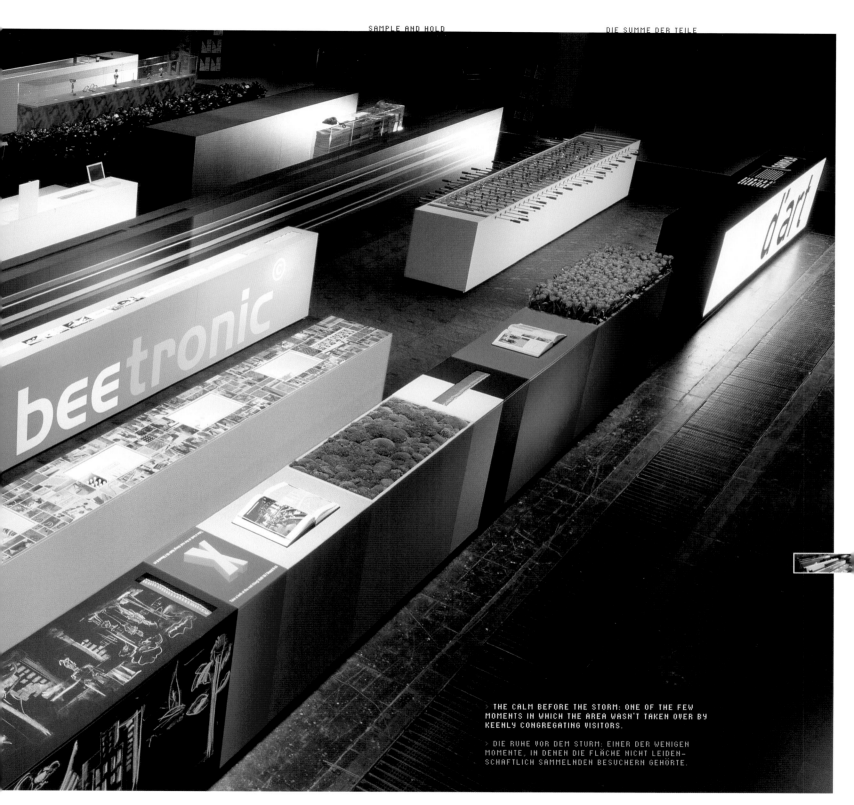

> THE CALM BEFORE THE STORM: ONE OF THE FEW
MOMENTS IN WHICH THE AREA WASN'T TAKEN OVER BY
KEENLY CONGREGATING VISITORS.

> DIE RUHE VOR DEM STURM: EINER DER WENIGEN
MOMENTE, IN DENEN DIE FLÄCHE NICHT LEIDEN-
SCHAFTLICH SAMMELNDEN BESUCHERN GEHÖRTE.

(SAMPLe)

> SAMPLE: A SMALL PORTION REPRESENTATIVE OF SOMETHING, JUST ENOUGH TO REPRODUCE THE ORIGINAL.

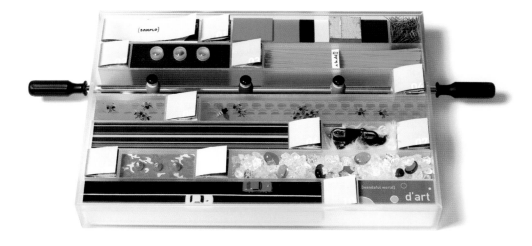

> THE HIGH-PERFORMANCE CONCEPT MODEL CLEARLY
BRINGS ACROSS THE BASIC IDEA.

> DAS HOCHPERFORMANTE KONZEPTMODELL
VERDEUTLICHT DIE GRUNDIDEE.

> THE 11-METRE LONG DRAGSTER TRACK WITH
PROFESSIONAL TIME RECORDER GENERATED QUEUES
ALMOST AS LONG ...

> DIE 11 METER LANGE DRAGSTER-BAHN MIT
PROFESSIONELLER ZEITMESSUNG SORGTE FÜR FAST
EBENSO LANGE WARTESCHLANGEN ...

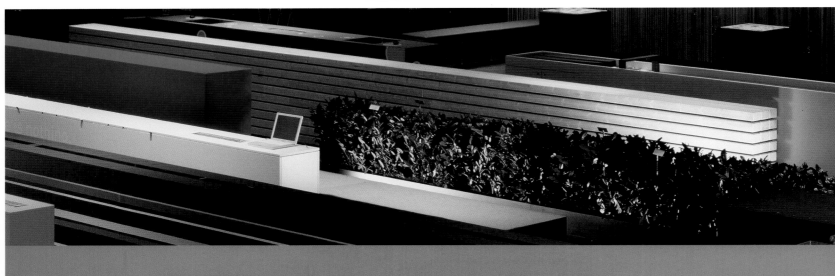

> THOSE NOT WANTING TO WRITE ANYTHING THEM-
SELVES WERE ABLE TO LISTEN TO THE AUDIO VERSION
OF OUR FOLLOW-UP NOVEL "THE SMALL BRIEFING" ON
THE TELEPHONE.

> WER NICHT SELBST ETWAS SCHREIBEN WOLLTE,
KONNTE DER HÖRSPIELFASSUNG UNSERES
FORTSETZUNGSROMANS "DAS KLEINE BRIEFING" AM
TELEFON LAUSCHEN.

> LOTS OF "GENUINE" MATERIAL SAMPLES AND
QUOTATIONS TAKEN FROM THE CONTEXT OF REALISED
PROJECTS DIDN'T LEAD TO ANY RESERVATIONS.

> VIELE "ECHTE" MATERIALMUSTER UND ZITATE AUS
DEM KONTEXT REALISIERTER PROJEKTE LIESSEN ERST
GAR KEINE BERÜHRUNGSÄNGSTE AUFKOMMEN.

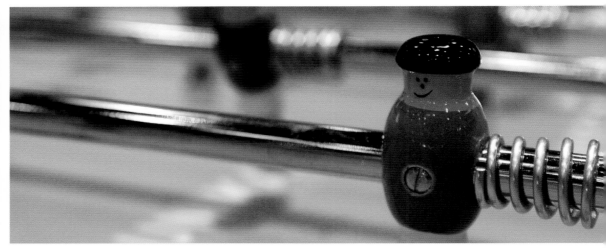

> A SPECIAL HIGHLIGHT AND ATTRACTION FOR MULTI-
NATIONAL TEAMS WAS THE 6-METRE LONG TABLE
FOOTBALL: "BE A GUEST AMONG FRIENDS" SO TO SPEAK.

> EIN BESONDERES HIGHLIGHT UND ANZIEHUNGSPUNKT
FÜR MULTINATIONALE TEAMS WAR DER 6 METER LANGE
TISCHKICKER: "ZU GAST BEI FREUNDEN" SOZUSAGEN.

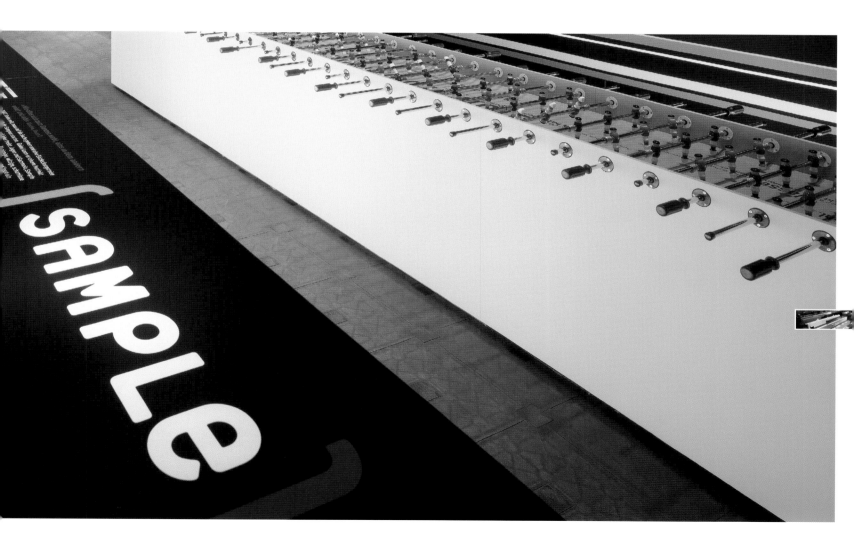

> AT THE PACKING STATION THE BROCHURES GATHERED
BY THE VISITORS WERE HANDILY PACKED AND SHRINK—
WRAPPED.

> AN DER PACKSTATION WURDEN DIE VON DEN
BESUCHERN GESAMMELTEN BROSCHÜREN HANDLICH
VERPACKT UND EINGESCHWEISST.

> ALTOGETHER "SAMPLE" BROCHURES ON TEN
DIFFERENT TOPICS WERE ABLE TO BE GATHERED.

> INSGESAMT KONNTEN "SAMPLE"-BROSCHÜREN ZU
ZEHN VERSCHIEDENEN THEMEN GESAMMELT WERDEN.

LIGHT HEADED \
LIGHT-GEDANKEN

PROJECT	TRADE FAIR DESIGN	MESSEDESIGN
LOCATION	LIGHT+BUILDING 2004, FRANKFURT	LIGHT+BUILDING 2004, FRANKFURT
DATE	2004-10	2004-10
CLIENT	PHILIPS LIGHTING	PHILIPS LIGHTING
DIMENSIONS	864 SQM	864 QM
TASK	THE TASK IS TO DESIGN THE TRADE FAIR APPEARANCE FOR PHILIPS LIGHTING, THE WORLDWIDE MARKET LEADER IN THE FIELDS OF LIGHTING AND LAMPS.	AUFGABE IST DIE GESTALTUNG DES MESSEAUFTRITTS FÜR PHILIPS LIGHTING, DEN WELTWEITEN MARKTFÜHRER IN DEN BEREICHEN BELEUCHTUNG UND LAMPEN.
ABOUT	"ENHANCE PEOPLE'S LIVES WITH LIGHTING", READS THE KEY MESSAGE FOR THE APPEARANCE OF THE AREAS "LAMPS" AND "LUMINAIRES" IN FRANKFURT. WHAT MORE COULD ONE WANT? ONE COULD NOT WISH FOR BETTER INTENTIONS ON THE PART OF THE CLIENTS; HOWEVER, THIS DOESN'T EXACTLY MAKE THE REALISATION ANY EASIER. FOR HOW IS IT POSSIBLE TO DISPLAY THIS VARIETY OF COMPLEXITIES OF "LIGHT FOR PEOPLE" AT A TRADE FAIR? THE MOST IMPORTANT STEP IS COOPERATION: A COMBINED STAND WITH A LARGE, CENTRAL COMMUNICATION ZONE IS CREATED FROM THE FORMER "MERE" NEIGHBOURING STANDS (PHILIPS + PHILIPS AEG LICHT). THE THEMES, THE SIZE OF THE AREAS AND THE CHOICE OF MATERIALS DEVELOP IN AN ALMOST EVOLUTIONARY WAY. ONLY THAT WHICH CAN HOLD ITS OWN IN THE DISCUSSIONS (IN THE TOUGH FIGHT FOR SURVIVAL) IS REALISED. THE RESULT IS A PROVOKINGLY EMOTIONAL, CIRCULAR ZONE COMPRISING 18 HIGH-CONTRAST, LIVELY ROOMS, WHICH MOVE AROUND A COMMUNICATION CORE THAT IS IN "CONTROLLED DARKNESS".	"ENHANCE PEOPLE'S LIVES WITH LIGHTING" LAUTET DIE SCHLÜSSELBOTSCHAFT FÜR DEN AUFTRITT DER BEREICHE "LAMPE" UND "LEUCHTE" IN FRANKFURT. WAS WILL MAN MEHR? BESSERE ABSICHTEN KANN MAN SICH VON KUNDENSEITE WOHL KAUM WÜNSCHEN, ALLERDINGS WIRD EINE UMSETZUNG DADURCH NICHT GERADE EINFACHER. DENN WIE KANN MAN DIESE UNGLAUBLICHE VIELFALT DER WELTWEITEN VERFLECHTUNGEN VON "LICHT FÜR MENSCHEN" AUF EINER MESSE ABBILDEN? DER WICHTIGSTE SCHRITT IST WOHL ZUSAMMENARBEITEN: AUS DEN EHEMALS "NUR" BENACHBARTEN STÄNDEN (PHILIPS + PHILIPS AEG LICHT) WIRD EIN GEMEINSAMER MESSESTAND MIT EINER GROSSEN, ZENTRALEN KOMMUNIKATIONSZONE. DIE THEMEN, DIE GRÖSSE DER EINZELNEN BEREICHE UND AUCH DIE WAHL DER MATERIALIEN ENTSTEHEN FAST EVOLUTIONÄR: NUR WAS SICH IM HARTEN ÜBERLEBENSKAMPF DER DISKUSSIONEN BEHAUPTEN KANN, WIRD UMGESETZT. DAS ENDERGEBNIS IST EINE PROVOZIEREND EMOTIONALE, RINGFÖRMIGE ZONE AUS 18 KONTRASTREICHEN, LEBENDIGEN RÄUMEN, DIE SICH UM EINEN IN "GESTEUERTER DUNKELHEIT" BEFINDLICHEN KOMMUNIKATIONSKERN BEWEGEN.

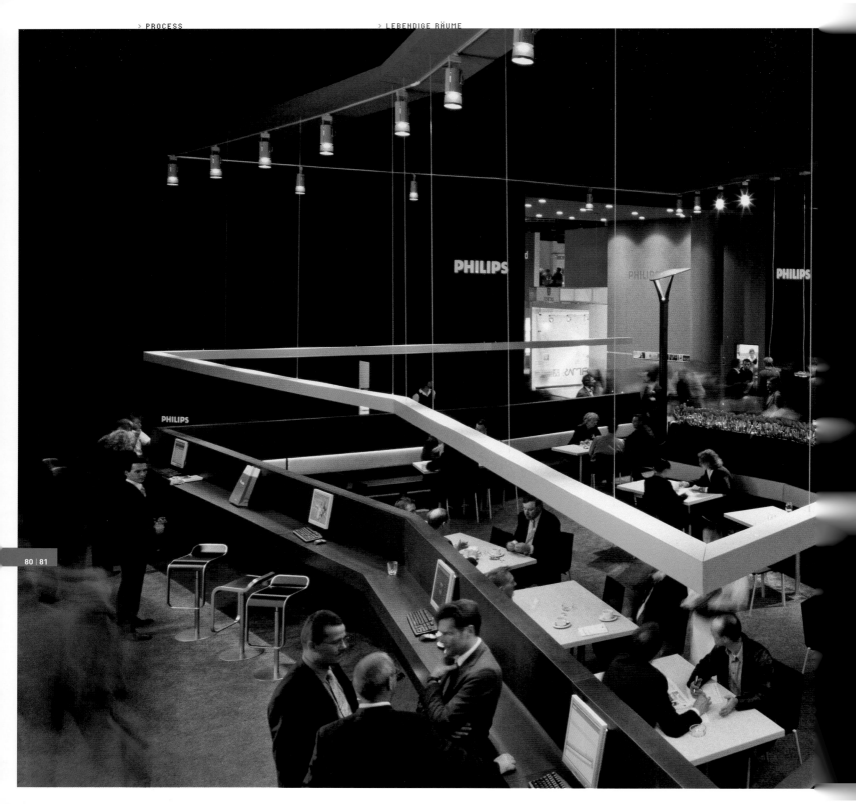

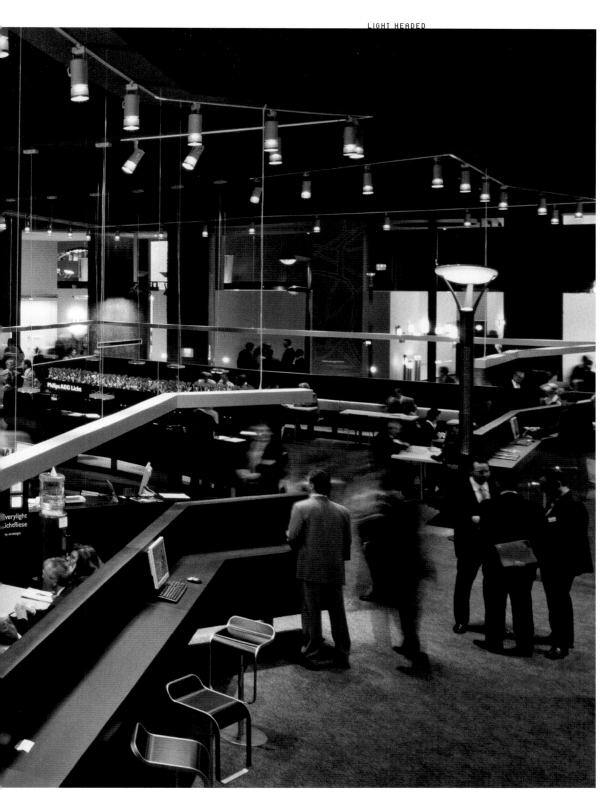

> THE HALLWAY BETWEEN THE NEIGHBOURING STAND
AREAS IS AN INTEGRATED COMPONENT OF THE
CENTRAL COMMUNICATION AREA.

> DER HALLENGANG ZWISCHEN DEN BENACHBARTEN
STANDFLÄCHEN IST INTEGRIERTER BESTANDTEIL DES
ZENTRALEN KOMMUNIKATIONSBEREICHS.

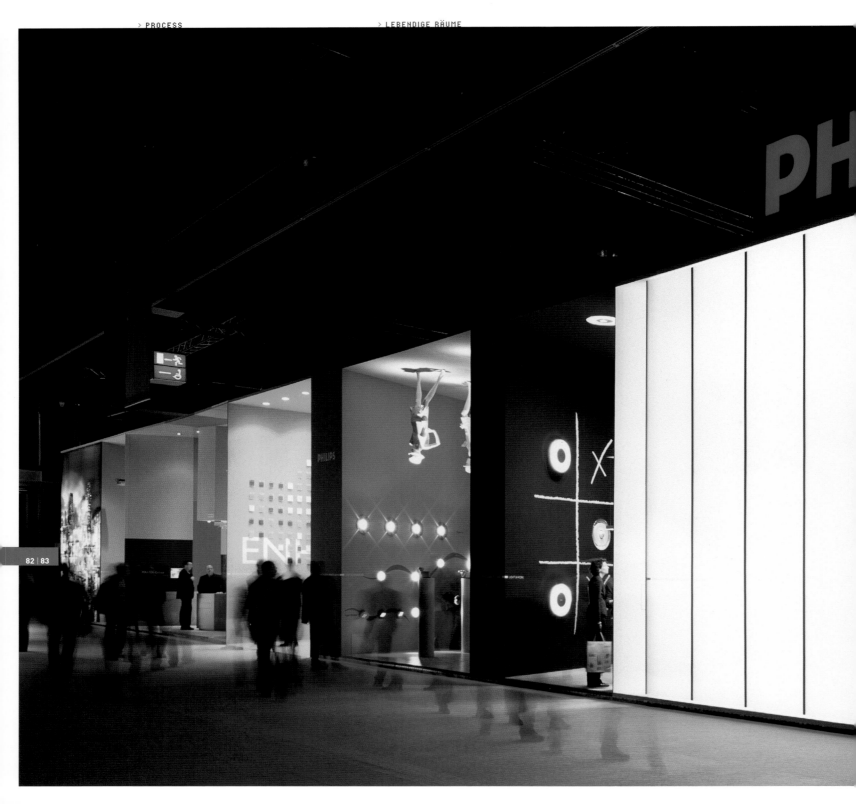

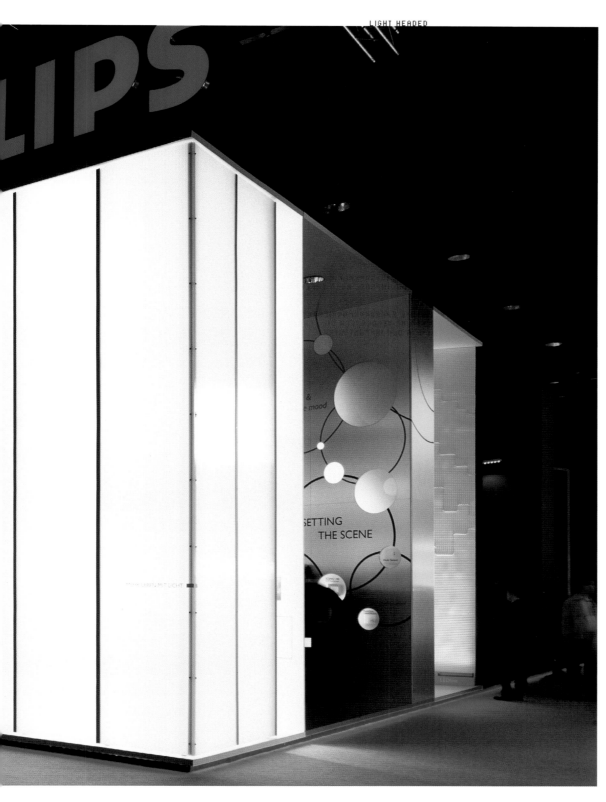

SETTING
THE SCENE

> THE 18 EXTREMELY HIGH-CONTRAST ROOMS DEALING
WITH ALL ASPECTS OF LIGHT. AN EXPERIENCE-
ORIENTATED AND EMOTIONAL DESIGN IS IN THE
FOREGROUND.

> DEN ÄUSSEREN RING BILDEN DIE 18 EXTREM
KONTRASTREICHEN RÄUME RUND UM DAS THEMA LICHT.
EINE ERLEBNISORIENTIERTE UND EMOTIONALE
AUSGESTALTUNG STEHT DABEI IM VORDERGRUND.

> THE CONNECTIONS BETWEEN LIGHT AND PRODUC-
TIVITY CAN BE EXPERIENCED DIRECTLY IN THE
"INDUSTRY" AREA THROUGH SELF-EXPERIMENTS.

> DIE ZUSAMMENHÄNGE ZWISCHEN LICHT UND
PRODUKTIVITÄT WERDEN IM BEREICH "INDUSTRIE"
DURCH SELBSTVERSUCHE DIREKT ERLEBBAR.

> INTELLIGENT ROAD-SURFACE MARKINGS DIRECT
THE TRAFFIC AND IMPROVE ROAD SAFETY IN THE
INNER CITIES.

> INTELLIGENTE FAHRBAHNMARKIERUNGEN LEITEN
DEN VEKEHR UND VERBESSERN DIE VERKEHRS-
SICHERHEIT IN DEN INNENSTÄDTEN.

> TRANSPARENT WALLS
MAKE THE HIDDEN LIGHT
CONTROL SIMPLE TO
UNDERSTAND.

> TRANSPARENTE WÄNDE
MACHEN DIE VERBORGENE
LICHTSTEUERUNG LEICHT
VERSTÄNDLICH.

84 | 85

> SPORTS ILLUMINATION: "ON THE PITCH YOU DON'T
GET ANYTHING FOR NOTHING" – THAT BECOMES ALL
THE MORE APPARENT WHEN YOU FIND YOURSELF
JUST ONCE WITH YOUR NOSE AT THE SAME HEIGHT
AS THE GRASSY TURF.

> SPORTBELEUCHTUNG: "AUF DEM PLATZ BEKOMMT
MAN NICHTS GESCHENKT" – DAS WIRD UMSO
DEUTLICHER, WENN MAN SICH SELBST EINMAL MIT
DER NASE AUF HÖHE DER GRASNARBE BEFINDET.

> DYNAMIC LIGHT EFFECTS BY MEANS OF
CLUSTERED LED LIGHT ENTICE SOME OF THE
VISITORS INTO A DETAILED EXAMINATION.

> DYNAMISCHE LICHTEFFEKTE DURCH GEBÜNDELTES
LED-LICHT VERLEITEN SO MANCHEN BESUCHER ZU
EINER EINGEHENDEN UNTERSUCHUNG.

> VICTOR, THE STREET ARTIST ILLUSTRATES THE
SCENES ON THE SUBJECT "LIGHT AND THE CITY" ON
A 5 X 6 METRE BLACKBOARD.

> VICTOR, DER STRASSENZEICHNER, ILLUSTRIERT
DIE SZENEN ZUM THEMA "LIGHT AND THE CITY" AUF
EINER 5 X 6 METER GROSSEN KREIDETAFEL.

> TANTALISING VISITOR QUESTIONNAIRES AND
PROMOTIONAL CAMPAIGNS ACT AS POINTS OF
CONTACT FOR HEATED DISCUSSIONS.

> SPANNENDE BESUCHERUMFRAGEN UND PROMOTION-
AKTIONEN DIENEN ALS ANKNÜPFUNGSPUNKTE FÜR
ANGEREGTE DISKUSSIONEN.

> CARPE DIEM: A DAY IN A "15-MINUTE TIME WARP"
CLEARLY SHOWS THE EFFECT OF THE NEW
INTELLIGENT LIGHTING IN THE OFFICE.

> CARPE DIEM: EIN TAG IM "15-MINUTEN-
ZEITRAFFER" VERDEUTLICHT DIE WIRKUNG DES
NEUEN INTELLIGENTEN LICHTS IM BÜRO.

> THE SHOP-WORLD IS GOING WILD ABOUT THE
PREMIERE OF THE NEW SPOTLIGHTS AND DOWNLIGHTS.

> DIE SHOP-WELT STEHT KOPF FÜR DIE PREMIERE
DER NEUEN STRAHLER UND DOWNLIGHTS.

> "NO MATTER WHAT COLOUR ..." THE MINIATURI-
ZATION OF THE MASTERCOLOUR LAMPS IS IN THE
FOREGROUND AND MAKES FOR TINY EXHIBITS.

> "GANZ GLEICH, WELCHE FARBE ..." DIE
MINIATURISIERUNG DER MASTERCOLOUR-LAMPEN
STEHT IM VORDERGRUND UND SORGT FÜR WINZIGE
EXPONATE.

> AN OPEN-AIR CINEMA
VISUALISES CONCEPTS
FOR ADVANCED URBAN
LIGHTING.

> EIN OPEN-AIR-KINO
VISUALISIERT KONZEPTE
FÜR FORTSCHRITTLICHE
STADTBELEUCHTUNG.

> FREE CHOICE OF
COLOUR FOR FREE
VISITORS IN THE INDOOR
DIMMING AREA.

> FREIE FARBWAHL FÜR
FREIE BESUCHER IM
BEREICH INDOOR DIMMING.

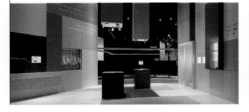 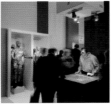

> RUTHLESS: THE ROBUST LED STRINGS ARE USED
IN THE FRESH WATER AQUARIUM.

> GNADENLOS: DIE ROBUSTEN LED-STRINGS
KOMMEN IM SÜSSWASSER-AQUARIUM ZUM EINSATZ.

> THE FUNCTIONING
FREECLIMBING WALL
SHOWS THE LEVEL OF THE
LIGHT SPOTS.

> DER FUNKTIONSFÄHIGE
FREECLIMBING—PARCOURS
VISUALISIERT DIE
LICHTPUNKT—HÖHEN.

> HOME IS THE NICEST
PLACE TO BE — EVEN
IF IT IS ONLY LIKE A
"PAINTING".

> ZUHAUSE IST ES
DOCH AM SCHÖNSTEN —
AUCH WENN ES NUR
"WIE GEMALT" IST.

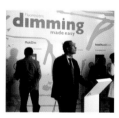

> FACTS AND FIGURES ON THE SUBJECT OF
ENVIRONMENTAL PROTECTION AND SOCIAL
RESPONSIBILITY WANT TO BE UNCOVERED.

> ZAHLEN UND FAKTEN ZUM THEMA UMWELTSCHUTZ
UND GESELLSCHAFTLICHE VERANTWORTUNG
WOLLEN AUFGEDECKT WERDEN.

> THE SUBTLEST OF LIGHT
NUANCES ARE REVEALED
IN AN ELABORATE SPACE
INSTALLATION.

> FEINSTE LICHTNUANCEN
ENTFALTEN SICH IN EINER
AUFWENDIGEN RAUM—
INSTALLATION.

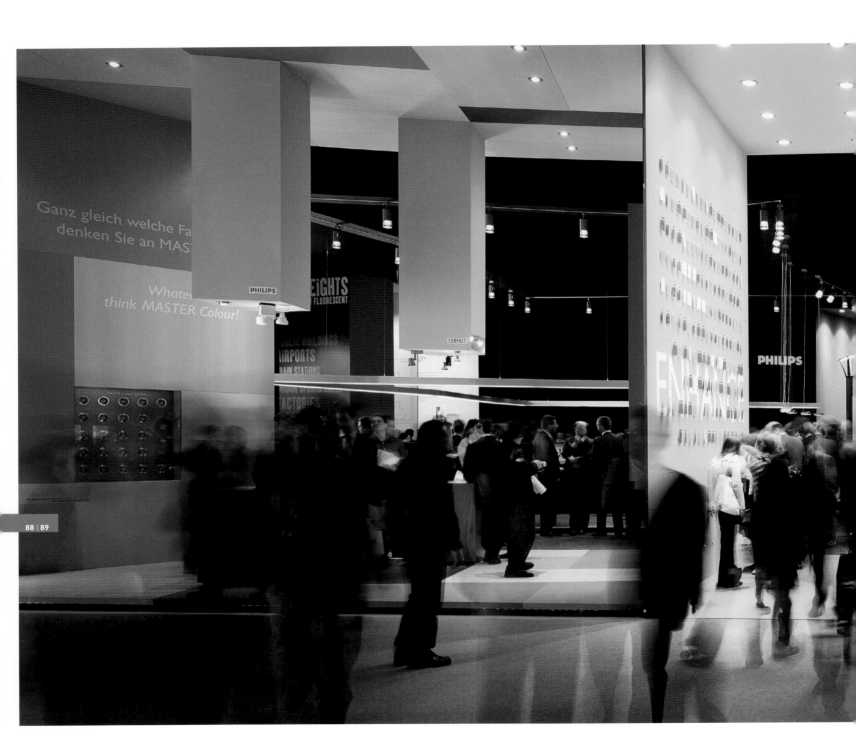

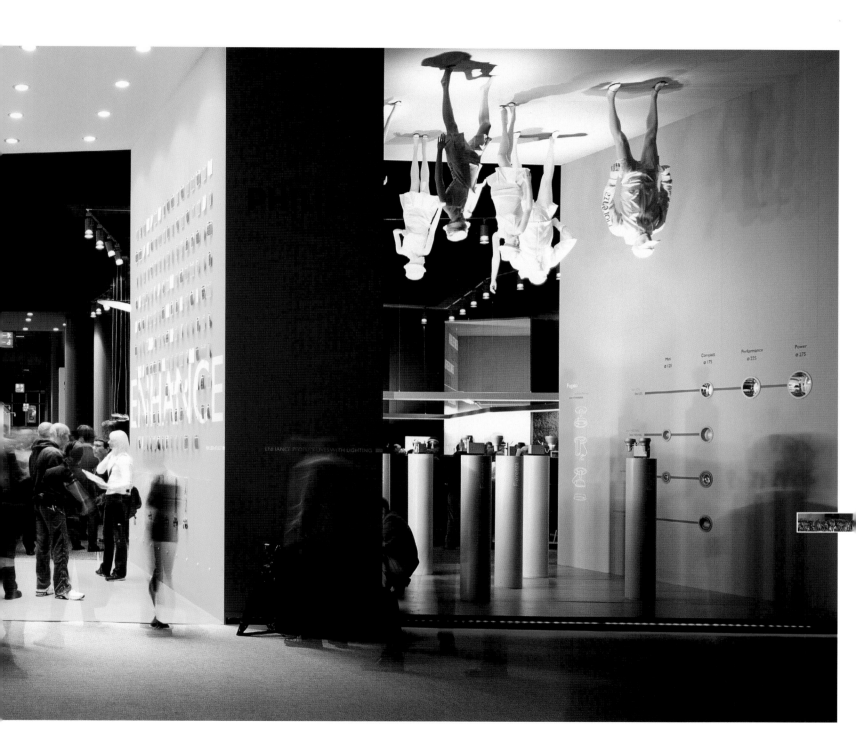

→ In 1952 John Cage performed his famous piece of music called 4' 33" for the first time: a period of 4 minutes and 33 seconds of complete silence. All the three musical parts begin with the instruction "tacet" [latin: be silent]. So during a performance you will suddenly hear all the little noises of the audience. One of the established messages of the composition is: silence does not exist.

Well, "you cannot not communicate" – I think that's the point. This world is not about absoluteness, it is more like a process all in all. So even if you somehow stop or reduce a

… to paraphrase that: designers getting paid for not designing?

[laughing] … to some extent, yes, but we insist on the communication concept to be the driving force within our projects. And creating these concepts is not exactly nothing, it is hard work most of the time. And I am not thinking of some dull marketing terms like "communicate that we are the market leader". We need to break that down to something less abstract. Something simple and more relevant concerning live face-to-face communication.

"People are not laser scanners made mobile, but individuals that will always create a personal interpretation of what they experience."

certain behaviour, this will have just as well an effect on the development of the process. This effect might be of a different kind but it will take place – for sure. That's one reason for our loud claim that we put design second. Take 4' 33" as an example: the chorus of out-rage in the media was certainly much louder and a very visible sign of reaction to doing nothing than the regular response you would have expected playing whatever kind of noises. So if you think that it is a good idea to ignore the sociocultural effects while doing nothing, you might end up eaten alive by the yellow press.

So if we cannot stop it anyway, what do you think we should do with this socio-cultural effect of our doing nothing?

Use it! It is something very powerful you will get for free. So much the worse if you try to react against it. We try to make use of these effects as much as we …

A matter of scale?

Indeed, you cannot expect visitors to remember every detail of a complex message. People are not laser scanners made mobile, but individuals that will always create a personal interpretation of what they experi-ence. That is to say, you have to consider this interference or background noise within the channel right from the start. Like a change in scale. And this attitude for instance is very compatible to the positioning of a market leader. A natural thing for someone as confi-dent as a leader is to make sure everybody gets the inspiring big idea and leaves the rest to find its own way. It is very important to include some 'connectivity' into the message. People will create their individual references by themselves. There is no point in insisting to dictate the terms of communication because every communication is actually based on the exact opposite – on misunder-standings.

Sorry, say again … ?

> GUIDO MAMCZUR

BORN 1969, STUDIED COMMUNICATION DESIGN AT THE UNIVERSITY OF APPLIED SCIENCES DÜSSELDORF, CREATIVE DIRECTION, MEMBER OF THE "NEUGIERONAUTIKER" AND A BIG CHILD

→ 1952 hat John Cage zum ersten Mal sein berühmtes Stück 4'33" aufgeführt: 4 Minuten und 33 Sekunden absolute Stille. Alle drei Sätze bestehen aus der Anweisung »tacet« [Lateinisch: schweigt]. In einer Aufführung hört man daher plötzlich all die kleinen Geräusche des Publikums. Eine der anerkannten Botschaften der Komposition lautet: es gibt kein Schweigen.

Oder: »man kann nicht nicht kommunizieren«. Ich glaube, darum geht es. Es gibt auf der Welt nichts Absolutes, sondern nur Prozesse. Wenn man ein bestimmtes Verhalten irgendwie unterbindet oder einschränkt, hat es trotzdem einen Einfluss auf die Entwicklung des Prozesses. Der Einfluss mag anders ausfallen, aber er ist mit Sicherheit da. Das ist ein Grund dafür, dass wir immer wieder betonen, dass wir das Design an zweite Stelle stellen. Um beim Beispiel 4'33" zu bleiben: Der Sturm der Entrüstung in den Medien war sicherlich lauter und eine sichtbarere Reaktion auf etwas, das nicht getan wurde, als man es bei der Vorführung von Geräuschen welcher Art auch immer erwartet hätte. Wenn man sich dafür entscheidet, die soziokulturellen Konsequenzen zu missachten, indem man nichts tut, wird man am Ende vielleicht von der Boulevardpresse in der Luft zerrissen.

Wenn wir es ohnehin nicht verhindern können, was sollten wir dann Ihrer Meinung nach mit den soziokulturellen Konsequenzen des Nichtstuns tun?

Sie nutzen! Das ist etwas sehr Mächtiges, das man umsonst bekommt. Umso schlimmer, wenn man versucht, dagegenzuarbeiten. Wir versuchen, es uns zunutze zu machen, ebenso wie …

… oder anders gesagt: Designer werden dafür bezahlt, dass sie nicht designen?

[lacht] … gewissermaßen, ja, aber wir bestehen darauf, dass das Kommunikationskonzept die Antriebsfeder unserer Projekte ist. Und diese Konzepte zu entwickeln, ist nicht gerade ›nichts‹, meist ist es harte Arbeit. Und ich spreche jetzt nicht von öden Standards wie »kommunizieren Sie, dass wir Marktführer sind«. Wir müssen es auf etwas weniger Abstraktes herunterbrechen. Auf etwas Einfacheres und Relevanteres für die Kommunikation von Angesicht zu Angesicht.

Eine Frage des Maßstabs?

Genau, man kann nicht erwarten, dass ein Besucher sich an jedes Detail einer komplexen Botschaft erinnert. Die Leute sind ja keine mobilen Laser-Scanner, sondern Individuen, die das, was sie erleben, immer auf ihre persönliche Weise interpretieren. Das heißt, man muss diese Interferenzen oder Hintergrundgeräusche im Kanal von Anfang an mit einplanen. Als Veränderung des Maßstabs. Und diese Einstellung passt zum Beispiel sehr gut zu der Positionierung eines Marktführers. Mit dem Selbstvertrauen eines Marktführers ist es ganz natürlich, nur dafür zu sorgen, dass die Leute die Gesamtidee verstehen, und den Rest sich selbst zu überlassen. Es ist wichtig, dass in der Message etwas Verbindendes liegt; die Leute stellen dann selbst ihren persönlichen Bezug her. Es hat keinen Zweck, die Kommunikationsgrundlagen diktieren zu wollen, denn jede Kommunikation basiert tatsächlich auf dem genauen Gegenteil – auf Missverständnissen.

Wie bitte?

› GUIDO MAMCZUR

JAHRGANG 1969, STUDIUM KOMMUNIKATIONSDESIGN AN DER FACHHOCHSCHULE DÜSSELDORF, CREATIVE DIRECTION, MITGLIED DER NEUGIERONAUTIKER UND EIN SPIELKIND

»Die Leute sind ja keine mobilen Laser-Scanner, sondern Individuen, die das, was sie erleben, immer auf ihre persönliche Weise interpretieren.«

MEMORY \
ERINNERUNG

→ Seventy-five years ago "1066 And All That" was published, a very successful book which is still in print. Ostensibly a guide to British history, it is a comic account of the past, stuffed with terrible puns and deliberate misquotations. (In the English Civil War the two sides are described as "Cavaliers – Wrong but Wromantic" and "Roundheads – Right but Repulsive"). It classifies historical events and persons as "a Good Thing" or "a Bad Thing", offers spurious explanations of events ("honi soit qui mal y pense", the motto of the Order of the Garter, is translated as "honey, your silk stocking's hanging down", for example). The book is based from the start on the principle that only the historical events that one can remember are relevant: if you can't remember it, it isn't history. Thus the title: 1066 – the year of the Norman invasion of Anglo-Saxon England – is the only memorable date in English history.

The book – quite apart from being very funny – is a parody of traditional schoolbooks, with their simplistic and nationalistic assumptions about history. It is also a nostalgic account of Britain's great role at a time when British prestige was rapidly being eclipsed by the superpowers: as the book says, after the First World War "America became Top Nation so history came to a full stop."

The philosophical argument about memory and history is not a subject the book addresses in the way Hegel did. But there is considerable academic debate about how to study the history of cultures with no written tradition, for example, and about the role of oral or informal records as against formal ones. Even in general terms, the idea that what one cannot remember is not worth knowing has a certain resonance.

One consequence of the undesigning approach is to create a role for memory. This is implicit from the start, in the aspect of bringing the client into the

→ Vor fünfundsiebzig Jahren erschien »1066 And All That«, ein sehr erfolgreiches Buch, das immer noch neu aufgelegt wird. Vorgeblich ein Buch über die Geschichte Großbritanniens, ist es eine komische Erzählung über die Vergangenheit, voller schlimmer Wortspiele und absichtlich falscher Zitate. (Die beiden Seiten im Englischen Bürgerkrieg werden als »Cavaliers – Wrong but Wromantic« und »Roundheads – Right but Repulsive« bezeichnet). Historische Ereignisse und Personen werden in »gut« und »schlecht« eingeteilt, und Dinge werden falsch erklärt (»honi soit qui mal y pense«, das Motto des Hosenbandordens, wird beispielsweise mit »Honey, dein Seidenstrumpf rutscht« übersetzt). Das Buch geht davon aus, dass nur die historischen Ereignisse relevant sind, an die man sich erinnert: wenn man sich nicht erinnert, ist es nicht Geschichte. Daher auch der Titel: 1066, das Jahr der normannischen Eroberung des angelsächsischen England, ist das einzige erinnernswerte Datum in der Geschichte Englands.

Das Buch ist sehr lustig und eine Parodie auf herkömmliche Schulbücher mit ihrem vereinfachenden und nationalistischen Geschichtsbild. Außerdem ist es eine nostalgische Erzählung über Großbritanniens herausragende Rolle zu einer Zeit, in der das britische Prestige von den Supermächten in den Schatten gestellt wurde: wie es im Buch heißt, wurde nach dem Ersten Weltkrieg »Amerika zur führenden Nation, und damit war die Geschichte beendet.«

Die philosophische Debatte über Erinnerung und Geschichte wird in dem Buch nicht auf hegelsche Weise geführt. Aber es gibt eine akademische Diskussion darüber, wie man etwa die Geschichte von Kulturen ohne schriftliche Tradition erforscht, und über die Rolle mündlicher und inoffizieller Überlieferungen im Vergleich zu den offiziellen. Die Vorstellung, dass etwas, woran man sich nicht erinnert, nicht wissenswert ist, hat ganz allgemein eine gewisse Resonanz. Ein Ziel des Undesigning ist es, ein Modell für die Erinnerung zu schaffen. Das schwingt von Beginn an mit, wenn der Kunde in allen Phasen am Prozess beteiligt wird, aber es zeigt sich auch im gestalterischen Ergebnis. Etwa bei einem Messestand: ein nur kurzzeitig existierender Bau, der der Öffentlichkeit nur für ein paar Tage

process at all stages, but it is also embedded into the design outcome. Take the question of the trade fair stand. These are temporary buildings, shown to their public for only a few days as settings or frames for the particular corporate messages that are to be presented. Normal logic would suggest it is the message not the messenger that counts in such a situation. No designer would want to be remembered for building an instantly forgettable stand, of course, but most designers would put the message ahead of the stand.

For D'art such a hierarchy is not the question: what matters is what the visitor takes away – what the visitor remembers – and they realise that that is a total experience, not separable into message and stand. The stand may only be there physically for a few days: many visitors may only see it once, but what is important is how long it remains in the visitor's mind. This experiential outcome is one of the key aims of the undesigning process.

gezeigt wird, als Kulisse oder Rahmen für die spezielle Botschaft eines Unternehmens. Der gesunde Menschenverstand würde davon ausgehen, dass in einer solchen Situation die Botschaft zählt, nicht der Botschafter. Natürlich möchte kein Gestalter dafür bekannt sein, dass er Stände baut, die man sofort vergisst, aber dennoch würden die meisten der Botschaft die Priorität über den Stand einräumen.

Für D'art stellt sich diese Hierarchiefrage gar nicht: es geht darum, was der Besucher mitnimmt – woran er sich erinnert – und sie sehen dies als ganzheitliche Erfahrung, die sich nicht in Botschaft und Stand aufteilen lässt. Der Stand mag nur für ein paar Tage dort stehen: viele Besucher sehen ihn nur einmal, aber es kommt darauf an, wie lange sie ihn im Gedächtnis behalten. Diese Wirkung ist eins der Hauptanliegen des Undesigning.

INSPIRED BY LIFE \
SPURENSUCHE

"Se fossi la regina del paese delle
esisterebbero solo crêpes con la man

Lisa, 4 anni

here would
lade pancakes to eat!"

Lisa, 4 years old

PROJECT	"INSPIRED BY LIFE", TRADE FAIR DESIGN	"INSPIRED BY LIFE", MESSEDESIGN
LOCATION	EUROCUCINA, MILAN, ITALY	EUROCUCINA, MAILAND, ITALIEN
DATE	2006-04	2006-04
CLIENT	ALNO AG	ALNO AG
DIMENSIONS	480 SQM	480 QM
TASK	HERE THE MOTTO IS ALSO THE ASSIGNMENT: "INSPIRED BY LIFE" IS THE MESSAGE FOR THE FIRST-TIME PARTICIPATION OF ALNO AG AT THE RENOWNED EUROCUCINA.	HIER IST DAS MOTTO ZUGLEICH AUCH DIE AUFGABE: "INSPIRED BY LIFE", SO LAUTET DIE BOTSCHAFT FÜR DIE ERSTMALIGE BETEILIGUNG DER ALNO AG AN DER RENOMMIERTEN EUROCUCINA
ABOUT	SHOW ME YOUR KITCHEN AND I'LL TELL YOU WHO YOU ARE: "INSPIRED BY LIFE" IS THE MESSAGE AND, JUST AS LIFE ITSELF IS SO RICHLY DIVERSE, SO TOO ARE THE STORIES THAT ARE TOLD BY THE OCCUPANTS OF A KITCHEN. THIS IS ESPECIALLY TRUE WHEN IT'S A QUESTION OF DISPLAYING SUCH AN EXTENSIVE PRODUCT FOLIO AS IN THIS CASE. THE DESIGN CONCEPT CONSUMMATES THIS IDEA BY MEANS OF MILIEU STUDIES, IN WHICH PERSONALISED "OCCUPANTS" LEAVE BEHIND TRACES OF THEMSELVES. EXHIBITED KITCHENS ARE ALWAYS IN A BELIEVABLE SOCIAL CONTEXT AND FOR THIS REASON ARE MORE EASILY REMEMBERED. THE "DISPLAYING" OF TRACES OF THE PROTAGONISTS GUIDES THE VISITOR ACROSS THE ENTIRE STAND AND LEADS FROM ONE WORLD OF LIVING TO THE NEXT. A CLEAR BRAND FRAME OF SHEER WALLS COVERED IN TRANSPARENT FABRICS CONTAINS THE PRESENTATION. OPENINGS POINT TO THE INTERIOR AND PRODUCE INTERPLAYS BETWEEN THE INDIVIDUAL KITCHEN WORLDS THAT ARE RICH IN CONTRAST.	ZEIGE MIR DEINE KÜCHE UND ICH SAGE DIR, WER DU BIST: "INSPIRED BY LIFE" HEISST DIE BOTSCHAFT, UND SO VIELFÄLTIG WIE DAS LEBEN SELBST SIND AUCH DIE GESCHICHTEN, DIE SICH VON DEN BEWOHNERN EINER KÜCHE ERZÄHLEN LASSEN. BESONDERS DANN, WENN ES GILT, EIN DERART UMFANGREICHES PRODUKTPORTFOLIO ABZUBILDEN WIE IN DIESEM FALL. DAS DESIGNKONZEPT VOLLZIEHT DIESEN GEDANKEN MITTELS ARCHITEKTONISCHER MILIEUSTUDIEN, IN DENEN PERSONALISIERTE "BEWOHNER" IHRE REALEN SPUREN HINTERLASSEN. DIE AUSGESTELLTEN KÜCHEN STEHEN IMMER IN EINEM GLAUBWÜRDIGEN SOZIALEN KONTEXT UND LASSEN SICH SOMIT EINFACHER UND TRENNSCHÄRFER ERINNERN. DIE "AUSGELEGTEN" SPUREN DER PROTAGONISTEN FÜHREN DEN BESUCHER ÜBER DEN GESAMTEN STAND UND LEITEN VON EINER LEBENSWELT ZUR NÄCHSTEN. GEFASST WIRD DIE PRÄSENTATION DURCH EINEN KLAREN MARKENRAHMEN, AUS MIT TRANSPARENTEN STOFFEN BESPANNTEN WANDSCHEIBEN. ÖFFNUNGEN WEISEN HIER INS INNERE UND ERZEUGEN KONTRASTREICHE WECHSELSPIELE ZWISCHEN DEN EINZELNEN KÜCHENWELTEN.

> THE TRACES THAT ARE FULLY VISIBLE FROM THE
STAND'S EXTERIOR ARE THE FIRST SIGNS OF LIFE
OF THE FICTITIOUS PROTAGONISTS IN THE VARIOUS
KITCHEN WORLDS.

> DIE VON DER AUSSENSEITE DES STANDES GUT
SICHTBAREN SPUREN SIND DIE ERSTEN "LEBENS-
ZEICHEN" DER FIKTIVEN PROTAGONISTEN IN DEN
VERSCHIEDENEN KÜCHENWELTEN.

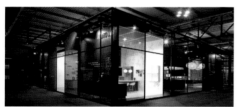

98 | 99

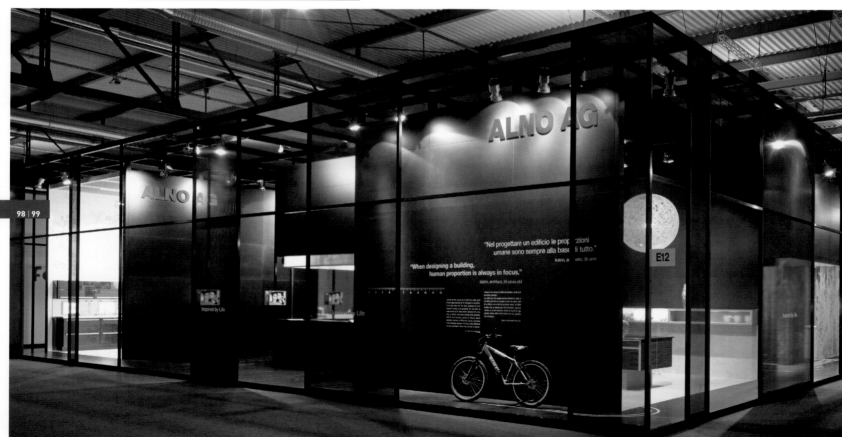

> FROM THE SENSITIVE INTERIOR DESIGNER TO THE
PERMANENTLY STRESSED PILOT TO THE LIVELY LARGE
FAMILY, NUMEROUS REALISTIC MILIEU STUDIES ARE
STAGED AROUND THE KITCHEN AREA.

> VON DER SENSIBLEN INNENARCHITEKTIN ÜBER DEN
DAUERGESTRESSTEN PILOTEN BIS HIN ZUR LEBHAFTEN
GROSSFAMILIE WERDEN ZAHLREICHE REALISTISCHE
MILIEUSTUDIEN UM DIE AUSGESTELLTEN KÜCHEN
INSZENIERT.

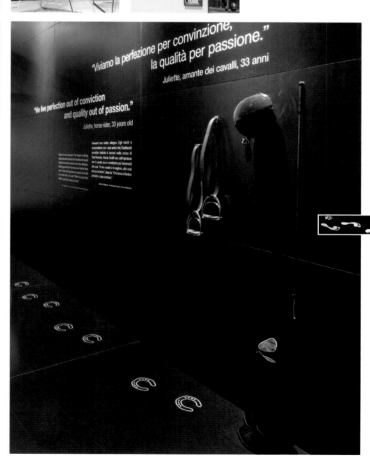

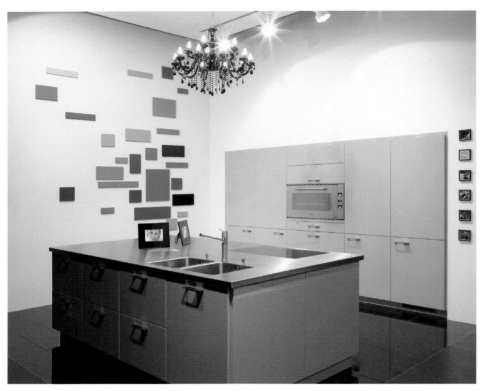

> THE NARRATIVE ELEMENT IN EACH SCENE CREATES
A MUCH HIGHER EMOTIONAL INTEREST IN THE
EXHIBITION ON THE PART OF THE TRADE FAIR VISITOR.
THE INSIGHTS INTO THE PRIVATE LIVES OF THE
PROTAGONISTS GENERATE VIVID MEMORIES OF THESE
ENCOUNTERS.

> DAS ERZÄHLERISCHE ELEMENT IN JEDER SZENE
ERZEUGT EINE VIEL HÖHERE EMOTIONALE ANTEIL-
NAHME DER MESSEBESUCHER AN DER AUSSTELLUNG.
DIE EINBLICKE IN DAS PRIVATLEBEN DER PROTA-
GONISTEN RUFEN INTENSIVE ERINNERUNGEN AN DIESE
BEGEGNUNGEN WACH.

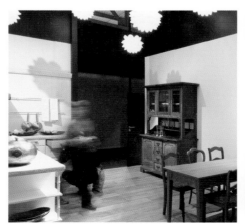

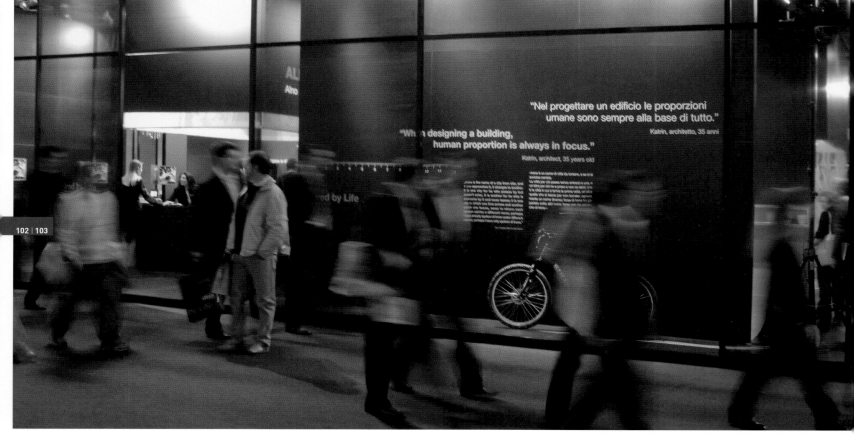

"Nel progettare un edificio le proporzioni umane sono sempre alla base di tutto."
Katrin, architetto, 35 anni

"When designing a building, human proportion is always in focus."
Katrin, architect, 35 years old

> THE SPECIFIED "BACKGROUND STORY" IS ONLY THE
BASIS (DEPENDING ON EXPERIENCE OF LIFE) FOR AN
INDIVIDUAL CONTINUATION AND INTERPRETATION BY
THE VISITOR IN THE INDIVIDUAL SCENES.

> DIE VORGEGEBENE "RAHMENHANDLUNG" IST NUR DIE
BASIS FÜR EINE (JE NACH LEBENSERFAHRUNG)
INDIVIDUELLE FORTFÜHRUNG UND INTERPRETATION DER
EINZELNEN SZENEN DURCH DIE BESUCHER.

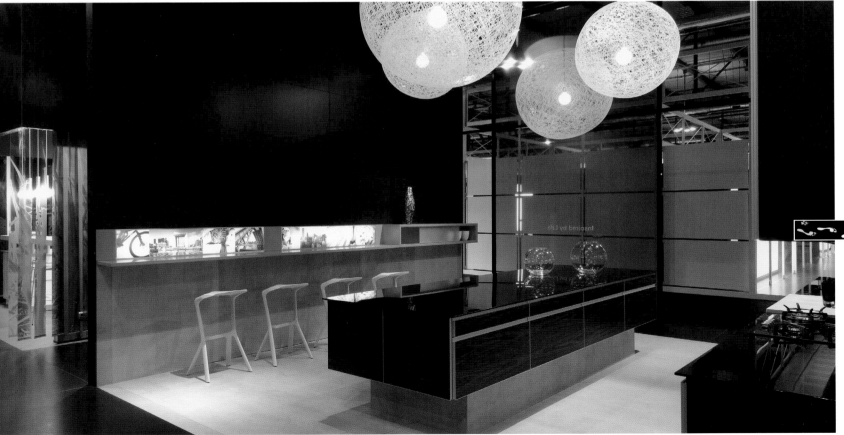

**WOODBLOCK RELOADED **
DER MÄRZ WIRD HEISS

PROJECT	E-MOTION PARK (TRADE FAIR CONCEPT)	E-MOTION PARK (MESSEDESIGN, KONZEPT)
LOCATION	CEBIT, HANOVER	CEBIT, HANNOVER
DATE	2004-10	2004-10
CLIENT	E-PLUS MOBILFUNK GMBH & CO. KG	E-PLUS MOBILFUNK GMBH & CO. KG
DIMENSIONS	4800 SQM	4800 QM
TASK	THE ASSIGNMENT IS THE DESIGN OF AN INTEGRATED CONCEPT OF ARCHITECTURE, INTERIOR DESIGN AND COMMUNICATION FOR THE ATTENDANCE AT THE CEBIT.	DIE AUFGABE IST DIE GESTALTUNG EINES GANZHEITLICHEN GESAMTKONZEPTES AUS ARCHITEKTUR, INNENARCHITEKTUR UND KOMMUNIKATION FÜR DIE BETEILIGUNG AN DER CEBIT.
ABOUT	REFRESHINGLY DIFFERENT: EXCESS VALUE AND BRAND VALUE TAKE CENTRE STAGE IN THE CONCEPT FOR THE E-PLUS "E-MOTION PARK". IN CONTRAST TO THE USUAL "CLOSED" PAVILION ARCHITECTURE ON THE OPEN SPACES OF THE CEBIT, THIS IDEA IS BASED ON AN "OPEN, COMMUNICATIVE" INTERPRETATION THAT INTEGRATES THE SURROUNDINGS. A LARGE PARK STANDS APART FROM THE BUILDINGS AND RECEIVES THE VISITORS WITH AN ANNUALLY CHANGING RANGE OF ACTIVITIES. THE SELF-CONTAINED DESIGN OF THE INDIVIDUAL BUILDINGS CORRESPONDS TO THEIR SIGNIFICANCE AND FUNCTION (PRESENTATION, MEETING, LOGISTICS) FOR THE TARGET GROUPS. THROUGH THE SPECIALISATION OF THE ARCHITECTURAL ELEMENTS, THEY CAN BE DESIGNED SMALLER AND MORE EFFICIENTLY. HERE THE INDIVIDUAL COMPONENTS OF THE ENSEMBLE ARE PART OF THE BRAND WORLD: AN ACCESSIBLE MESSAGE, IN WHICH ONE CAN IMMERSE ONESELF, DISCOVER AND DIRECTLY EXPERIENCE E-PLUS. A CLEARLY VISIBLE SIGNAL THAT CONNECTS; SURPRISING AND DIRECT.	ERFRISCHEND ANDERS: MEHRWERT UND MARKENWERT STEHEN KLAR IM MITTELPUNKT DER KONZEPTION FÜR DEN E-PLUS "E-MOTION PARK". IM GEGENSATZ ZUR ÜBLICHEN "GESCHLOS-SENEN" PAVILLON-ARCHITEKTUR AUF DEN FREIFLÄCHEN DER CEBIT BASIERT DIESE IDEE AUF EINER "OFFENEN, KOMMUNIKATIVEN" INTERPRETATION, WELCHE DIE UMGEBUNG MIT EINBEZIEHT. EIN GROSSZÜGIG BEMESSENER PARK IST DEN EIGENTLICHEN GEBÄUDEN VORGELAGERT UND EMPFÄNGT DIE MESSEBESUCHER MIT EINEM JÄHRLICH WECHSELNDEN ANGEBOT AN AKTIVITÄTEN. DIE EIGENSTÄNDIGE GESTALTUNG DER EINZELNEN GEBÄUDE ENTSPRICHT IHRER BEDEUTUNG UND FUNKTION (PRÄSENTATION, MEETING, LOGISTIK) FÜR DIE UNTERSCHIEDLICHEN ZIELGRUPPEN. DURCH DIE SPEZIALISIE-RUNG DER ARCHITEKTURELEMENTE KÖNNEN DIESE KLEINER, SCHNELLER UND EFFIZIENTER FORMULIERT WERDEN. DIE EINZELNEN BESTANDTEILE DES ENSEMBLES SIND HIER TEIL DER MARKENWELT: EINE BEGEHBARE BOTSCHAFT, IN DIE MAN EINTAUCHEN, DIE MAN ENTDECKEN UND SO E-PLUS HAUTNAH ERLEBEN KANN. EIN DEUTLICH SICHTBARES SIGNAL, DAS VERBINDET; ÜBERRASCHEND UND DIREKT.

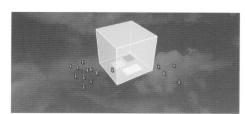

> ENCLOSED, LARGE-SCALE PAVILIONS WITH ANCILLARY INTERNAL FUNCTIONAL AREAS DOMINATE THE OPEN SPACES.

> AUF DEN FREIFLÄCHEN DOMINIEREN PAVILLONS MIT EINER GESCHLOSSENEN GROSSFORM UND UNTERGE-ORDNETEN INNEREN FUNKTIONSZONEN.

> BY RELINQUISHING THE "IMPOSING" YET LESS COMMUNICATIVE LARGE SCALE, A SIGNIFICANTLY LARGER AREA BECOMES REALISABLE.

> DURCH DEN VERZICHT AUF DIE "IMPONIERENDE", ABER WENIG KOMMUNIKATIVE GROSSFORM WIRD EINE DEUTLICH GRÖSSERE FLÄCHE REALISIERBAR.

> THE VISITORS ARE NOW RECEIVED IN THE ENTIRE AREA, WHICH "NEUTRALISES" THE IMPRESSIONS OF THE COMPETITORS AND PREPARES FOR NEW IMPULSES.

> DIE GESAMTE FLÄCHE NIMMT JETZT DIE BESUCHER IN EMPFANG, "NEUTRALISIERT" DIE EINDRÜCKE DER WETTBEWERBER UND STIMMT AUF NEUE INHALTE EIN.

E-MOTION PARK

> VARIABLE ADVENTURE ZONES CONNECT THE VISITORS IN AN EMOTIONAL WAY WITH THE BRAND AND ITS VALUES.

> VARIABLE ERLEBNISZONEN VERBINDEN DIE BESUCHER AUF EMOTIONALE ART UND WEISE MIT DER MARKE UND IHREN WERTEN.

> SPECIALISTS WITH CHARACTER: BUILDINGS FOCUSED ON THEIR FUNCTION ENSURE MAXIMUM PERFORMANCE FOR PRESENTATION, MEETING AND LOGISTICS.

> SPEZIALISTEN MIT CHARAKTER: AUF IHRE FUNKTION FOKUSSIERTE GEBÄUDE GEWÄHRLEISTEN MAXIMALE LEISTUNG FÜR PRÄSENTATION, MEETING UND LOGISTIK.

> FOR THE PREMIERE THE PARK APPEARS IN ITS MOST REPRESENTATIONAL PERMUTATION: FIR AND PINE TREES ARE DISPLAYED "REFRESHINGLY DIFFERENTLY".

> FÜR DIE PREMIERE ZEIGT SICH DER PARK IN SEINER GEGENSTÄNDLICHSTEN UMSETZUNG: FICHTEN UND TANNEN SIND UNÜBERSEHBAR "ERFRISCHEND ANDERS".

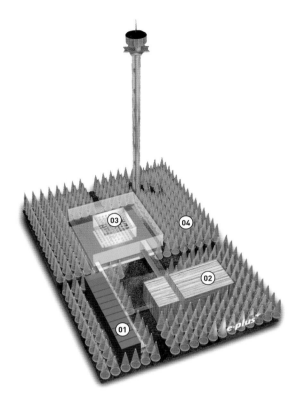

01 THINGTANK

> THE CENTRAL SUPPLY UNIT: 600 SQM OF LOGISTICS IN STANDARD CONTAINERS, STORAGE, TECHNICAL EQUIPMENT, POWER SUPPLY, ETC.

> DIE VERSORGUNGSZENTRALE: 600 QM LOGISTIK IN STANDARD-CONTAINERN, LAGER, TECHNIK, ENERGIEVERSORGUNG, ETC.

02 WOODBLOCK

> GET TOGETHER: 600 SQM OF MEETING AREA ON TWO LEVELS, RECEPTION, OFFICE, B2B AREA (LOUNGE), KITCHEN, BACK OFFICE

> GET TOGETHER: 600 QM MEETINGBEREICH AUF ZWEI GESCHOSSEN, EMPFANG, SEKRETARIAT, B2B-BEREICH (LOUNGE), KÜCHE, BACK OFFICE

03 HIGH TOUCH ARENA

> SHOWTIME: 1200 SQM OF PRESENTATION AREA, EVENT AREA IN THE ATRIUM, GROUND LEVEL = CONSUMER, UPPER LEVEL = BUSINESS

> SHOWTIME: 1200 QM PRÄSENTATIONSFLÄCHE, EVENTBEREICH IM ATRIUM, EG = CONSUMER, OG = BUSINESS

04 4-PLAY

> ALWAYS REFRESHINGLY DIFFERENT: THE ENTIRE ADVENTURE ZONE CHANGES ITS THEME AND APPEARANCE ANNUALLY.

> IMMER ERFRISCHEND ANDERS: DIE GESAMTE ERLEBNISZONE WECHSELT JÄHRLICH IHR THEMA UND AUSSEHEN.

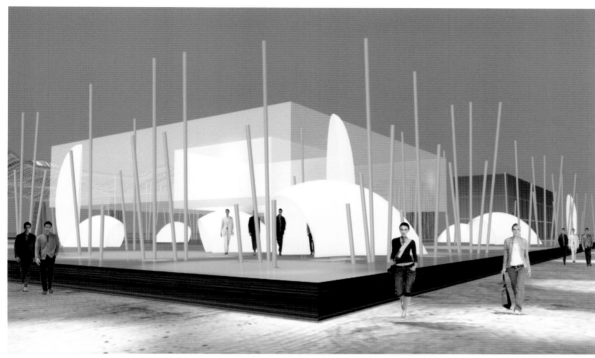

> THE STRONG FIRST APPEARANCE STAYS FIXED IN
THE MEMORY AND IS MAGNIFIED IN THE YEARS TO
FOLLOW WITH THE NEW THEMES SUCH AS "PRODUCT
HIGHLIGHT" OR "TESTIMONIAL" CAMPAIGN.

> DER STARKE ERSTE AUFTRITT BLEIBT IN ERINNERUNG
UND MULTIPLIZIERT SICH IN DEN FOLGEJAHREN MIT
NEUEN THEMEN WIE "PRODUKT-HIGHLIGHT" ODER
"TESTIMONIAL"-KAMPAGNE.

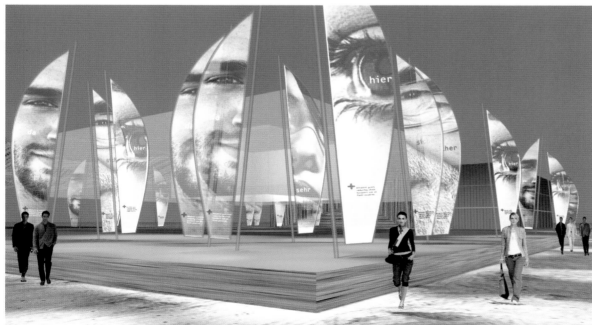

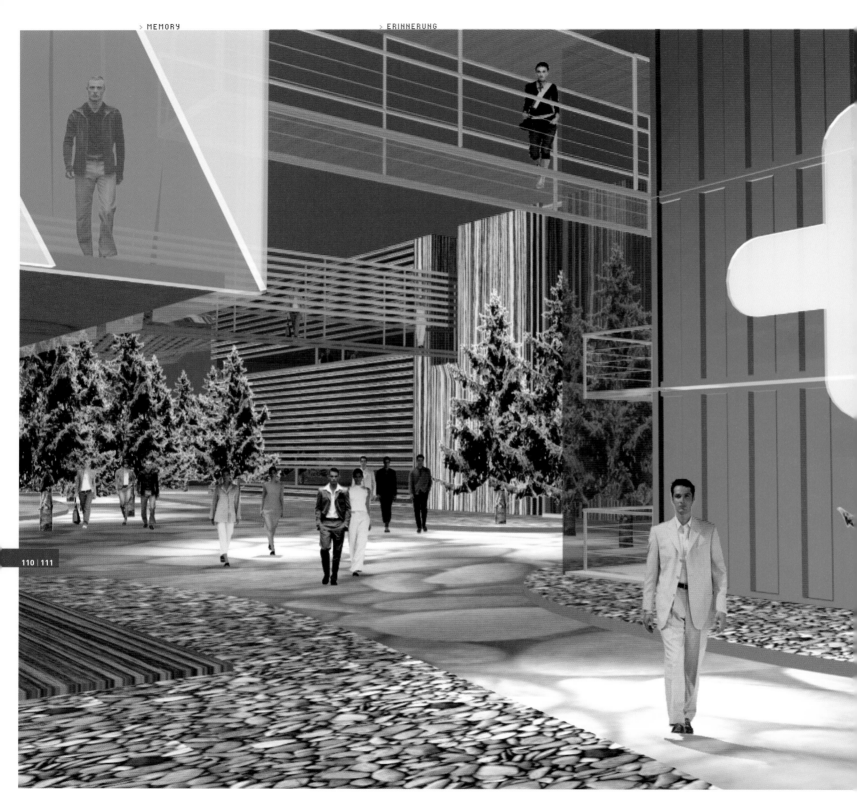

GOOD BOY

hend anders.

SERVIETTEN
STROHHALME
GESCHIRR

> THE ARCHITECTURE IS SIMPLE, TO BE TAKEN AT
FACE VALUE, AND FUNCTIONAL. GANGWAYS AND
BRIDGES BETWEEN THE INDIVIDUAL BUILDINGS FORM A
SECOND ACCESSIBLE LEVEL.

> DIE ARCHITEKTUR IST EINFACH, DIREKT ZU
VERSTEHEN UND FUNKTIONSORIENTIERT. GANGWAYS
UND BRÜCKEN ZWISCHEN DEN EINZELNEN GEBÄUDEN
BILDEN EINE ZWEITE ERSCHLIESSUNGSEBENE.

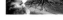

> THE AREA IN THE CENTRE OF THE PARK CONNECTS
THE INDIVIDUAL BUILDINGS AND PROVIDES INTEREST-
ING VIEWS OF THE INTERIOR AND EXTERIOR OF THE
CAMPUS-LIKE ARRANGEMENT.

> DER PLATZ IM ZENTRUM DES PARKS VERBINDET DIE
EINZELNEN GEBÄUDE UND BIETET INTERESSANTE EIN-
UND AUSBLICKE AUF DIE CAMPUSARTIGE ANLAGE.

> THE MEETING AREA STANDS FOR RELAXING TALKS IN
A HIGH-QUALITY ATMOSPHERE.

> DER MEETINGBEREICH STEHT FÜR ENTSPANNTE
GESPRÄCHE IN EINER HOCHWERTIGEN ATMOSPHÄRE.

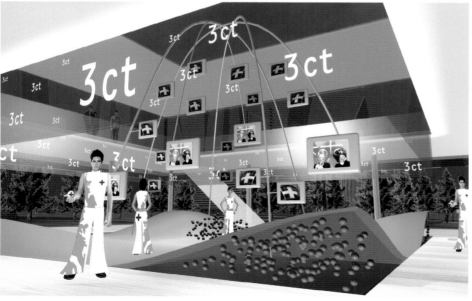

> THE TRANSPARENT ARENA IS THE FLASHY STAGE FOR PRODUCT PRESENTATION AND PROMOTIONAL EVENTS. THE ATRIUM OF THE ARENA PROVIDES SPACE ON TWO LEVELS FOR PRODUCT RANGE AND CUSTOMER ADVICE, ALONGSIDE PLAY AND FUN ACTIVITIES.

> DIE TRANSPARENTE ARENA IST DIE GLITZERNDE BÜHNE FÜR PRODUKTPRÄSENTATION UND PROMOTION-EVENTS. DAS ATRIUM DER ARENA BIETET AUF ZWEI EBENEN NEBEN SPIEL UND SPASS RAUM FÜR PRODUKTPALETTE UND BERATUNG.

> WHETHER AS A FOREST RANGER WITH DOG,
TOURIST CAMPER, JOGGER OR LITTLE GREEN RIDING
HOOD, CAMOUFLAGED PROMOTIONAL STAFF GUARANTEE
EXCITING ENCOUNTERS.

> ALS FÖRSTER MIT HUND, ZELTENDE TOURISTEN,
JOGGER ODER GRÜNKÄPPCHEN GETARNTES PROMOTION-
PERSONAL SORGT FÜR SPANNENDE BEGEGNUNGEN.

→ Do you believe in ghosts?
No, I don't – but I'm still kind of afraid of the dark if you tell me the right kind of story, to be honest [laughs] … and I'm not alone in that: as a family man I can give as much explanation as I want to my children, but the media remain stronger … [pause] But you still can do something that will work: use stories against stories. Goodnight stories for example.

tell in each kitchen: children's outdoor shoes, a mountain bike, and so on. And there would be a text by each, which would help the visitor imagine whom the person might be. Each of these leads the visitor into a different environment, offers them a way of thinking about the products in terms of people, not just appearance or technology. And this idea of inventing stories made the stand different from much of the competition, which were

"Sometimes it is easier to remember a story than a kitchen !"

Like the defence tactics against the shape-shifters called "boggarts" in those Harry Potter tomes?
I see we are aware of the same technical literature [laughs] … yes, it's like fighting the fire with fire. You shouldn't try to repress fears – remember the Shell 'Brent Spar' PR-disaster, for example. The good stories are always stronger than the stories of fear and terror.

Some time ago Walt Disney expressed his big concept "what we're selling is a belief in fantasy and storytelling". Can you see some similarities to your concept?
We find telling stories is a very useful tool. It's simply not enough just to present things in a nice way. We have to be aware that visitors have a lot of other things to look at, so we have to integrate them in some way – through touching something, through reading, through narrative, for example, so that they will remember afterwards.

Can you give an example of that approach?
Take the stand we designed for Alno for Eurocucina in Milan. The products – kitchens – are not very visible from the outside, but what can be seen are elements in the stories we

just saying, "Look how beautiful my products are". We were inviting the visitor to imagine whom the products might be for. Sometimes it is easier to remember a story than a kitchen!

And stories are much more handy to take with you than kitchens …
Yes, and they are even faster to transmit and – assuming you are not forgetful – can last longer than the visual memory of a kitchen. The visitor may be at the fair for one or two days, so it is very important to make the experience memorable, to make it work for a longer time than just the visit. Narrative is a powerful way of doing that, because it engages people's curiosity.

> JOCHEN HÖFFLER
BORN 1966, STUDIED INTERIOR DESIGN AT THE GESAMTHOCHSCHULE WUPPERTAL, MEMBER OF THE D'ART DESIGN GRUPPE MANAGEMENT, MEMBER OF THE FDA (FORUM DESIGN UND ARCHITEKTUR), TEACHER AT THE PETER BEHRENS SCHOOL OF ARCHITECTURE (PBSA) IN DÜSSELDORF

»Manchmal erinnert man sich doch eher an eine Geschichte als an das Aussehen einer Küche!«

> JOCHEN HÖFFLER

JAHRGANG 1966, STUDIUM
DER INNENARCHITEKTUR
AN DER GESAMTHOCH-
SCHULE WUPPERTAL,
MITGLIED DER GESCHÄFTS-
FÜHRUNG DER D'ART
DESIGN GRUPPE, MITGLIED
IM FORUM DESIGN UND
ARCHITEKTUR (FDA),
LEHRTÄTIGKEIT AN DER
PETER BEHRENS SCHOOL
OF ARCHITECTURE (PBSA)
IN DÜSSELDORF

→ **Glauben Sie an Geister?**

Nein – aber wenn Sie mir die richtige Geschichte erzählen, habe ich, ehrlich gesagt, immer noch ein bisschen Angst im Dunkeln [lacht] … und damit bin ich nicht allein: als Familienvater kann ich meinen Kindern so viel erklären, wie ich will, die Medien bleiben stärker … [Pause] Aber eins funktioniert trotzdem: Geschichten gegen die Geschichten einsetzen. Gutenacht-Geschichten zum Beispiel.

Wie die Verteidigungsstrategien gegen die Gestaltwandler, genannt »Irrwichte«, bei Harry Potter?

Offensichtlich haben wir dieselbe Fachliteratur gelesen [lacht] … ja, als ob man das Feuer mit Feuer bekämpft. Man soll Ängste nicht zu unterdrücken versuchen – denken Sie nur an das PR-Desaster für Shell wegen der Brent Spar. Gute Geschichten sind immer stärker als Geschichten von Angst und Terror.

Walt Disney stellte sein Konzept einmal so dar: »Was wir verkaufen, ist der Glaube an die Phantasie und ans Geschichtenerzählen.« Sehen Sie da Ähnlichkeiten zu Ihrem Konzept?

Wir empfinden das Geschichtenerzählen als sehr brauchbares Werkzeug. Es reicht einfach nicht, Dinge nur hübsch zu präsentieren. Wir müssen bedenken, dass die Besucher noch jede Menge anderes zu betrachten haben, also müssen wir sie irgendwie einbeziehen – indem sie etwas anfassen oder lesen, indem wir ihnen etwas erzählen, zum Beispiel, damit sie sich später daran erinnern.

Können Sie ein Beispiel für diesen Ansatz nennen?

Der Stand für Alno auf der Eurocucina in Mailand. Das Produkt – Küchen – ist von außen nicht besonders gut sichtbar; was man sieht, sind Elemente der Geschichten, die wir in den einzelnen Küchen erzählen: Kinderschuhe, ein Mountainbike und so weiter. Dazu gab es jeweils einen Text, der dem Besucher half, sich die entsprechende Person vorzustellen. Er wird jedes Mal in eine andere Umgebung geführt und erhält so die Möglichkeit, über das Produkt in Bezug auf die Menschen nachzudenken, nicht nur auf das Aussehen oder die Technik. Durch die Idee, Geschichten zu erfinden, unterschied der Stand sich von einem Großteil der Ausstellung, der lediglich sagte: »Guckt mal, wie schön meine Produkte sind«. Wir haben den Besucher eingeladen sich vorzustellen, für wen die Produkte gemacht sind. Manchmal erinnert man sich doch eher an eine Geschichte als an das Aussehen einer Küche!

Und Geschichten kann man auch viel besser mitnehmen als Küchen …

Ja, außerdem sind sie schneller zu übermitteln, und sie bleiben – wenn man nicht allzu vergesslich ist – länger bei einem als die visuelle Erinnerung an eine Küche. Der Besucher ist vielleicht ein oder zwei Tage auf der Messe, daher ist es sehr wichtig, die Erfahrung einprägsam zu gestalten, damit sie länger anhält als der eigentliche Besuch. Geschichten sind eine sehr wirksame Möglichkeit dafür, weil sie die Neugier der Leute wecken.

NARRATIVE \
HÖRENSAGEN

→ Memory is one of the most complex functions in the animal and human world: what is it that drives a salmon after three years in the ocean back to the river in which it was spawned? What was it in the madeleine that prompted Proust to write thirteen volumes? We all have our moments of memory: a colour, a smell, a sound can unexpectedly evoke our remembrance of a scene, a moment, a person. In parallel with these unexpected memories are more tangible ones, that we can invoke by a deliberate effort.

Very often the deliberate process (as opposed to the "unconscious" one) uses narrative as a trigger: "what did X say when I met him in the corridor?", "how long did it take to get to Y?" and so on. So a designer who wishes to create memory as an outcome can always use narrative as a tool.

As an example, take a project D'art developed for a car producer some time ago. Buyers of new cars, then as now, had the option of collecting their vehicles from the factory: before collection, they were invited to tour the factory, to check out that vorsprung was indeed durch technik. What the client wanted were some modules to help guide the visitor around. The conventional answer would have been panels or monitors explaining the different stages of the manufacturing process, the quality control and so on. What D'art proposed was not that.

The visit started in a darkened room, where the only element was the presenter's voice. This told the listeners the story of an anonymous new owner, and how he had come to the factory to collect his car, and what his reasons for doing so were and what his future expectations were also. In sum, it created a narrative that the listeners could identify with and use as a model for remembering their own experiences.

→ Die Erinnerung ist eine der kompliziertesten Funktionen in der tierischen und menschlichen Welt: Was ist es, das einen Lachs nach drei Jahren im Meer wieder in den Fluss treibt, in dem er gelaicht wurde? Was war es in den Madeleines, das Proust veranlasste, dreizehn Bände zu schreiben? Wir alle haben unsere Momente der Erinnerung. Eine Farbe, ein Duft, ein Ton kann unerwartet Erinnerungen an eine Begebenheit, einen Augenblick, eine Person wachrufen. Und neben diesen unerwarteten Erinnerungen liegen greifbarere, die wir bewusst hervorrufen können.

Dieses bewusste Erinnern hat (im Gegensatz zum »unbewussten«) oft eine Geschichte als Auslöser: »Was hat X gesagt, als ich ihn auf dem Flur traf?«, »Wie lange haben wir nach Y gebraucht?« und so weiter. Ein Gestalter, der als Ergebnis Erinnerungen produzieren möchte, kann daher immer eine Geschichte als Instrument einsetzen.

Als Beispiel sei ein Projekt genannt, das D'art vor einiger Zeit für einen Automobilhersteller entwickelte. Wer ein neues Auto kauft, hatte damals wie heute die Möglichkeit, es direkt in der Fabrik abzuholen. Zuvor ist der Kunde eingeladen, die Fabrik zu besichtigen, sich zu vergewissern, dass Vorsprung tatsächlich durch Technik kommt. Der Kunde wollte einige Module, die den Besucher an verschiedenen Stationen informierten. Die konventionelle Lösung wären Tafeln oder Monitore gewesen, die die einzelnen Produktionsschritte, die Qualitätskontrolle etc. erklären. Aber D'art schlug etwas anderes vor.

Der Besuch begann in einem abgedunkelten Raum, dessen einziges Element eine Stimme war. Sie erzählte den Besuchern die Geschichte eines anonymen Neuwagen-Besitzers, wie er zur Autofabrik kommt, um seinen Wagen abzuholen, warum er das tut, und was ihn in Zukunft erwartet. Es wird also eine Geschichte erzählt, mit der der Besucher sich identifiziert und die er als Vorlage für die Erinnerung an seine eigenen Erfahrungen verwenden kann.

Es handelt sich hier um eine unstrukturierte Erzählung, im Gegensatz zur Erzähllinie in einem Film oder Schauspiel, wo der Besucher »seinen Unglauben ablegen« und in die Realität der Fiktion eintauchen soll. Hier fungiert die

This is a form of unstructured narrative, as it were, as compared to the narrative line in a film or stage play where the viewer is expected to "suspend their disbelief" and accept the reality of the fiction. Here narrative acts as a pathway, a set of directional signals that encourages the participant to remember but does not seek to condition or control the resulting memory. It is not so much drama as fiction, where readers have the space and opportunity to disengage, or to adopt their own views about the action. It is a more complex project, but by enabling users to apply it for themselves, it is a much more powerful method of evoking memory.

Erzählung als Pfad, als eine Reihe von Wegweisern, die den Teilnehmer zum Erinnern ermutigen, aber die entstehende Erinnerung nicht beeinflussen oder kontrollieren wollen. Es ist weniger ein Schauspiel als vielmehr ein Roman, in dem der Leser den Raum und die Möglichkeit hat, sich davon zu lösen oder seine eigenen Ansichten zum Geschehen zu entwickeln. Es ist ein komplexeres Projekt; aber indem man dem Benutzer ermöglicht, es auf sich selbst anzuwenden, ist es auch viel geeigneter, in Erinnerung zu bleiben.

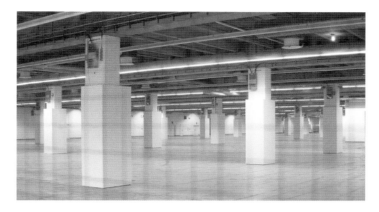

> IN 1991 THE OFFICIAL STORY OF THE D'ART DESIGN GRUPPE
BEGAN IN HALL 8 OF THE FRANKFURT TRADE FAIR: WITH THE
FIRST APPEARANCE IN MARKETING SERVICES.

> IN HALLE 8 DER FRANKFURTER MESSE "BEGINNT"
1991 DIE OFFIZIELLE GESCHICHTE DER D'ART DESIGN GRUPPE:
MIT DEM ERSTEN AUFTRITT AUF DER MARKETING SERVICES.

IMPOSSIBLE IS NOTHING \
ADI DASSLER BRAND CENTER

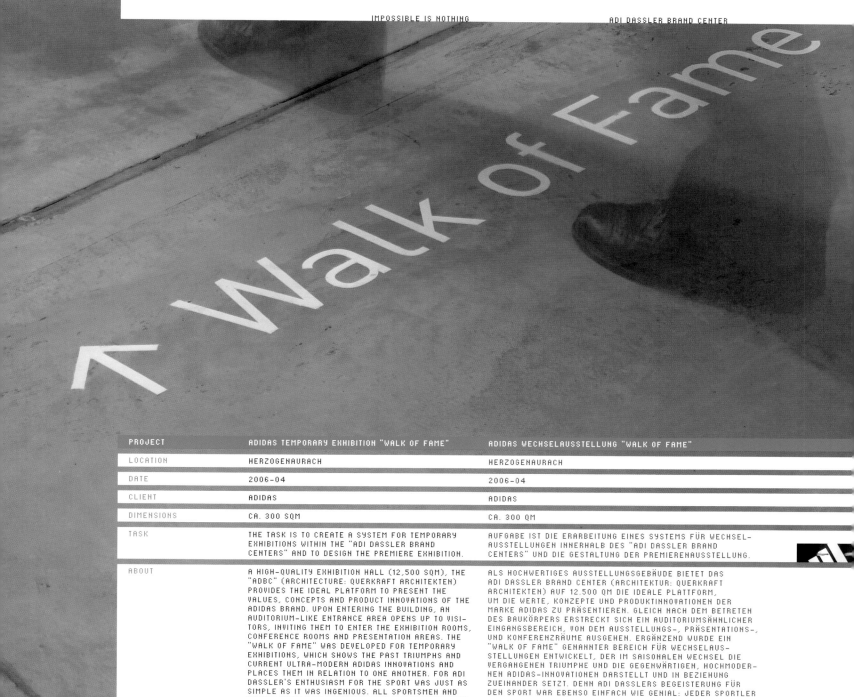

↗ Walk of Fame

PROJECT	ADIDAS TEMPORARY EXHIBITION "WALK OF FAME"	ADIDAS WECHSELAUSSTELLUNG "WALK OF FAME"
LOCATION	HERZOGENAURACH	HERZOGENAURACH
DATE	2006-04	2006-04
CLIENT	ADIDAS	ADIDAS
DIMENSIONS	CA. 300 SQM	CA. 300 QM
TASK	THE TASK IS TO CREATE A SYSTEM FOR TEMPORARY EXHIBITIONS WITHIN THE "ADI DASSLER BRAND CENTERS" AND TO DESIGN THE PREMIERE EXHIBITION.	AUFGABE IST DIE ERARBEITUNG EINES SYSTEMS FÜR WECHSEL-AUSSTELLUNGEN INNERHALB DES "ADI DASSLER BRAND CENTERS" UND DIE GESTALTUNG DER PREMIERENAUSSTELLUNG.
ABOUT	A HIGH-QUALITY EXHIBITION HALL (12,500 SQM), THE "ADBC" (ARCHITECTURE: QUERKRAFT ARCHITEKTEN) PROVIDES THE IDEAL PLATFORM TO PRESENT THE VALUES, CONCEPTS AND PRODUCT INNOVATIONS OF THE ADIDAS BRAND. UPON ENTERING THE BUILDING, AN AUDITORIUM-LIKE ENTRANCE AREA OPENS UP TO VISITORS, INVITING THEM TO ENTER THE EXHIBITION ROOMS, CONFERENCE ROOMS AND PRESENTATION AREAS. THE "WALK OF FAME" WAS DEVELOPED FOR TEMPORARY EXHIBITIONS, WHICH SHOWS THE PAST TRIUMPHS AND CURRENT ULTRA-MODERN ADIDAS INNOVATIONS AND PLACES THEM IN RELATION TO ONE ANOTHER. FOR ADI DASSLER'S ENTHUSIASM FOR THE SPORT WAS JUST AS SIMPLE AS IT WAS INGENIOUS. ALL SPORTSMEN AND WOMEN SHOULD BE EQUIPPED WITH THE OPTIMUM GEAR FOR THEIR NEEDS, ENABLING THEM TO GIVE THEIR VERY BEST PERFORMANCE. THUS AT THE PREMIERE, THE EXHIBITION IS ALSO DEDICATED PREDOMINANTLY TO THE NUMEROUS EXAMPLES OF THE SPECTACULAR SUCCESSES OF THIS PHILOSOPHY OF THE FOUNDER, ADI DASSLER.	ALS HOCHWERTIGES AUSSTELLUNGSGEBÄUDE BIETET DAS ADI DASSLER BRAND CENTER (ARCHITEKTUR: QUERKRAFT ARCHITEKTEN) AUF 12.500 QM DIE IDEALE PLATTFORM, UM DIE WERTE, KONZEPTE UND PRODUKTINNOVATIONEN DER MARKE ADIDAS ZU PRÄSENTIEREN. GLEICH NACH DEM BETRETEN DES BAUKÖRPERS ERSTRECKT SICH EIN AUDITORIUMSÄHNLICHER EINGANGSBEREICH, VON DEM AUSSTELLUNGS-, PRÄSENTATIONS-, UND KONFERENZRÄUME AUSGEHEN. ERGÄNZEND WURDE EIN "WALK OF FAME" GENANNTER BEREICH FÜR WECHSELAUS-STELLUNGEN ENTWICKELT, DER IM SAISONALEN WECHSEL DIE VERGANGENEN TRIUMPHE UND DIE GEGENWÄRTIGEN, HOCHMODER-NEN ADIDAS-INNOVATIONEN DARSTELLT UND IN BEZIEHUNG ZUEINANDER SETZT. DENN ADI DASSLERS BEGEISTERUNG FÜR DEN SPORT WAR EBENSO EINFACH WIE GENIAL: JEDER SPORTLER SOLLTE MIT DEM FÜR IHN OPTIMALEN EQUIPMENT AUSGERÜSTET WERDEN, DAS IHN ZU SEINEN BESTLEISTUNGEN BEFÄHIGT. SO WIDMET SICH DER "WALK OF FAME" BEI DER PREMIERE THEMATISCH AUCH ÜBERWIEGEND DEN ZAHLREICHEN BEISPIELEN FÜR DIE SPEKTAKULÄREN ERFOLGE DIESER PHILOSOPHIE DES FIRMENGRÜNDERS ADI DASSLER.

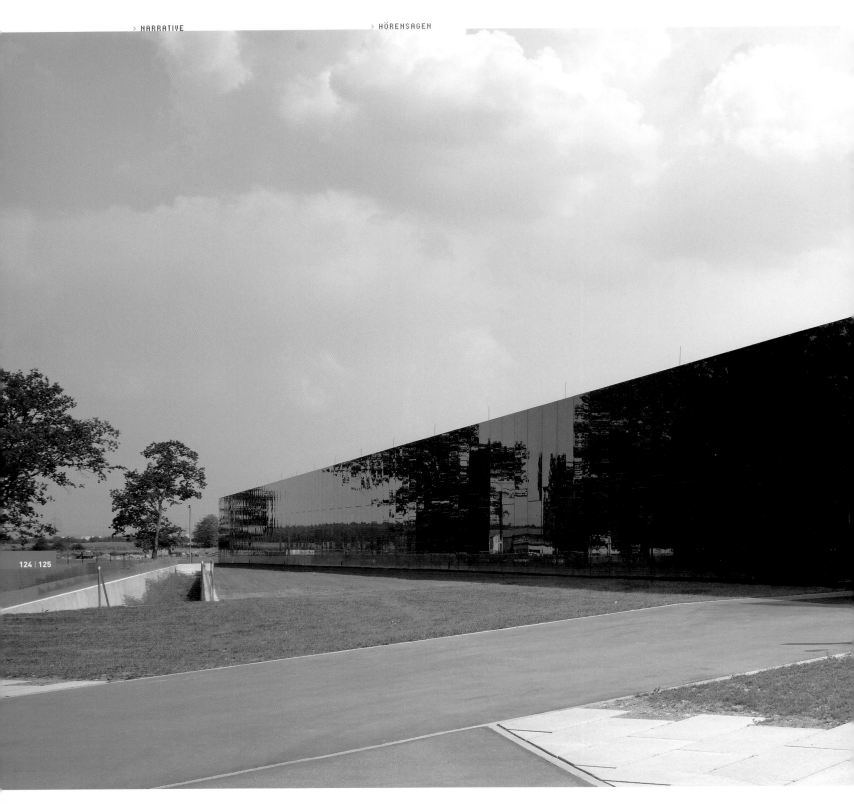

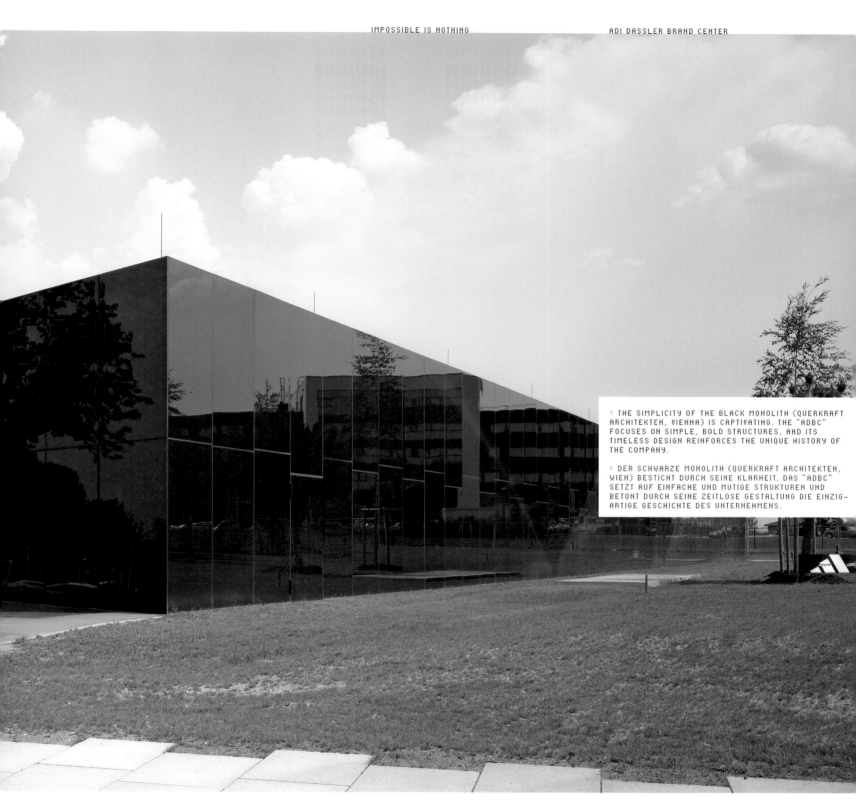

> THE SIMPLICITY OF THE BLACK MONOLITH (QUERKRAFT ARCHITEKTEN, VIENNA) IS CAPTIVATING. THE "ADBC" FOCUSES ON SIMPLE, BOLD STRUCTURES, AND ITS TIMELESS DESIGN REINFORCES THE UNIQUE HISTORY OF THE COMPANY.

> DER SCHWARZE MONOLITH (QUERKRAFT ARCHITEKTEN, WIEN) BESTICHT DURCH SEINE KLARHEIT. DAS "ADBC" SETZT AUF EINFACHE UND MUTIGE STRUKTUREN UND BETONT DURCH SEINE ZEITLOSE GESTALTUNG DIE EINZIG-ARTIGE GESCHICHTE DES UNTERNEHMENS.

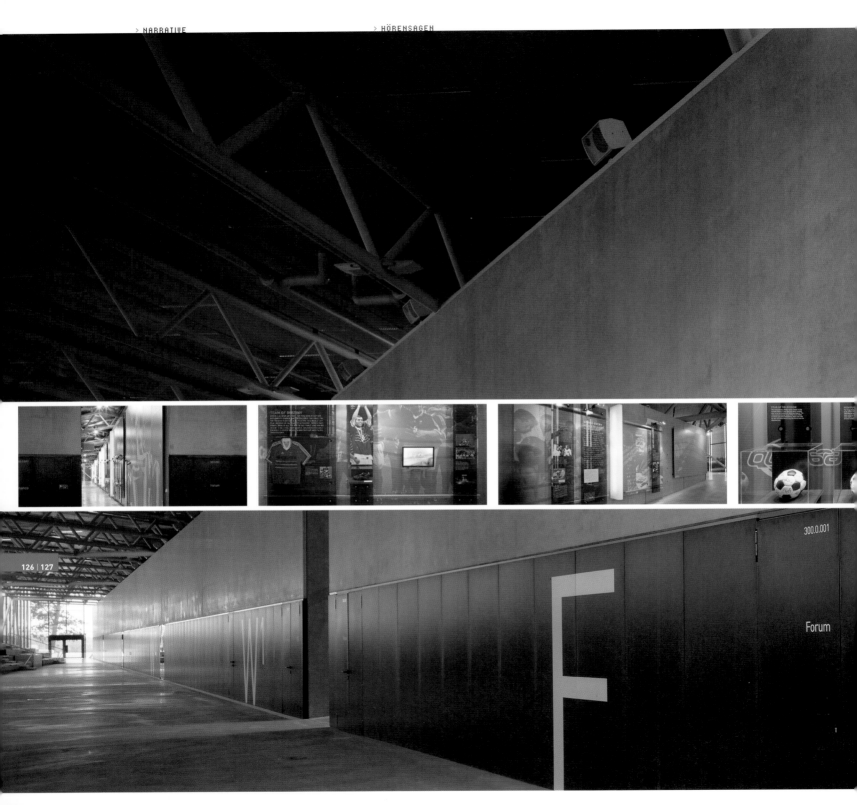

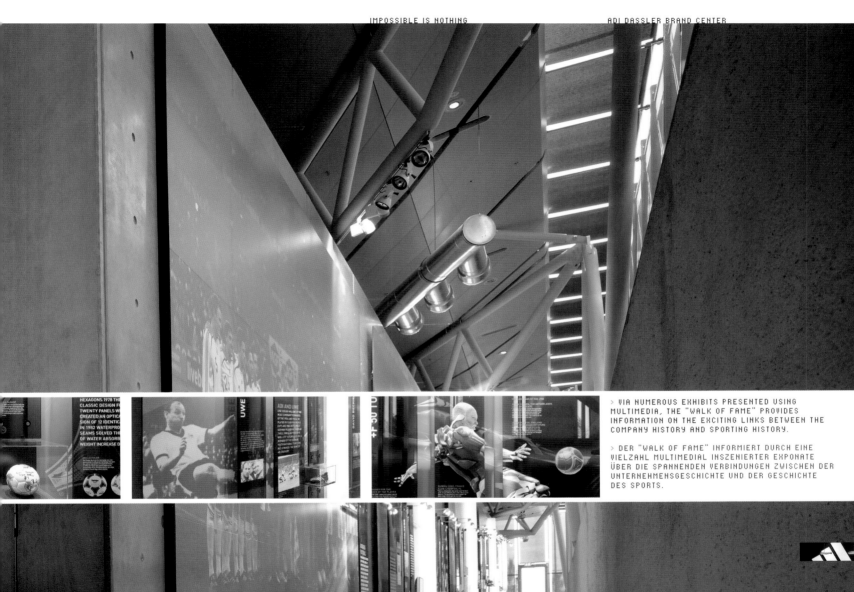

> VIA NUMEROUS EXHIBITS PRESENTED USING MULTIMEDIA, THE "WALK OF FAME" PROVIDES INFORMATION ON THE EXCITING LINKS BETWEEN THE COMPANY HISTORY AND SPORTING HISTORY.

> DER "WALK OF FAME" INFORMIERT DURCH EINE VIELZAHL MULTIMEDIAL INSZENIERTER EXPONATE ÜBER DIE SPANNENDEN VERBINDUNGEN ZWISCHEN DER UNTERNEHMENSGESCHICHTE UND DER GESCHICHTE DES SPORTS.

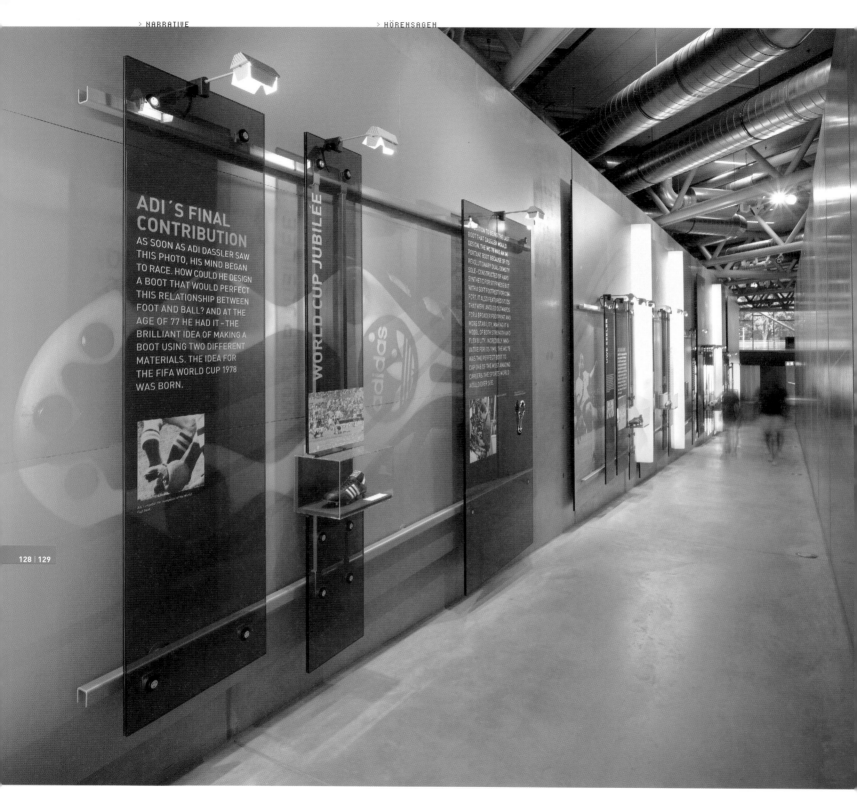

ADI´S FINAL CONTRIBUTION

AS SOON AS ADI DASSLER SAW THIS PHOTO, HIS MIND BEGAN TO RACE. HOW COULD HE DESIGN A BOOT THAT WOULD PERFECT THIS RELATIONSHIP BETWEEN FOOT AND BALL? AND AT THE AGE OF 77 HE HAD IT – THE BRILLIANT IDEA OF MAKING A BOOT USING TWO DIFFERENT MATERIALS. THE IDEA FOR THE FIFA WORLD CUP 1978 WAS BORN.

WORLD-CUP JUBILÉE

> UNLIKE ANY OTHER SPORTS ARTICLE MANUFAC-
TURER, THE HISTORY OF ADIDAS HAS VERY CLOSE
CONNECTIONS WITH SPORTING HISTORY. THE TWO
NARRATIVE THREADS ARE REPRESENTED BY TWO
DIFFERENT "LOW LEVELS" AND INTERWOVEN OVER
A TOTAL LENGTH OF CA. 120 METRES.

> DIE GESCHICHTE VON ADIDAS IST, WIE BEI KEINEM
ANDEREN SPORTARTIKELHERSTELLER, SEHR ENG MIT
DER SPORTHISTORIE VERBUNDEN. DIE BEIDEN ERZÄHL-
STRÄNGE WERDEN DURCH ZWEI UNTERSCHIEDLICHE
"TIEFENEBENEN" REPRÄSENTIERT UND AUF EINER
GESAMTLÄNGE VON CA. 120 METERN MITEINANDER
VERWOBEN.

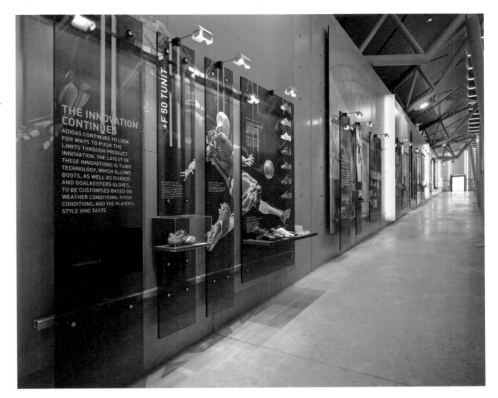

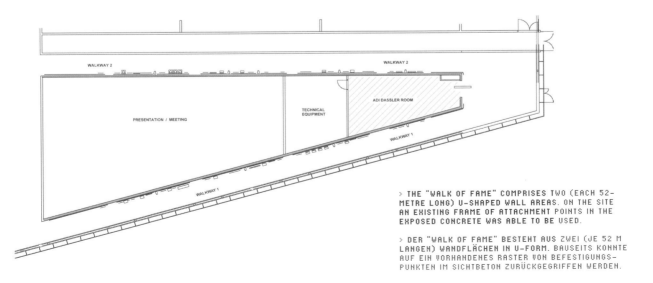

> THE "WALK OF FAME" COMPRISES TWO (EACH 52-
METRE LONG) U-SHAPED WALL AREAS. ON THE SITE
AN EXISTING FRAME OF ATTACHMENT POINTS IN THE
EXPOSED CONCRETE WAS ABLE TO BE USED.

> DER "WALK OF FAME" BESTEHT AUS ZWEI (JE 52 M
LANGEN) WANDFLÄCHEN IN U-FORM. BAUSEITS KONNTE
AUF EIN VORHANDENES RASTER VON BEFESTIGUNGS-
PUNKTEN IM SICHTBETON ZURÜCKGEGRIFFEN WERDEN.

> THE "HEART" OF THE EXHIBITION IS THE "ADI
DASSLER ROOM" RESERVED FOR VIP GUESTS. THIS IS,
AS IT WERE, THE SOURCE, THE ORIGIN OF A "WORLD
OF SPORTS" – HERE THE SPIRIT OF THE COMPANY
FOUNDER IS POSITIVELY TANGIBLE IN THE AIR.

> DAS "HERZSTÜCK" DER AUSSTELLUNG IST DER VIP-
GÄSTEN VORBEHALTENE "ADI DASSLER RAUM". HIER
IST SOZUSAGEN DIE QUELLE, DER AUSGANGSPUNKT
FÜR EINE "WORLD OF SPORTS" – HIER LIEGT DER
SPIRIT DES FIRMENGRÜNDERS FÖRMLICH "GREIFBAR"
IN DER LUFT.

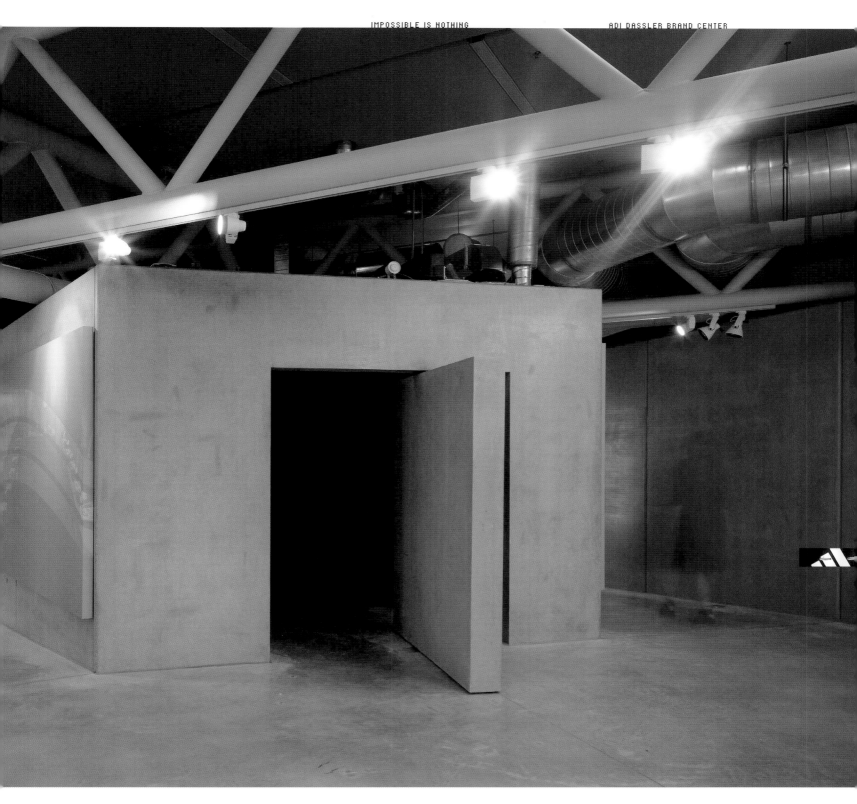

HIGH TOUCH \
EIN PLUS VERBINDET

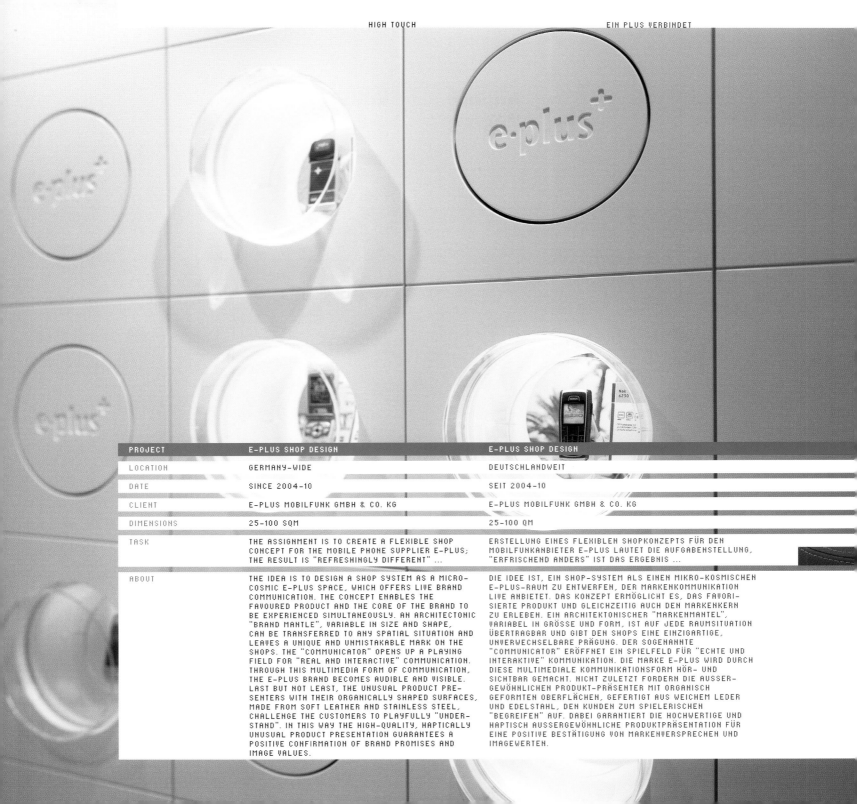

PROJECT	E-PLUS SHOP DESIGN	E-PLUS SHOP DESIGN
LOCATION	GERMANY-WIDE	DEUTSCHLANDWEIT
DATE	SINCE 2004-10	SEIT 2004-10
CLIENT	E-PLUS MOBILFUNK GMBH & CO. KG	E-PLUS MOBILFUNK GMBH & CO. KG
DIMENSIONS	25-100 SQM	25-100 QM
TASK	THE ASSIGNMENT IS TO CREATE A FLEXIBLE SHOP CONCEPT FOR THE MOBILE PHONE SUPPLIER E-PLUS; THE RESULT IS "REFRESHINGLY DIFFERENT" ...	ERSTELLUNG EINES FLEXIBLEN SHOPKONZEPTS FÜR DEN MOBILFUNKANBIETER E-PLUS LAUTET DIE AUFGABENSTELLUNG, "ERFRISCHEND ANDERS" IST DAS ERGEBNIS ...
ABOUT	THE IDEA IS TO DESIGN A SHOP SYSTEM AS A MICRO-COSMIC E-PLUS SPACE, WHICH OFFERS LIVE BRAND COMMUNICATION. THE CONCEPT ENABLES THE FAVOURED PRODUCT AND THE CORE OF THE BRAND TO BE EXPERIENCED SIMULTANEOUSLY. AN ARCHITECTONIC "BRAND MANTLE", VARIABLE IN SIZE AND SHAPE, CAN BE TRANSFERRED TO ANY SPATIAL SITUATION AND LEAVES A UNIQUE AND UNMISTAKABLE MARK ON THE SHOPS. THE "COMMUNICATOR" OPENS UP A PLAYING FIELD FOR "REAL AND INTERACTIVE" COMMUNICATION. THROUGH THIS MULTIMEDIA FORM OF COMMUNICATION, THE E-PLUS BRAND BECOMES AUDIBLE AND VISIBLE. LAST BUT NOT LEAST, THE UNUSUAL PRODUCT PRE-SENTERS WITH THEIR ORGANICALLY SHAPED SURFACES, MADE FROM SOFT LEATHER AND STAINLESS STEEL, CHALLENGE THE CUSTOMERS TO PLAYFULLY "UNDER-STAND". IN THIS WAY THE HIGH-QUALITY, HAPTICALLY UNUSUAL PRODUCT PRESENTATION GUARANTEES A POSITIVE CONFIRMATION OF BRAND PROMISES AND IMAGE VALUES.	DIE IDEE IST, EIN SHOP-SYSTEM ALS EINEN MIKRO-KOSMISCHEN E-PLUS-RAUM ZU ENTWERFEN, DER MARKENKOMMUNIKATION LIVE ANBIETET. DAS KONZEPT ERMÖGLICHT ES, DAS FAVORI-SIERTE PRODUKT UND GLEICHZEITIG AUCH DEN MARKENKERN ZU ERLEBEN. EIN ARCHITEKTONISCHER "MARKENMANTEL", VARIABEL IN GRÖSSE UND FORM, IST AUF JEDE RAUMSITUATION ÜBERTRAGBAR UND GIBT DEN SHOPS EINE EINZIGARTIGE, UNVERWECHSELBARE PRÄGUNG. DER SOGENANNTE "COMMUNICATOR" ERÖFFNET EIN SPIELFELD FÜR "ECHTE UND INTERAKTIVE" KOMMUNIKATION. DIE MARKE E-PLUS WIRD DURCH DIESE MULTIMEDIALE KOMMUNIKATIONSFORM HÖR- UND SICHTBAR GEMACHT. NICHT ZULETZT FORDERN DIE AUSSER-GEWÖHNLICHEN PRODUKT-PRÄSENTER MIT ORGANISCH GEFORMTEN OBERFLÄCHEN, GEFERTIGT AUS WEICHEM LEDER UND EDELSTAHL, DEN KUNDEN ZUM SPIELERISCHEN "BEGREIFEN" AUF. DABEI GARANTIERT DIE HOCHWERTIGE UND HAPTISCH AUSSERGEWÖHNLICHE PRODUKTPRÄSENTATION FÜR EINE POSITIVE BESTÄTIGUNG VON MARKENVERSPRECHEN UND IMAGEWERTEN.

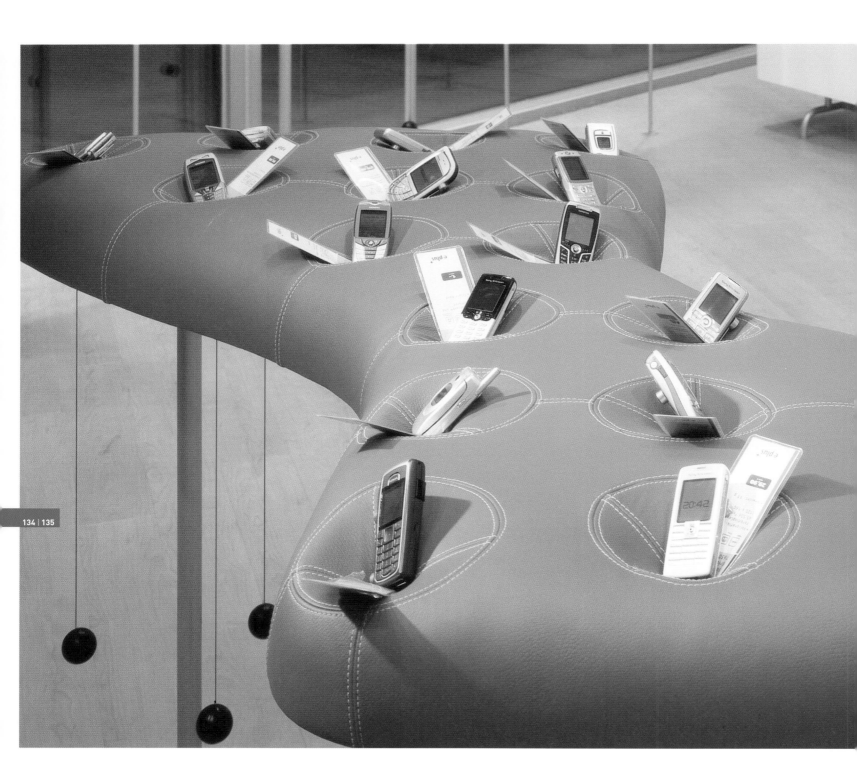

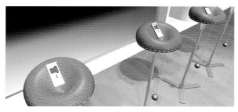

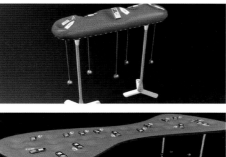

> THE BROAD SPECTRUM OF PRESENTATION FURNITURE COMPRISES "MOBILE POINTS", MOBILE LINES", AND "MOBILE POOLS". THE PRODUCTS ARE SECURED WITH STEEL WIRES AND RUBBER BALLS ACTING AS COUNTER WEIGHTS (THE FUN STOPS HERE ...).

> DAS BREITE SPEKTRUM DER PRÄSENTATIONSMÖBEL BESTEHT AUS "HANDYPOINTS", "HANDYLINES" UND "HANDYPOOLS". DIE PRODUKTE WERDEN DURCH STAHLSEILE UND GUMMIKUGELN ALS GEGENGEWICHTE GESICHERT (DA HÖRT DER SPASS DANN AUF ...)

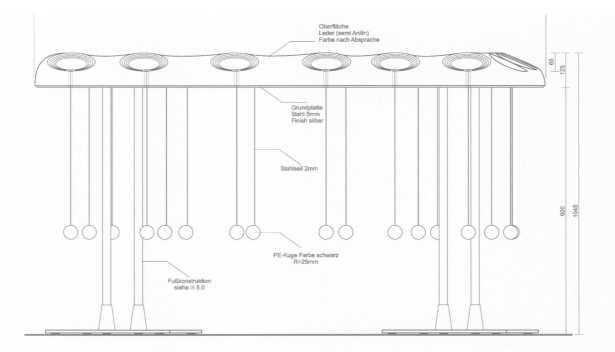

Oberfläche
Leder (semi Anilin)
Farbe nach Absprache

Grundplatte
Stahl 5mm
Finish silber

Stahlseil 2mm

PE-Kuge Farbe schwarz
R=25mm

Fußkonstruktion
siehe ⊕ 5.0

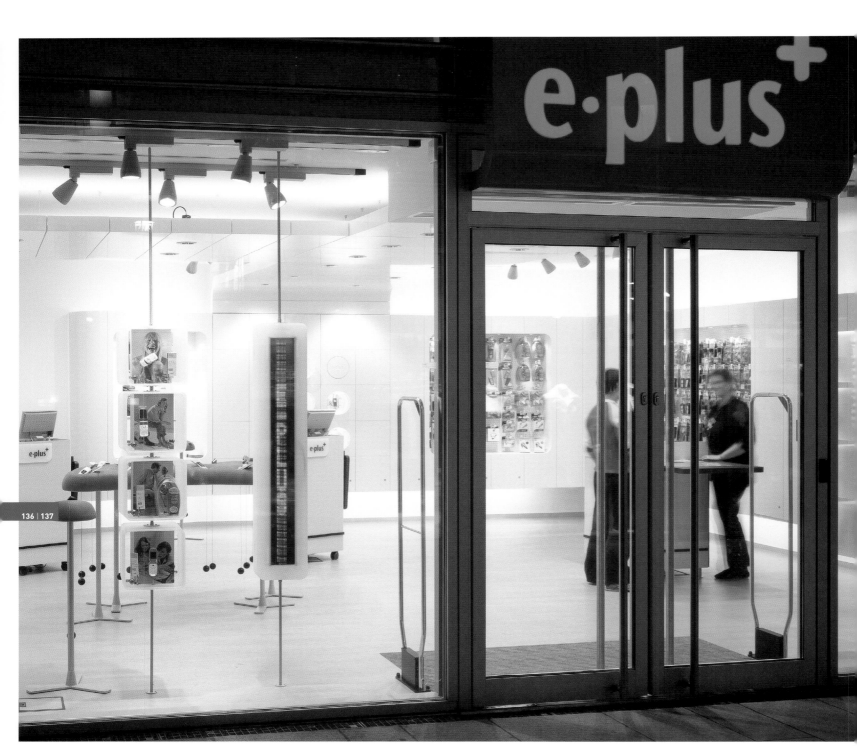

136 | 137

> THE VARIABLY SEGMENTED "BRAND MANTLE"
PRODUCES A DISTINCTIVE SPATIAL BRANDING.

> DER VARIABEL SEGMENTIERTE "MARKENMANTEL"
ERZEUGT EIN EINDEUTIGES RAUMBRANDING.

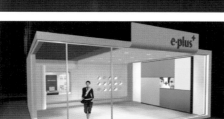

> THE SYSTEMATIC NATURE OF THE WALL ELEMENTS
PROVIDES THE SPACE WITH STRUCTURE AND
INTEGRATES THE PRODUCTS ON OFFER: SERVICE,
ACCESSORIES AND MOBILE HIGHLIGHTS.

> DIE SYSTEMATIK DER WANDELEMENTE STRUKTURIERT
DEN RAUM UND INTEGRIERT DIE ANGEBOTE: SERVICE,
ZUBEHÖR UND HIGHLIGHT-HANDYS.

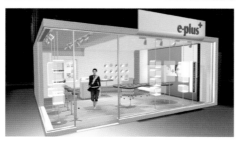

> UNUSUAL PRODUCT PRESENTATIONS HIGHLIGHT THE
PREMIUM DEMAND.

> AUSSERGEWÖHNLICHE PRODUKTPRÄSENTATIONEN
UNTERSTREICHEN DEN PREMIUM-ANSPRUCH.

> THE INTERACTIVE "COMMUNICATOR" ELEMENT
ENCOURAGES CUSTOMERS TO PLAY OR CHAT.

> DAS INTERAKTIVE "COMMUNICATOR"-ELEMENT
ANIMIERT ZUM SPIELEN ODER CHATTEN.

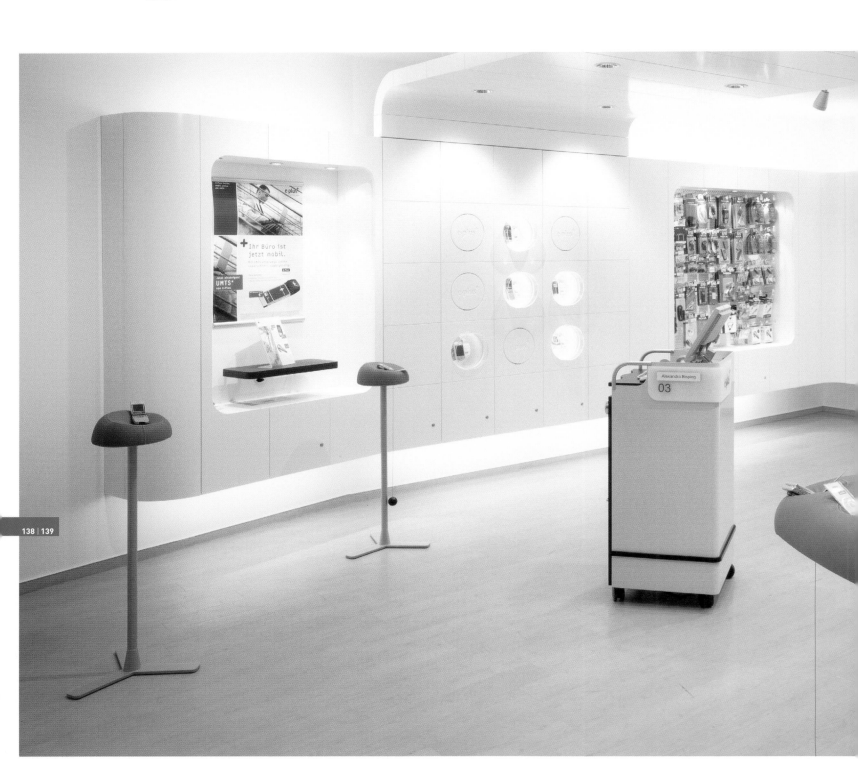

> THE PLAYFULLY SIMPLE APPROACH TO THE "OBJECT
OF DESIRE" WAS ENTHUSIASTICALLY RECEIVED.

> DER SPIELERISCH EINFACHE ZUGANG ZUM "OBJEKT
DER BEGIERDE" WURDE BEGEISTERT ANGENOMMEN.

> FOR THE IMPORTANT PERSONAL TALK, SMALLER
MOBILE UNITS, THE TROLLEYS, REPLACE THE CLASSIC
SALES COUNTERS. EVERY MEMBER OF STAFF HAS
THEIR OWN TROLLEY ON WHICH THEIR NAME IS
CLEARLY MARKED.

> FÜR DAS WICHTIGE PERSÖNLICHE GESPRÄCH WIRD
DIE KLASSISCHE VERKAUFSTHEKE DURCH KLEINERE
MOBILE EINHEITEN, DIE "TROLLEYS", ERSETZT. JEDER
MITARBEITER HAT EINEN EIGENEN TROLLEY MIT
DEUTLICHER NAMENSKENNZEICHNUNG.

"... nobody is really interested in a conversation dominated by one partner."

→ **Visitors to trade fairs and exhibitions are normally only confronted with what is – hopefully – the perfect result of a long-term process. How much of it originates on site?**

Well, obviously we do not create things at a scale of 1:1 off site, but there is of course always a certain percentage within complex projects that cannot be foreseen in every detail. By the way that's just what makes them so interesting, I think. [smiling] In trying to create something new you will always have to look out for surprises. Add to that the fact that a high number of our projects are not using or intended for serial production; they are mostly very individual designs. Therefore it's nearly always "the first time" when we translate an idea into practice.

Well, let me specify the question then: which part of a project can't be planned in every detail?

You can't foresee the interaction of the visitors in detail. That's the basic idea of live communication: to create dialogue. And that is something with an open result. Not something you will have full control over. If you try to, you will have counter-productive effects because nobody is really interested in a conversation dominated by one partner. Hence the planning is more like a projection based on a certain amount of data mixed with a bit of know-how.

"Learning by doing" as opposed to "implementing programmes", then?

Yes, and we are not oracles, we are very much into action. Unless the idea is not tested or realized we are not really satisfied. Successful application is always the aim, not just a good concept. To promise someone the earth is the easy part of it – to make it true is poles apart. An element of risk always remains. To give you a little example: whilst installing the Horst balloons we did foresee they might get punched or pulled and therefore had a special connector developed. We had plenty of backup balloons and did some tests on how to refill them inconspicuously if necessary. What we didn't think of was that the stand, due to its even floor, became very popular with groups of inline-skaters, who developed the habit of speeding along underneath the balloons. And they had the tendency to collide with another group of people that posed among the balloons to take photographs of themselves with their favourite balloon. Such is life.

So you could say, an approach to the basic human instincts is more promising than complicated communication tactics?

Yes, [laughing] people are looking for great experiences: playful things and emotional adventures touching their souls. One of my principles is that everything I do goes straight to the visitor, to his or her mind or soul. Don't forget either, within the daily endless downpour of information you only have seconds to make a difference. And it improves your chances a lot if you are really willing to communicate with "tender loving care" with the visitors rather than seeing them just as talking credit cards.

> NINA WIEMER

BORN 1976, STUDIED INTERIOR DESIGN AT THE FACHHOCHSCHULE LIPPE/ HÖXTER, INDEPENDENT MEMBER OF THE GIRLIE-FLITZER-GLITZER-BLING-BLING-DING (GFGBBD)

> NINA WIEMER

JAHRGANG 1976, STUDIUM
INNENARCHITEKTUR AN
DER FACHHOCHSCHULE
LIPPE/HÖXTER,
UNABHÄNGIGES MITGLIED
IM GIRLIE-FLITZER-
GLITZER-BLING BLING-
DING (GFGBBD)

→ Messe- und Ausstellungsbesucher stehen normalerweise vor etwas, das – hoffentlich – das perfekte Ergebnis eines langwierigen Prozesses ist. Wie viel davon ergibt sich erst vor Ort?

Es ist ja klar, dass wir nicht im Maßstab 1:1 entwerfen, und es gibt in einem komplexen Projekt natürlich immer einen bestimmten Prozentsatz an unvorhersehbaren Details. Das ist auch das, was sie so spannend macht, glaube ich. [lächelt] Wenn man etwas Neues schaffen möchte, muss man immer mit Überraschungen rechnen. Hinzu kommt, dass die meisten unserer Projekte keine Serienproduktionen benutzen und nicht in Serie hergestellt werden sollen; es sind zumeist sehr individuelle Entwürfe. Daher ist es immer »das erste Mal«, wenn wir eine Idee in die Tat umsetzen.

Um die Frage noch zu konkretisieren: welcher Teil eines Projekts kann nicht bis ins Detail vorausgeplant werden?

Man kann die Interaktion mit den Besuchern nicht genau voraussehen. Das ist die Grundidee der direkten Kommunikation: einen Dialog anzuregen. Da ist das Ergebnis offen, man hat es nicht unter Kontrolle. Das zu versuchen, wäre auch kontraproduktiv, denn niemand interessiert sich für eine Konversation, die von einem der Partner vorgegeben wird. Daher ist die Planung eher eine Projektion auf der Grundlage einer bestimmten Datenmenge und etwas Know-how.

Also »Learning by doing« statt »das übliche Programm durchziehen«?

Ja, und wir sind kein Orakel, wir müssen es auch in die Tat umsetzen. Solange wir eine Idee nicht ausprobiert oder realisiert haben, sind wir nicht zufrieden. Das Ziel ist immer die erfolgreiche Anwendung, nicht nur ein gutes Konzept. Jemandem die Welt zu versprechen ist der leichteste Teil – es wahr zu machen, ist ein völlig anderes Ding. Ein Restrisiko bleibt immer. Ein Beispiel: Als wir die Horst-Ballons installierten, haben wir damit gerechnet, dass Leute dagegen schlagen oder daran ziehen würden, und haben eine spezielle Klemmverbindung entwickeln lassen. Wir hatten jede Menge Ersatzballons dabei und haben vorher ausprobiert, wie man sie unauffällig aufblasen kann. Womit wir nicht gerechnet hatten, war, dass der Stand, weil er so einen glatten Boden hatte, bei einer Gruppe von Inline-Skatern sehr beliebt wurde, die unter den Ballons hindurchsausten. Und sie neigten dazu, mit anderen Gästen zusammenzustoßen, die vielleicht gerade für ein Foto mit ihrem Lieblingsballon posierten. C'est la vie.

Dann könnte man sagen, menschliche Grundbedürfnisse anzusprechen ist vielversprechender als ausgefeilte Kommunikationsstrategien?

Ja, [lacht] die Menschen wollen etwas erleben: spielerische und emotionale Abenteuer, die sie anrühren. Eines meiner Prinzipien ist, dass alles, was ich tue, direkt beim Besucher ankommen soll, in seinem oder ihrem Herzen oder der Seele. Beides darf man in den täglichen, endlosen Informationsstürmen nicht vergessen, da geht es um Sekunden. Und es macht eine Menge aus, wenn man wirklich bereit ist, in »liebevoller Zuwendung« mit den Besuchern zu kommunizieren, statt sie nur als wandelnde Kreditkarten zu sehen.

» ... niemand interessiert sich für eine Konversation, die von einem der Partner vorgegeben wird. «

REFLECTIVITY \
SICHTWEISEN

→ Undesigning is a process, and as such it would be inappropriate to try and fix in stone a methodology for the approach. But a certain number of key phases can be identified, even if the first rule is that there are no rules. Take the case of a new client approaching D'art Design with a project outside their usual range of activity. After a discussion in house to decide if the project was worthwhile, the first phase would be a meeting with the client, with D'art represented by one of the directors and two or three designers. Their job would be to listen to what the client has to say, and report back on that to a first large working group, who would discuss the project very freely. This first large group discussion is the second phase of the project. This discussion is about identifying the aims and outcomes of the project and the background to it in the client's business. It is not about visual solutions and certainly not about aesthetics. This discussion also identifies the first core team, who will then start working on the design concept and, in parallel, on the method for presenting the design to the client. This is the third phase.

From time to time during the development of the design concept and the presentation concept, the small group will reconvene the larger group to present the work in progress and generate feedback about it. This may lead to exploring different approaches, to changes in the design team, and so forth. This is the fourth phase, after which the design is presented to the client. The design concept is then developed with the client, and through further iterations of the small group and large group meetings, until the design is finished. The final phase is the analysis of the delivered design and its effect, both in-house and with the client.

→ Undesigning ist ein Prozess, und daher wäre es sicher nicht angebracht, eine bestimmte Methode für diesen Ansatz in Stein zu meißeln. Dennoch lassen sich verschiedene Phasen erkennen, auch wenn die oberste Regel lautet, dass es keine Regeln gibt. Nehmen wir an, ein neuer Kunde tritt mit einem Projekt an D'art Design heran, das über ihre üblichen Aktivitäten hinausgeht. Nach einer hausinternen Diskussion darüber, ob man das Projekt übernehmen möchte, wäre die erste Phase ein Treffen mit dem Kunden, bei dem D'art von verantwortlichen Gestaltern und Geschäftsführern vertreten wird. Ihre Aufgabe ist es, dem Kunden zuzuhören, und das Ergebnis einer ersten größeren Arbeitsgruppe vorzutragen, die das Projekt dann sehr frei diskutiert. Diese erste große Gruppendiskussion stellt die zweite Phase dar. In dem Gespräch geht es darum, die Ziele und erwünschten Wirkungen des Projekts und seine Vorgeschichte im Unternehmen des Kunden zu definieren. Es geht nicht um die visuelle Umsetzung und sicher nicht um die Ästhetik. Bei dieser Gelegenheit bildet sich außerdem eine erste Arbeitsgruppe, die dann beginnt, ein gestalterisches Konzept zu entwickeln und parallel dazu eine Methode, dem Kunden das Design zu präsentieren. Das ist die dritte Phase.

Während der Entwicklung des Gesamtkonzepts und der Präsentationsstrategie tritt die kleinere Gruppe wieder mit der größeren Gruppe zusammen, um über den Stand der Dinge zu berichten und Rückmeldungen einzuholen. Das kann dazu führen, dass verschiedene Herangehensweisen durchgespielt werden, dass das Gestaltungsteam sich anders zusammensetzt und so weiter. Dies ist die vierte Phase, nach der der Entwurf dem Kunden präsentiert wird. Das Konzept wird dann anschließend mit dem Kunden gemeinsam weiterentwickelt, durchläuft mehrere Meetings der kleinen und der großen Gruppe, bis zur endgültigen Fertigstellung. Nach der Realisation des Projektes erfolgt eine Analyse des Gestaltungskonzepts und seiner Wirkung, sowohl hausintern als auch mit dem Kunden.

The key part of this process is the small group and large group meeting cycle. The relationship between the two groups is not a hierarchical one at all, but a cooperative one. The large group is not monitoring the working group, but is there to support it. This is completely different from the formal reporting structure that exists in many design agencies, and this absence of formality extends to the way such meetings are run, being directed towards outcomes rather than following a formal agenda. This structural difference is not the only one: ownership is another. In other design companies, once a team is assigned to a project, the team remains fixed and is in control of the project: they own the project. There is often the same process of exchange and consultation between the team and the client, but the rest of the agency is in some way excluded. The D'art approach makes almost the whole agency partici-pants in the development of the design and thus owners of it as well, even if not engaged with it on a regular basis.

This process also creates reflectivity: the fact that the project is regularly discussed in the wider context – and in positive terms – enables the designers involved to reflect on their own creative processes in a similarly positive way. Reflectivity should be a standard mode of action for any creative, but embedding it into the process is a major support for this necessary activity.

The series of exchanges created by the small group and large group method also allow for different modes of creative development to be utilised to the full. These can be broadly classified as intuitive and analytical: both are necessary, both can produce results. The intuitive approach is freeform thinking, wandering from one idea to another and letting one concept flow into another, while the analytical approach follows the elements of the brief to

Der Kern dieses Prozesses sind die wiederkehrenden Meetings in der kleinen und der großen Gruppe. Die Beziehung zwischen den beiden Gruppen ist nicht hierarchisch, sondern kooperativ. Die große Gruppe kontrolliert die kleine nicht, sondern unterstützt sie. Das ist ein großer Unterschied zu den förmlichen Berichtstrukturen in vielen anderen Gestaltungsateliers, und dieses Fehlen von Förmlichkeit zeigt sich auch an der Art dieser Meetings: sie sind zielgerichtet und halten sich nicht an einen formalen Plan. Diese strukturelle Andersartigkeit ist nicht die einzige: eine andere sind die Besitzverhältnisse. In anderen Ateliers bleibt ein Team, wenn es für ein Projekt zusammengestellt ist, bestehen und kümmert sich um das Projekt: das Projekt gehört ihm. Oft gibt es denselben Austausch zwischen Team und Kunde, aber der Rest der Agentur ist gewissermaßen ausgeschlossen. Bei D'art Design nimmt beinahe die gesamte Belegschaft an der Entwicklung teil, das Projekt gehört allen, auch wenn sie nicht regelmäßig damit beschäftigt sind.

Dieses Vorgehen sorgt auch für Reflexion: dass ein Projekt regelmäßig im größeren Kontext besprochen wird – und unter positiven Vorzeichen – ermöglicht es den beteiligten Gestaltern, ihren eigenen kreativen Prozess auf eine ebenfalls positive Weise zu reflektieren. Reflexion sollte ein grundsätzlicher Arbeits-modus jedes Kreativen sein, und dabei stellt es eine große Hilfe dar, sie in den gesamten Prozess einzubetten.

Der fortgesetzte Austausch durch die wechselnden Treffen in der kleinen und der großen Gruppe ermöglicht es außerdem, die unterschiedlichen kreativen Entwicklungs-möglichkeiten voll auszuschöpfen. Sie lassen sich grob in intuitive und analytische einteilen: beide sind notwendig, beide können Ergebnisse bringen. Der intuitive Ansatz arbeitet mit freien Gedankenspielen, bei denen man sich von einer Idee zur nächsten treiben lässt und ein Konzept ins nächste übergeht, während der analytische Ansatz den Details des Briefings folgt, um eine logische Lösung zu finden. Dadurch, dass die Erwägungen des Briefings immer wieder auf den Tisch kommen,

construct a logical solution. By regularly reopening the consideration of the brief, both these approaches can contribute, and also avoid the "tunnel vision" that concentrating the work in the hands of a small group can create.

können beide Ansätze etwas beitragen und darüber hinaus den Tunnelblick vermeiden helfen, der entstehen kann, wenn die gesamte Arbeit in den Händen einer kleinen Gruppe liegt.

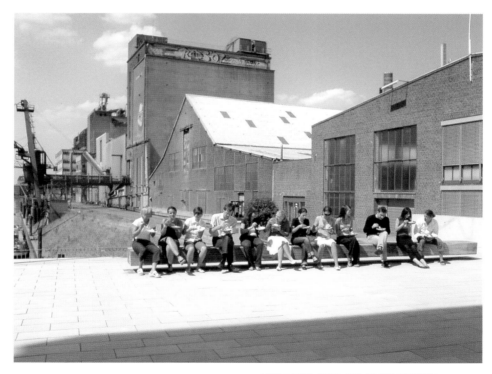

> LONG BREAK AFTER ONE OF THE INFAMOUS "LARGE" GROUP MEETINGS.

> GROSSE PAUSE NACH EINEM DER BERÜCHTIGTEN MEETINGS IN DER "GROSSEN" GRUPPE.

PBSA \
FH DÜSSELDORF

Absender • Sent from:

Firma • Company

Name, Vorname • Surname, First Name

Straße • Street

PLZ, Ort • Postcode, Town

avedition GmbH
Königsallee 57

71638 Ludwigsburg

Germany

Ich bin an weiteren Informationen über Ihr Buchprogramm interessiert
I am interested in further information on your publications catalogue

- [] Gesamtprogramm • Complete programme
- [] Architektur • Architecture
- [] Design • Design
- [] Messe • Trade Fairs

- [] Lebensart • Lifestyle
- [] Handbuch Berufspraxis
 Handbooks on professional tips

Diese Karte habe ich folgendem Buch entnommen:
I have taken this card from the following book:

Auf dieses Buch wurde ich aufmerksam durch
This book came to my attention via

- [] Buchhandlung • Book Shop
- [] Versandkatalog • Delivery catalogue
- [] Verlagsprospekt • Publishers catalogue
- [] Anzeige • Advert

- [] Empfehlung • Recommendation
- [] Besprechung • Critique
- [] Geschenk • Gift
- [] Internet • Internet

Mehr über die **av**edition unter: www.avedition.de
More information on **av**edition under: www.avedition.com

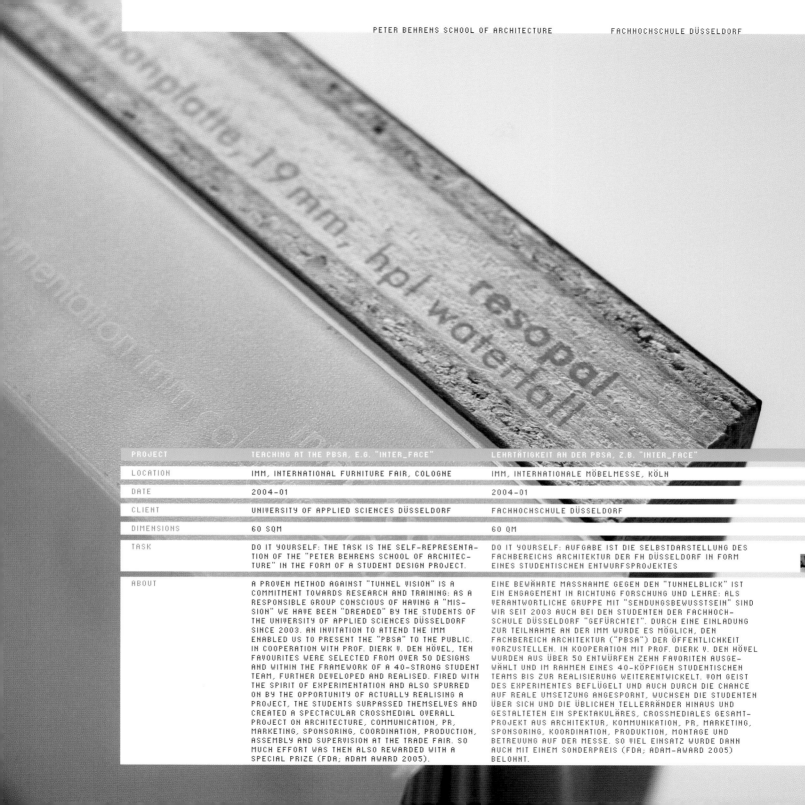

PROJECT	TEACHING AT THE PBSA, E.G. "INTER_FACE"	LEHRTÄTIGKEIT AN DER PBSA, Z.B. "INTER_FACE"
LOCATION	IMM, INTERNATIONAL FURNITURE FAIR, COLOGNE	IMM, INTERNATIONALE MÖBELMESSE, KÖLN
DATE	2004-01	2004-01
CLIENT	UNIVERSITY OF APPLIED SCIENCES DÜSSELDORF	FACHHOCHSCHULE DÜSSELDORF
DIMENSIONS	60 SQM	60 QM
TASK	DO IT YOURSELF: THE TASK IS THE SELF-REPRESENTATION OF THE "PETER BEHRENS SCHOOL OF ARCHITECTURE" IN THE FORM OF A STUDENT DESIGN PROJECT.	DO IT YOURSELF: AUFGABE IST DIE SELBSTDARSTELLUNG DES FACHBEREICHS ARCHITEKTUR DER FH DÜSSELDORF IN FORM EINES STUDENTISCHEN ENTWURFSPROJEKTES
ABOUT	A PROVEN METHOD AGAINST "TUNNEL VISION" IS A COMMITMENT TOWARDS RESEARCH AND TRAINING: AS A RESPONSIBLE GROUP CONSCIOUS OF HAVING A "MISSION" WE HAVE BEEN "DREADED" BY THE STUDENTS OF THE UNIVERSITY OF APPLIED SCIENCES DÜSSELDORF SINCE 2003. AN INVITATION TO ATTEND THE IMM ENABLED US TO PRESENT THE "PBSA" TO THE PUBLIC. IN COOPERATION WITH PROF. DIERK V. DEN HÖVEL, TEN FAVOURITES WERE SELECTED FROM OVER 50 DESIGNS AND WITHIN THE FRAMEWORK OF A 40-STRONG STUDENT TEAM, FURTHER DEVELOPED AND REALISED. FIRED WITH THE SPIRIT OF EXPERIMENTATION AND ALSO SPURRED ON BY THE OPPORTUNITY OF ACTUALLY REALISING A PROJECT, THE STUDENTS SURPASSED THEMSELVES AND CREATED A SPECTACULAR CROSSMEDIAL OVERALL PROJECT ON ARCHITECTURE, COMMUNICATION, PR, MARKETING, SPONSORING, COORDINATION, PRODUCTION, ASSEMBLY AND SUPERVISION AT THE TRADE FAIR. SO MUCH EFFORT WAS THEN ALSO REWARDED WITH A SPECIAL PRIZE (FDA; ADAM AWARD 2005).	EINE BEWÄHRTE MASSNAHME GEGEN DEN "TUNNELBLICK" IST EIN ENGAGEMENT IN RICHTUNG FORSCHUNG UND LEHRE: ALS VERANTWORTLICHE GRUPPE MIT "SENDUNGSBEWUSSTSEIN" SIND WIR SEIT 2003 AUCH BEI DEN STUDENTEN DER FACHHOCHSCHULE DÜSSELDORF "GEFÜRCHTET". DURCH EINE EINLADUNG ZUR TEILNAHME AN DER IMM WURDE ES MÖGLICH, DEN FACHBEREICH ARCHITEKTUR ("PBSA") DER ÖFFENTLICHKEIT VORZUSTELLEN. IN KOOPERATION MIT PROF. DIERK V. DEN HÖVEL WURDEN AUS ÜBER 50 ENTWÜRFEN ZEHN FAVORITEN AUSGEWÄHLT UND IM RAHMEN EINES 40-KÖPFIGEN STUDENTISCHEN TEAMS BIS ZUR REALISIERUNG WEITERENTWICKELT. VOM GEIST DES EXPERIMENTES BEFLÜGELT UND AUCH DURCH DIE CHANCE AUF REALE UMSETZUNG ANGESPORNT, WUCHSEN DIE STUDENTEN ÜBER SICH UND DIE ÜBLICHEN TELLERRÄNDER HINAUS UND GESTALTETEN EIN SPEKTAKULÄRES, CROSSMEDIALES GESAMTPROJEKT AUS ARCHITEKTUR, KOMMUNIKATION, PR, MARKETING, SPONSORING, KOORDINATION, PRODUKTION, MONTAGE UND BETREUUNG AUF DER MESSE. SO VIEL EINSATZ WURDE DANN AUCH MIT EINEM SONDERPREIS (FDA; ADAM-AWARD 2005) BELOHNT.

> ONE OF THE BASIC CONCERNS IS TO ALSO OFFER
THE STUDENTS THE POSSIBILITY OF REALISTIC,
PRACTICAL EXPERIENCE ALONGSIDE THE CONCEP-
TIONAL EXAMINATION.

> EINES DER GRUNDSÄTZLICHEN ANLIEGEN IST ES,
DEN STUDENTEN NEBEN DER KONZEPTIONELLEN
AUSEINANDERSETZUNG EBEN AUCH REALISTISCHE,
PRAKTISCHE ERFAHRUNGEN ZU ERMÖGLICHEN.

148 | 149

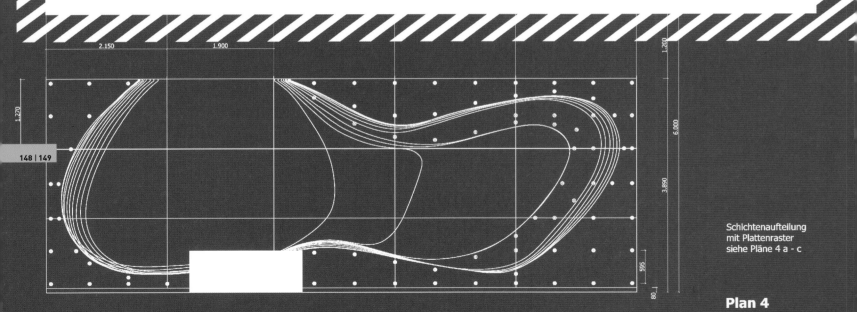

2.150 1.900

1.270

6.000

3.890

595

80

1.200

Schichtenaufteilung
mit Plattenraster
siehe Pläne 4 a - c

Plan 4

400 |215| 690

2.550 2.000 5.950

10.500

FH DÜSSELDORF	Prof. Dieck van den H.
	Dipl. Ing. Dieter Wrof
inter_face	imm 200
Grundriss	
mit Plattenraster	M 1 /

> THE COMPETITIVENESS CONCEPT OF THE COMPETITION CAME UNDER THE HEADLINE "INTER-FACE": AN INTERFACE BETWEEN STUDYING AND WORKING LIFE. A "POOL OF IDEAS" FOR GETTING TO KNOW ONE ANOTHER WAS THE GUIDING IDEA FOR THE APPEARANCE AT THE IMM 2004. THE HARD, ANGULAR EXTERNAL FORM CONTRASTS WITH THE SOFT, ORGANIC STRUCTURE OF THE INTERNAL FORM. THE CHOSEN SPACING OF THE INDIVIDUAL LAYERS GIVES THE OVERALL CONSTRUCTION A SOLID AND CLOSED, YET AT THE SAME TIME TRANSPARENT AND OPEN APPEARANCE.

> DAS SIEGERKONZEPT DES WETTBEWERBS STAND UNTER DER ÜBERSCHRIFT "INTER_FACE": EINE SCHNITT-STELLE ZWISCHEN STUDIUM UND ARBEITSLEBEN. EIN "IDEEN-POOL" ZUM GEGENSEITIGEN KENNENLERNEN WAR DER LEITGEDANKE FÜR DEN AUFTRITT AUF DER IMM 2004. DIE HARTE, KANTIGE AUSSENFROM KONTRASTIERTE MIT DEN WEICHEN, ORGANISCHEN STRUKTUREN DER INNENFORM. DIE GEWÄHLTEN ABSTÄNDE DER EINZELNEN SCHICHTEN LASSEN DEN GESAMTKÖRPER ZUGLEICH FEST UND GESCHLOSSEN, ABER AUCH TRANSPARENT UND OFFEN ERSCHEINEN.

inter_face

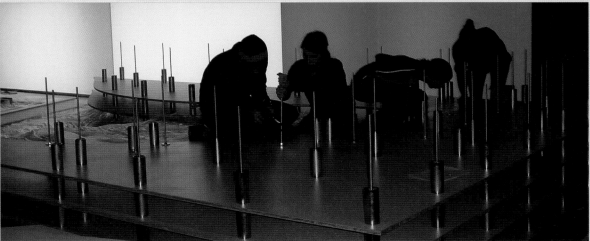

> TEAMWORK: THE CNC-MILLED FACE PLATES WERE LAMINATED AND FIXED ONTO SIMPLE THREADED RODS LAYER BY LAYER BY THE STUDENTS.

> TEAMWORK: DIE CNC-GEFRÄSTEN SPANPLATTEN WURDEN DURCH DIE STUDENTEN SCHICHT FÜR SCHICHT AUF EINFACHE GEWINDESTANGEN GESCHICHTET UND FIXIERT.

PBSA

Peter Behrens School
of Architecture

Department of FH Düsseldorf
University of Applied Sciences

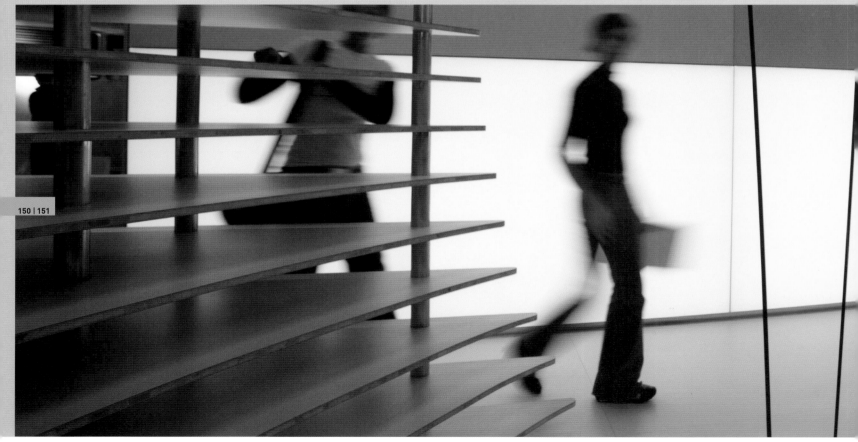

> THE TRADE FAIR APPEARANCE WAS ONLY ONE COMPONENT OF THE EXTENSIVE, INTEGRATED COMMUNICATION CONCEPT: ALSO CREATED WERE A PARALLEL WEBSITE, TEASER POSTCARDS, PROMOTIONAL CAMPAIGNS AND A PRINT DOCUMENTATION WITH CD-ROM AND SAMPLE MATERIAL. THE LABORIOUS ACQUISITION OF THE NECESSARY SPONSORS FOR REALISING THE PROJECT WAS ALSO TAKEN CARE OF BY THE STUDENTS.

> DER MESSEAUFTRITT WAR NUR EIN BAUSTEIN DES UMFANGREICHEN INTEGRIERTEN KOMMUNIKATIONSKONZEPTES: SO ENTSTANDEN PARALLEL WEBSITE, TEASER-POSTKARTEN, PROMOTIONAKTIONEN UND EINE GEDRUCKTE DOKUMENTATION MIT CD-ROM UND MATERIAL-MUSTER. DIE AUFWENDIGE AKQUIRIERUNG DER FÜR DIE REALISIERUNG NÖTIGEN SPONSOREN WURDE EBENFALLS DURCH DIE STUDENTEN GELEISTET.

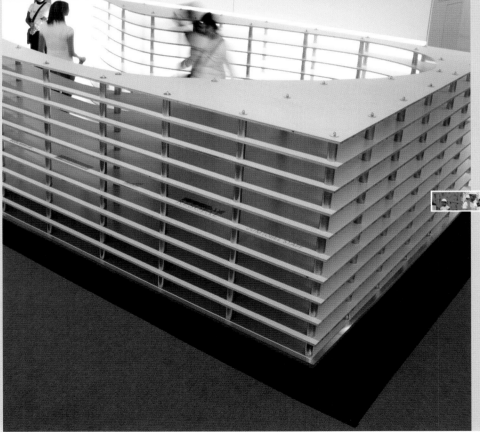

RUDOLPH IS BACK \
EINE WEIHNACHTSGESCHICHTE

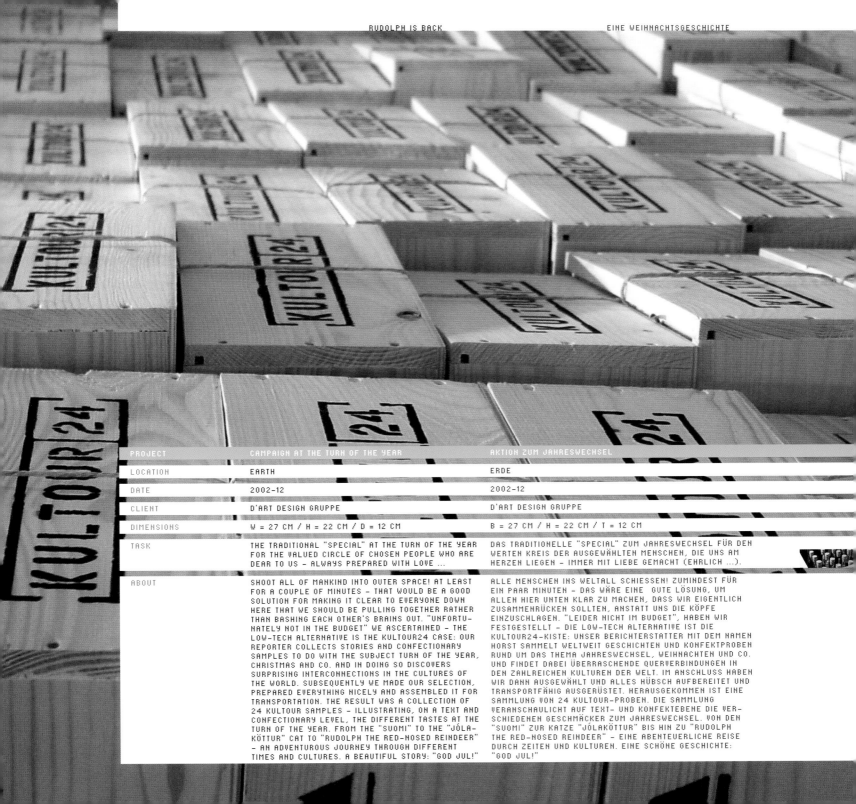

PROJECT	CAMPAIGN AT THE TURN OF THE YEAR	AKTION ZUM JAHRESWECHSEL
LOCATION	EARTH	ERDE
DATE	2002–12	2002–12
CLIENT	D'ART DESIGN GRUPPE	D'ART DESIGN GRUPPE
DIMENSIONS	W = 27 CM / H = 22 CM / D = 12 CM	B = 27 CM / H = 22 CM / T = 12 CM
TASK	THE TRADITIONAL "SPECIAL" AT THE TURN OF THE YEAR FOR THE VALUED CIRCLE OF CHOSEN PEOPLE WHO ARE DEAR TO US – ALWAYS PREPARED WITH LOVE ...	DAS TRADITIONELLE "SPECIAL" ZUM JAHRESWECHSEL FÜR DEN WERTEN KREIS DER AUSGEWÄHLTEN MENSCHEN, DIE UNS AM HERZEN LIEGEN – IMMER MIT LIEBE GEMACHT (EHRLICH ...).
ABOUT	SHOOT ALL OF MANKIND INTO OUTER SPACE! AT LEAST FOR A COUPLE OF MINUTES – THAT WOULD BE A GOOD SOLUTION FOR MAKING IT CLEAR TO EVERYONE DOWN HERE THAT WE SHOULD BE PULLING TOGETHER RATHER THAN BASHING EACH OTHER'S BRAINS OUT. "UNFORTU-NATELY NOT IN THE BUDGET" WE ASCERTAINED – THE LOW-TECH ALTERNATIVE IS THE KULTOUR24 CASE: OUR REPORTER COLLECTS STORIES AND CONFECTIONARY SAMPLES TO DO WITH THE SUBJECT TURN OF THE YEAR, CHRISTMAS AND CO. AND IN DOING SO DISCOVERS SURPRISING INTERCONNECTIONS IN THE CULTURES OF THE WORLD. SUBSEQUENTLY WE MADE OUR SELECTION, PREPARED EVERYTHING NICELY AND ASSEMBLED IT FOR TRANSPORTATION. THE RESULT WAS A COLLECTION OF 24 KULTOUR SAMPLES – ILLUSTRATING, ON A TEXT AND CONFECTIONARY LEVEL, THE DIFFERENT TASTES AT THE TURN OF THE YEAR. FROM THE "SUOMI" TO THE "JÓLA-KÖTTUR" CAT TO "RUDOLPH THE RED-NOSED REINDEER" – AN ADVENTUROUS JOURNEY THROUGH DIFFERENT TIMES AND CULTURES. A BEAUTIFUL STORY: "GOD JUL!"	ALLE MENSCHEN INS WELTALL SCHIESSEN! ZUMINDEST FÜR EIN PAAR MINUTEN – DAS WÄRE EINE GUTE LÖSUNG, UM ALLEN HIER UNTEN KLAR ZU MACHEN, DASS WIR EIGENTLICH ZUSAMMENRÜCKEN SOLLTEN, ANSTATT UNS DIE KÖPFE EINZUSCHLAGEN. "LEIDER NICHT IM BUDGET", HABEN WIR FESTGESTELLT – DIE LOW-TECH ALTERNATIVE IST DIE KULTOUR24-KISTE: UNSER BERICHTERSTATTER MIT DEM NAMEN HORST SAMMELT WELTWEIT GESCHICHTEN UND KONFEKTPROBEN RUND UM DAS THEMA JAHRESWECHSEL, WEIHNACHTEN UND CO. UND FINDET DABEI ÜBERRASCHENDE QUERVERBINDUNGEN IN DEN ZAHLREICHEN KULTUREN DER WELT. IM ANSCHLUSS HABEN WIR DANN AUSGEWÄHLT UND ALLES HÜBSCH AUFBEREITET UND TRANSPORTFÄHIG AUSGERÜSTET. HERAUSGEKOMMEN IST EINE SAMMLUNG VON 24 KULTOUR-PROBEN. DIE SAMMLUNG VERANSCHAULICHT AUF TEXT- UND KONFEKTEBENE DIE VER-SCHIEDENEN GESCHMÄCKER ZUM JAHRESWECHSEL. VON DEN "SUOMI" ZUR KATZE "JÓLAKÖTTUR" BIS HIN ZU "RUDOLPH THE RED-NOSED REINDEER" – EINE ABENTEUERLICHE REISE DURCH ZEITEN UND KULTUREN. EINE SCHÖNE GESCHICHTE: "GOD JUL!"

> WHAT AT THE BEGINNING OF THE STORY APPEARS TO ARRIVE AS THE USUAL CASE OF "SPIRITS" TAKES ON A COMPLETELY DIFFERENT APPEARANCE ONCE IT'S BEEN OPENED.

> WAS ZU BEGINN DER GESCHICHTE NOCH ALS DIE ÜBLICHE KISTE "GEISTIGER GETRÄNKE" DAHERKOMMT, SIEHT NACH DEM ÖFFNEN SCHON GANZ ANDERS AUS.

> 24 WELL-PROTECTED TEST TUBES AWAIT AN INITIAL
CURIOUS REACTION BY THE RECIPIENT. EACH TUBE
CONTAINS ANOTHER STORY AND AN APPROPRIATE
"TASTE SAMPLE".

> 24 GUT GESCHÜTZTE REAGENZGLÄSER WARTEN AUF
EINE ERSTE NEUGIERIGE REAKTION DER EMPFÄNGER.
JEDES RÖHRCHEN ENTHÄLT EINE ANDERE GESCHICHTE
UND EINE PASSENDE "GESCHMACKSPROBE".

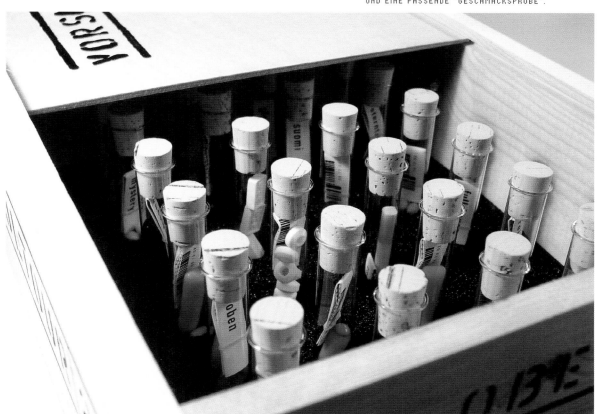

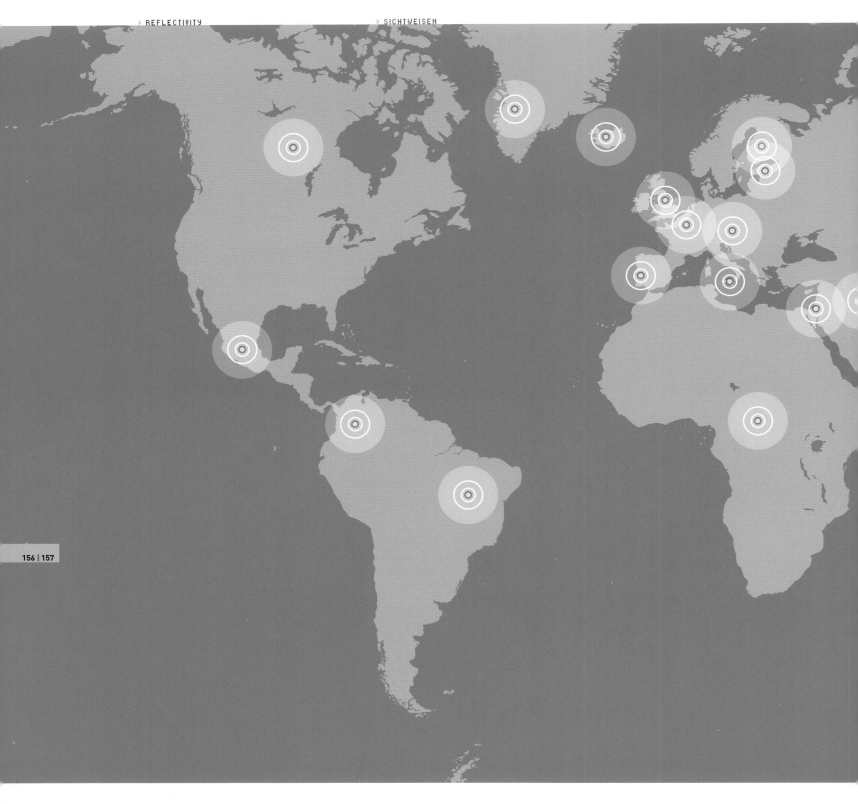

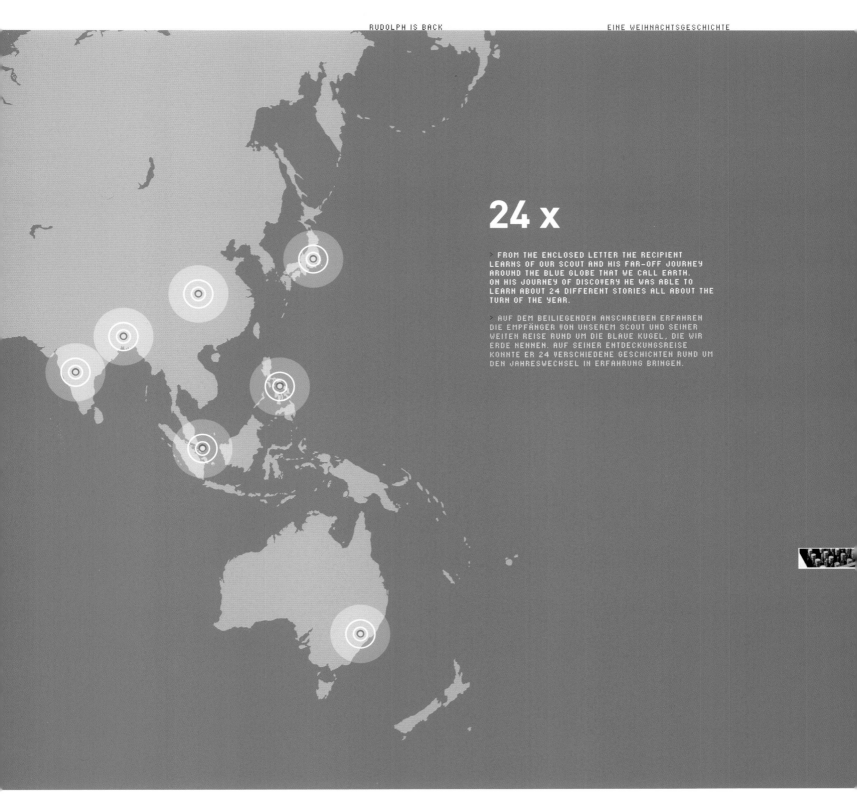

24 x

> FROM THE ENCLOSED LETTER THE RECIPIENT
LEARNS OF OUR SCOUT AND HIS FAR-OFF JOURNEY
AROUND THE BLUE GLOBE THAT WE CALL EARTH.
ON HIS JOURNEY OF DISCOVERY HE WAS ABLE TO
LEARN ABOUT 24 DIFFERENT STORIES ALL ABOUT THE
TURN OF THE YEAR.

> AUF DEM BEILIEGENDEN ANSCHREIBEN ERFAHREN
DIE EMPFÄNGER VON UNSEREM SCOUT UND SEINER
WEITEN REISE RUND UM DIE BLAUE KUGEL, DIE WIR
ERDE NENNEN. AUF SEINER ENTDECKUNGSREISE
KONNTE ER 24 VERSCHIEDENE GESCHICHTEN RUND UM
DEN JAHRESWECHSEL IN ERFAHRUNG BRINGEN.

COMMUNICATION \
EPILOG

→ This account of the work of D'art Design Gruppe has focussed on the design process and on the concept of undesigning. The formal and aesthetic aspects of the finished work have not been discussed as they are evident from the images of the work in this book. There is also a further reason: the D'art Design Gruppe are indeed designers, and so concerned with the appearance, functionality and visual values of their work. But they are also communicators, and communicators first, using design as a communication channel or language.

Communication has three aspects for D'art. Firstly there is communication within the agency itself: witness the absence of a hierarchical office system, the use of freeform large group meetings to investigate and develop projects, the refusal to categorise members of the team by their skills. This creates a working mode in which communication, in terms of co-operation and sharing, is at the forefront. Secondly there is communication with the client. This goes beyond keeping the client informed towards making the client a partner in the process, a participant in, not just a user of, the final design. Thirdly, they seek to communicate with the customer, the final beneficiary of the design. Their design work, whether in the form of a shop design or a trade fair stand, is not an end in itself, aesthetically or formally, nor an exclusively visual explanation of the corporate values and messages of the client, but a platform for an ongoing dialogue between the client and the client's customers and stakeholders. Their work is not about looking good or acting correctly but about being memorable, about building a link between the client and the customer. And their mission is to find new and memorable ways of building or

→ Diese Darstellung der Arbeit der D'art Design Gruppe hat sich auf den gestalterischen Prozess und auf das Konzept des Undesigning konzentriert. Die formalen und ästhetischen Aspekte der fertigen Arbeiten sind nicht behandelt worden, denn sie sind aus den Bildern ersichtlich. Und es gibt noch einen weiteren Grund: die D'art Design Gruppe besteht in der Tat aus Gestaltern, und daher geht es in ihrer Arbeit um Aussehen, Funktionalität und optische Werte. Aber sie betreiben in erster Linie Kommunikation und benutzen das Design als Kommunikationsmittel oder Sprache.

Kommunikation findet bei D'art auf drei Ebenen statt. Erstens die Kommunikation innerhalb der Agentur: Durch die Abwesenheit eines hierarchischen Bürosystems, die frei gestalteten Meetings in der großen Gruppe zur Entwicklung von Projekten und die Weigerung, Teammitglieder nach ihren Fähigkeiten zu kategorisieren, entsteht eine Arbeitsatmosphäre, in der Kommunikation im Sinne von Zusammenarbeit und Teilnahme ganz groß geschrieben wird. Zweitens die Kommunikation mit dem Kunden. Sie hält den Kunden nicht nur auf dem Laufenden, sondern macht ihn darüber hinaus zum Partner im Gestaltungsprozess, zum Teilnehmer und nicht nur Benutzer des Endergebnisses. Drittens bemüht sich die D'art Design Gruppe um die Kommunikation mit dem Kunden des Kunden, dem Endbenutzer. Ihre gestalterische Arbeit, ob für einen Shop oder einen Messestand, ist kein Ende, ästhetisch oder formal, und nicht ausschließlich eine visuelle Darstellung der Werte und Botschaften des Kundenunternehmens, sondern ein Forum für einen fortdauernden Dialog zwischen dem Kunden und seinen Kunden. Es geht bei ihrer Arbeit nicht darum, gut auszusehen oder sich korrekt zu verhalten, sondern darum, in Erinnerung zu bleiben, und darum, Verbindungen zwischen dem Kunden und seinen Kunden zu schaffen. Es ist ihre Mission, neue und einprägsame Wege zu finden, diese Verbindungen herzustellen oder zu verstärken, damit der Dialog mit dem Endkunden fortgesetzt wird und sich weiterentwickelt. Dieses Ziel erreicht man nicht mit Bildern allein.

reinforcing such links, so that the client/customer dialogue continues and develops. This purpose and this process is something that images alone cannot convey, but it is central to D'art's present and past successes, and remains the key to their future.

Es ist die Grundlage für die gegenwärtigen und vergangenen Erfolge von D'art und bleibt der Schlüssel für ihre Zukunft.

DESIGN GRUPPE

CONTACT:

D'ART DESIGN GRUPPE
HAUS AM PEGEL
AM ZOLLHAFEN 5
D-41460 NEUSS

PHONE: +49 (0) 21 31 . 40 30 70
FAX:　　+49 (0) 21 31 . 40 30 7-89

www.d-art-design.de
welcome@d-art-design.de

MEMBER OF:

FDA
Forum Design
und Architektur

HANS PETER JÜLICHS,
FINANCES AND PROJECT
MANAGEMENT

>

ENTWICKLUNG KENNT
KEINE SICHERHEIT

MILA MALLIA,
OFFICE MANAGEMENT

>

ENGEL FLIEGEN,
WEIL SIE SICH LEICHT
NEHMEN

KARUNA PRAKOSAY,
ORGANIZATION

>

WENN ZU PERFEKT,
GOTT WIRD BÖSE

MARKUS SCHMITZ,
FINANCES AND PROJECT
MANAGEMENT

>

PUNKT, PUNKT, KOMMA,
STRICH ...

INGE BRÜCK-SEYNSTAHL,
MARKETING, CONTACT
AND PR

>

ABWECHSLUNG LÄSST
DEN ALLTAG TANZEN

SWENJA KREMER,
MARKETING
OFFICE MANAGEMENT

>

DAS WORT ERST VOLL-
ENDET DIE IDEE UND
GIBT IHR DAS LEBEN

BARBARA WOLFF,
COMMUNICATION DESIGN,
CONTACT AND PR

>

PHANTASIE IST
WICHTIGER ALS WISSEN

CLAUDIA WILLECKE,
INTERIOR DESIGN

>

DIE EWIGKEIT DAUERT
LANGE, BESONDERS
GEGEN ENDE

KLAUS MÜLLER,
INTERIOR DESIGN AND
PROJECT MANAGEMENT

>

IDEEN SIND WIE KINDER;
DIE EIGENEN SIND DIE ...

CONNY CAYLEK,
COMMUNICATION DESIGN

>

BLINDES HUHN SIEHT
NUR DEN HAHN

DIETER WOLFF,
INTERIOR DESIGN,
MANAGEMENT

>

NICHTS IST BESTÄNDIGER
ALS DIE VERÄNDERUNG

GUIDO MAMCZUR,
COMMUNICATION DESIGN,
CREATIVE DIRECTION

>

FOLLOW THE WHITE
RABBIT

VOLKER WRENSCH,
ORGANIZATION AND
PROJECT MANAGEMENT

>

DER STEIN DER WEISEN
SIEHT DEM STEIN DER
NARREN SEHR ÄHNLICH

DOMINIK HOF,
INTERIOR DESIGN

>

AM NEST ERKENNT
MAN'S VÖGLEIN

SARAH WILLE,
INTERIOR DESIGN

>

JEDE SCHÖPFUNG IST
EIN WAGNIS

SVENJA HANSEN,
INTERIOR DESIGN

>

AUCH DIE EWIGKEIT
BESTEHT AUS
AUGENBLICKEN

JOCHEN HÖFFLER,
INTERIOR DESIGN,
MANAGEMENT

>

GUTE NACHT JOHN-BOY,
GUTE NACHT MARY-
ELLEN, ...

MIRA LEE,
COMMUNICATION DESIGN

>

WENN DU GESIEGT HAST,
SCHNALLE DEN HELM
FESTER

KARIN BLANKE,
INTERIOR DESIGN AND
PROJECT MANAGEMENT

>

ANDER WIND, ANDER
WETTER

JONAS REINSCH,
COMMUNICATION DESIGN

>

AUCH TIEFE WASSER
SIND NASS

NINA WIEMER,
INTERIOR DESIGN

>

GEDULD BRINGT ROSEN

ANGIE GRUISINGA,
TRAINEE

>

ETIAM STULTORUM

FREDDY JUSTEN,
PRODUCT DESIGN,
MANAGEMENT

>

EINE ENTE MACHT DEN
FLUSS NICHT TRÜBE

INGO BACKE,
INTERIOR DESIGN AND
PROJECT MANAGEMENT

>

MAN MUSS AUCH AUF
ENTBEHRUNGEN
VERZICHTEN KÖNNEN

ANGELA KETTLER,
COMMUNICATION DESIGN

>

THE QUICK BROWN
FOX JUMPS OVER THE
LAZY DOG

BIRTE FARIN,
MARKETING, CONTACT
AND PR

>

... ES WIRD VIEL
PASSIEREN ...

NADIA JUSTEN,
COMMUNICATION DESIGN,
CONTACT AND PR

>

ADAM: DER ERSTE
ENTWURF FÜR EVA

NINA KRASS,
INTERIOR DESIGN

>

OHNE LEIDENSCHAFT
GIBT ES KEINE
GENIALITÄT

→ **The D'art Design Gruppe would like to thank all clients and cooperation partners for their trust in us.**

→ Die D'art Design Gruppe bedankt sich bei allen Kunden und Kooperationspartnern für das entgegengebrachte Vertrauen.

THANKS TO \
DANKSAGUNG

100world, 1. FC Kaiserslautern, 3M, Aces, Adidas, Alcan, Allianz, Alno, Altana, Ara, Arte, Audi, Bayer, Bmz+more, Bridgestone, Claus Koch, Curiavant, Daewoo, DaimlerChrysler, Deutsche Börse, Deutsche Haus und Boden, DEW, DFB, EDG, EGN, Elefanten, E.ON Ruhrgas, E-plus, Ergoline, Erima, Eurobike, Evivo, FC Schalke 04, Fresenius, Gabor Shoes, Gea Happel, Gft Solutions, Gutjahr, Hanes Europe, Haverkamp, Hertha BSC, Holtmann, Hotel Stadt Dormagen, Ision, JS Design, Kabel NRW, Karstadt, Kaufhof, Keramag, Kludi, Kogag, KSW Gruppe, LG, Lloyd Shoes, Loewe, Lord Excellent Shoes, Lotto Hessen, Mabege, Mercedes-Benz, MFI, MG Rover, Mitsui, Mobilcom, Mono, M-real Zanders, Nokia, Nothelle, Novum, Nintendo, Oki Systems, Otto Bock, Panasonic, Paperproducts, Pfleiderer, Philips, Philips AEG Licht, Phoenix Contact, Picard, Quadriga, Renault, Richter Junge Schuhe, Rimage, Rosenthal, Rösle, Rowenta, Runners Point, RWE, Samsonite, Samsung, Scheurich, Silhouette, Soldan, Sony, Sporthaus Eybl, Stadt Neuss, Stiebel Eltron, Talkline, Technokom, Travel 24, TSV Bayer 04, TÜV Rheinland, VDP, Voblo, Vodafone, Westdeutsche Lotterie, Windsor, WMF, W&V, Zack, ZDF

> TYPOGRAPHY

SUPERNATURAL (FREEWARE FONT)
COPYRIGHT, 2003 SVEN STÜBER FOR
52NORD DESIGNBÜRO, GERMANY
WWW.SUPERIEUR-GRAPHIQUE.COM

FF DIN
COPYRIGHT, 1995 ALBERT-JAN POOL FOR
FONTFONT; FSI FONTSHOP INTERNATIONAL
WWW.FONTFONT.COM

MYRIAD PRO
COPYRIGHT, 1992 ADOBE TYPE STAFF:
CAROL TWOMBLY, CHRISTOPHER SLYE,
FRED BRADY, ROBERT SLIMBACH;
AGFA / MONOTYPE

> PAPER
PRIMASET, 150 GR/SQM, PAPIER UNION

> TYPOGRAFIE

SUPERNATURAL (FREEWARE FONT)
COPYRIGHT, 2003 SVEN STÜBER FÜR
52NORD DESIGNBÜRO.
WWW.SUPERIEUR-GRAPHIQUE.COM

FF DIN
COPYRIGHT, 1995 ALBERT-JAN POOL FÜR
FONTFONT; FSI FONTSHOP INTERNATIONAL
WWW.FONTFONT.COM

MYRIAD PRO
COPYRIGHT, 1992 ADOBE TYPE STAFF:
CAROL TWOMBLY, CHRISTOPHER SLYE,
FRED BRADY, ROBERT SLIMBACH;
AGFA / MONOTYPE

> PAPIER
PRIMASET, 150 GR/QM, PAPIER UNION

COLOPHON \
KOLOPHON

PICTURE CREDITS \
BILDNACHWEIS

BIBLIOGRAPHIC INFORMATION PUBLISHED BY
DIE DEUTSCHE NATIONALBIBLIOTHEK

DIE DEUTSCHE NATIONALBIBLIOTHEK LISTS THIS
PUBLICATION IN THE DEUTSCHE NATIONAL-
BIBLIOGRAFIE; DETAILED BIBLIOGRAPHIC DATA ARE
AVAILABLE IN THE INTERNET AT HTTP://DNB.D-NB.DE

ISBN-10: 3-89986-073-X
ISBN-13: 978-3-89986-073-3

CONCEPT / DESIGN
D'ART DESIGN GRUPPE: GUIDO MAMCZUR

WWW.D-ART-DESIGN.COM
WELCOME@D-ART-DESIGN.COM

TEXT / INTERVIEWS
CONWAY LLOYD MORGAN /
PROJECT DESCRIPTIONS: GUIDO MAMCZUR

TRANSLATIONS
ISABEL BOGDAN, JO STEAD

DTP
HKP GMBH, DUESSELDORF AND
D'ART DESIGN GRUPPE

PRODUCTION / PRINT
LEIBFARTH & SCHWARZ GMBH & CO. KG,
DETTINGEN/ERMS

PRINTED IN GERMANY

BIBLIOGRAFISCHE INFORMATION DER DEUTSCHEN
NATIONALBIBLIOTHEK

DIE DEUTSCHE NATIONALBIBLIOTHEK VERZEICHNET DIESE
PUBLIKATION IN DER DEUTSCHEN NATIONALBIBLIOGRAFIE;
DETAILLIERTE BIBLIOGRAFISCHE DATEN SIND IM
INTERNET ABRUFBAR UNTER HTTP://DNB.D-NB.DE

ISBN-10: 3-89986-073-X
ISBN-13: 978-3-89986-073-3

KONZEPT / GESTALTUNG
D'ART DESIGN GRUPPE: GUIDO MAMCZUR

WWW.D-ART-DESIGN.DE
WELCOME@D-ART-DESIGN.DE

TEXT / INTERVIEWS
CONWAY LLOYD MORGAN /
PROJEKTBESCHREIBUNGEN: GUIDO MAMCZUR

ÜBERSETZUNG
ISABEL BOGDAN, JO STEAD

DTP
HKP GMBH, DÜSSELDORF UND
D'ART DESIGN GRUPPE

PRODUKTION / DRUCK
LEIBFARTH & SCHWARZ GMBH & CO. KG,
DETTINGEN/ERMS

PRINTED IN GERMANY

IMPRINT \
IMPRESSUM

THESE ARE MY PRINCIPLES, IF YOU DON'T LIKE THEM, I HAVE OTHERS. [GROUCHO MARX]